MW01071474

HITCHCOCK'S
HEROINES

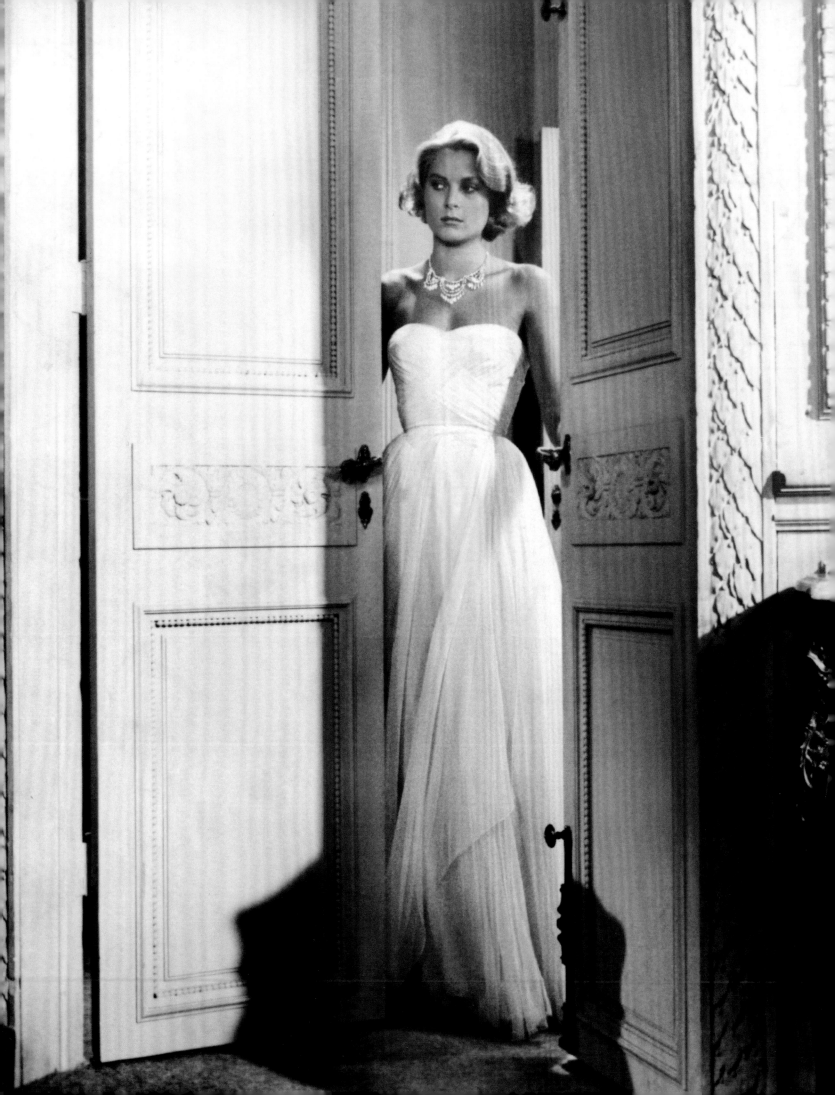

HITCHCOCK'S
HEROINES

Caroline Young

INSIGHT
EDITIONS
San Rafael, California

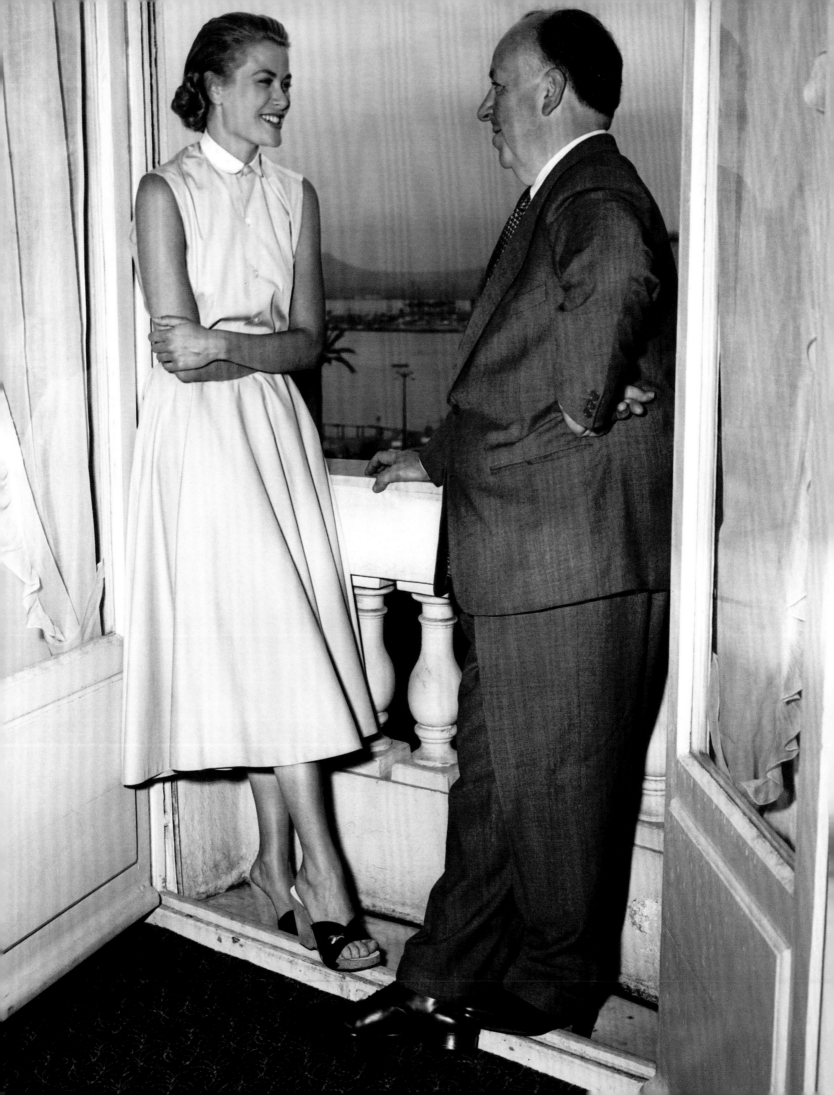

CONTENTS

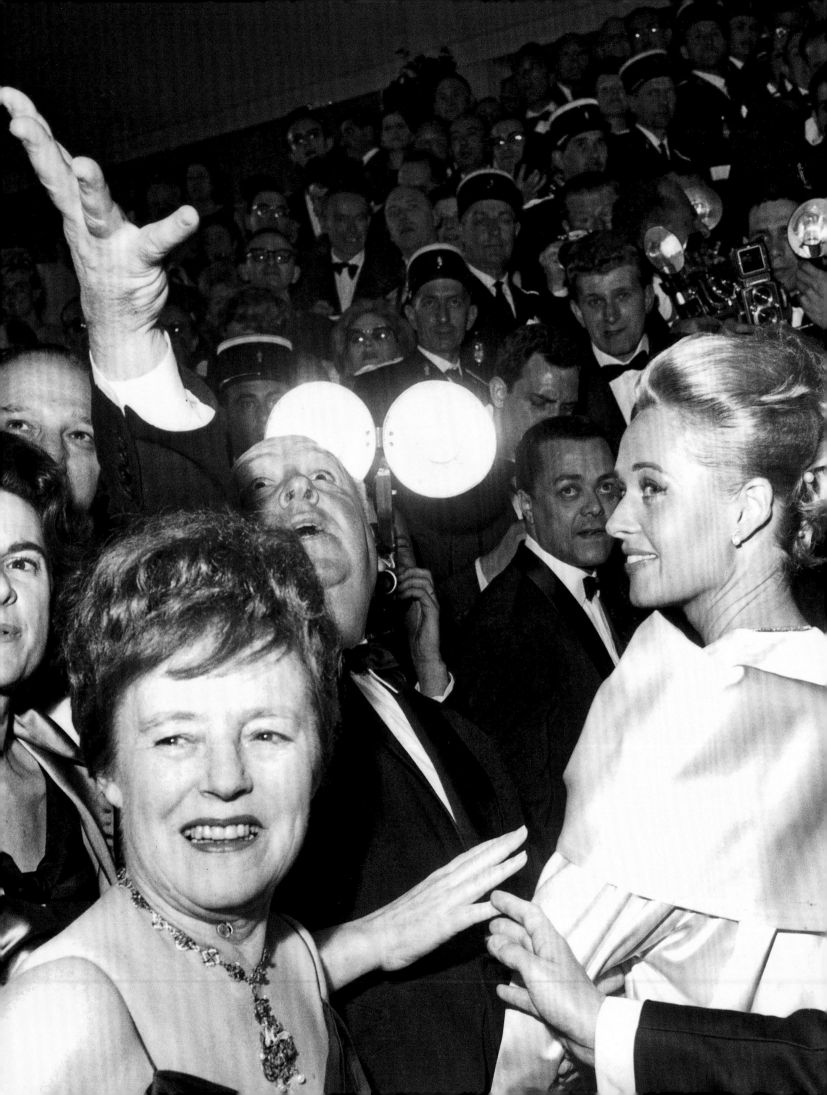

INTRODUCTION

With a career that spanned six decades, Alfred Hitchcock is both the most respected and most maligned of directors, whose idolatry of blonde women is said to border on fetishism. His hugely popular films offered suspense, fear, sex, beautiful costumes, exotic locations, and humor to break the tension.

But it is Hitchcock's heroines that this book pays tribute to. Hitchcock's films in the 1950s and early 1960s notoriously focused on the glacial blonde, as he tried to re-create the magic he found with Grace Kelly. This tradition can also be traced back to *The Lodger* (1927), in which a serial killer has a sadistic desire for beautiful blondes.

Hitchcock's heroines weren't all blondes—there were brunettes like Teresa Wright and Margaret Lockwood, light-brown-haired Joan Fontaine and Ingrid Bergman, and the redheaded barmaid, played by Anna Massey, in *Frenzy*. In addition to being elegant and beautifully dressed, these women could be brave, plucky, sensual, complicated, obsessive, and most important, sympathetic. We see his films from their perspective, and when it comes to solving the crime, often it is the woman who has the wits to do so. Lisa in *Rear Window*, for example, springs into action and places herself in danger while her partner, played by James Stewart, is incapacitated. While Hitchcock's films are sometimes considered misogynistic, he takes the heroine's point of view in many of his films including *Rebecca*, *Suspicion*, *Notorious*, and *The Birds*, where we experience the bird attack through Melanie Daniels.

Hitchcock's heroines are celebrated through their carefully constructed image, as it is through their appearance that their personality is conveyed. While June and Anny Ondra were two of Hitchcock's early blondes, Madeleine Carroll was the first heroine whose image and

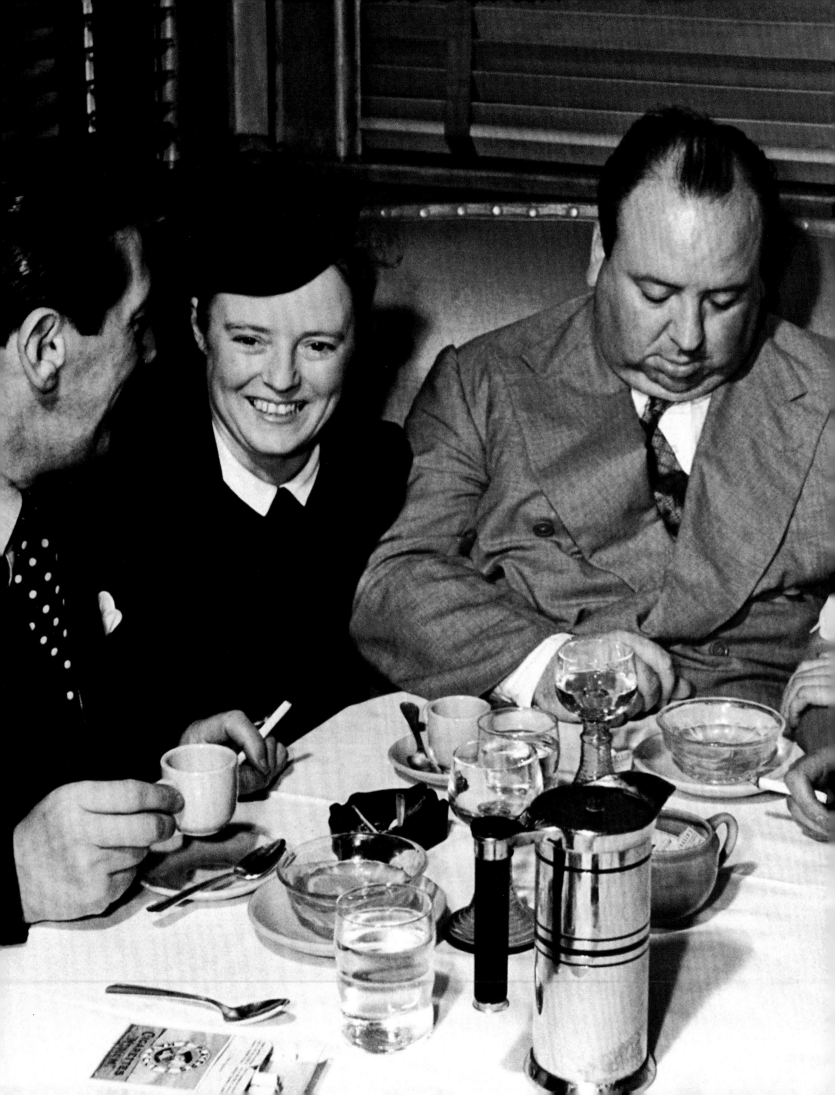

character he truly went out of his way to shape on screen. A period of strong, dark-haired leading ladies followed, until the 1950s, when elegant blondes, such as Grace Kelly, became the dominant heroines of his films.

After Grace Kelly, whose allure Hitchcock was never able to fully shake off, he looked to find another actress who could fill her shoes–first Vera Miles, then Tippi Hedren. Much is made of the coolness of the blonde, with Kim Novak in *Vertigo* as the most remote and ghost-like, but they were congenial too—Grace Kelly brought warmth to the screen, Ingrid Bergman, more light brunette than blonde, is endearing, Marion in *Psycho* was heart-renderingly likeable and appealing, so much so that her death is devastating. The women most of all are sympathetic, and Hitchcock himself said: "I believe that the vast majority of women, in all ranks of life, are idealists. They may not live up to their own ideals, often they cannot do so, but they do like to see them personified by their favorite film heroines."

Hitchcock was meticulous about the visuals, and this involved finessing hair, wardrobe, and makeup, to create elegance and style. As his career developed, he became more specific with the image as, like a painter, he worked to create subliminal messages through color, particularly in *Vertigo* and *Marnie*.

Hitchcock's films spanned generations that saw huge changes in society and experienced World War II, the Cold War, the Civil Rights Movement, and the women's liberation movement. At times, Hitchcock struggled to keep up with these changes. But one of the greatest things about his work is that each of his films says so much about the era in which it was made. He loved the atmosphere and color of street scenes, and just observing the styles of the extras in his films provides a real taste of time and place: those opening Madison Avenue scenes in *North by Northwest*, the rowdy music hall in *The 39 Steps*, the climax in the Royal Albert Hall with a full audience in *The Man Who Knew Too Much*.

According to biographer Peter Ackroyd, Hitchcock compared "the thriller to the fairytale, conflating an atmosphere of fantasy and wish-fulfilment with the essential narrative of good and evil." And while his heroines could be awoken and saved by a handsome prince—as in *Notorious*—that prince was not Hitchcock. The director cast himself

9401-937

9401-941

9401-945

9401-938

9401-942

9401-946

9401-939

9401-943

9401-944

as the beast in *Beauty and the Beast*—trapped in a large body, watching those blondes on screen as fantasy and wish-fulfilment.

"I always thought of him as the prince locked in the frog," *Psycho*'s costume designer Rita Riggs said. "He truly loved beauty so much and set out to create it. I think his perversities and his frustration with his exterior were part of his wonderful creativity."

Hitchcock enjoyed the company of women, and he was surrounded by women who assisted him, collaborated with him, and advised him. His wife, Alma Reville, worked as a scriptwriter and editor before they got married. She was a talented filmmaker with a shrewd eye, and she wrote many of the script treatments, in addition to advising on scripts. If she didn't believe a story would make a good film, then Hitchcock would move on to something else. As actress Diane Baker recalled: "His wife was a very strong character in his life, the wind under his wings." Other close associates included Joan Harrison, Hitchcock's secretary from the 1930s who went on to produce his TV series *Alfred Hitchcock Presents*, and Peggy Robertson, who became his right-hand woman.

Hitchcock designed films for women, as they made up a large percentage of the audience, and "it's generally the woman who has the final say on which picture a couple is going to see," as he told fellow

Introduction page 6: Alma Reville (L) Alfred Hitchcock (center), and Tippi Hedren (R) at the Cannes Film Festival as part of *The Birds* publicity tour, 1963.

Previous page: Hitchcock, a notorious snoozer, fast asleep while sitting between his writing team of wife Alma Reville (second left) and Joan Harrison (R) and friend Mike Hogan (L).

Opposite: Alfred Hitchcock and Janet Leigh in stills from *Psycho*.

filmmaker François Truffaut, who later wrote a book on Hitchcock based on their conversations in 1962.

In the 1930s and 1940s, many women wished to see a glamorous star on screen whom they could identify with and whose wardrobe they could admire, so Hitchcock paid close attention to curating that perfect image.

Hitchcock had the Victorian suppressive instinct for fetishism. He was fascinated by the allure of covered-up sexuality, of voyeurism, and of fantasies around certain features or items of clothing, such as black heels, blonde hair, and even glasses.

Hitchcock's press was often based on the idea of him as Svengali. He was regularly quoted on how he preferred the Nordic type of woman and how elegance and hidden sex appeal was much more attractive than the Marilyn Monroe flavor of carnal desire. "I don't personally care for obvious sex," he told the press in 1959. "A woman's appeal should come from gradual unfolding of her nature rather than wares displayed. The blonde northern woman with her apparent coolness actually is extremely sexy; I think this is very intriguing."

Exploring these themes in his films wasn't necessarily to satisfy his own kinks, as he made films for his audience. He had an instinct for what they wanted to see and feel, and often that was for a woman to suffer on screen—as well as to triumph. Hitchcock told Truffaut that he was celibate and didn't get a kick out of doing love scenes at all. The reason he chose to film an intimate scene in *Psycho*, which showed Janet Leigh in a bra, was that it was what young audience members expected.

The actresses who worked with him have reported different experiences. Ingrid Bergman considered him a close friend, as did Grace Kelly and Janet Leigh,

who had a good time working with him on *Psycho*. But four years later, something changed. *Marnie*, by all reports, was an unhappy experience for many of those involved, particularly Tippi Hedren and Diane Baker. By then, Hitchcock was not the same content, creative person he had been in his Paramount years.

"Kim Novak had a different experience to me and Tippi; she adored Hitch and never experienced anything like that," Baker says. "We were both young and inexperienced, and we didn't have the protection that Kim Novak did. We were newcomers, and he was already the Master of Suspense."

"I think he liked women. And I think you can communicate best about that which you have affinity for."

KAREN BLACK, ACTRESS, *FAMILY PLOT*

While Tippi Hedren has spoken of her traumatic experiences working with Hitchcock, many of his other leading ladies had only warm things to say of him and were fond of him. He liked his stars to appreciate his bawdy, schoolboy humor, and he was a practical joker who could at times be cruel. He could be vindictive to those with whom he didn't get along. It seems that the actresses signed to his personal contracts—such as Vera Miles and Tippi Hedren— bore the brunt of his attitude, while experienced actresses and those under studio contracts, like Kim Novak with Columbia, had a form of protection, as they were already controlled by their studio.

"I think he liked women. And I think you can communicate best about that which you have affinity for," said Karen Black, who starred in his last film, *Family Plot*.

Suzanne Pleshette, who costarred in *The Birds*, added, "I think that in the sense that he's given credit for being very controlling, yes, he controls his films. They were his films. They were out of his imagination, and the way they were styled and how we appeared in them, and the men as well, were part of the full impact that he wanted."

While the actresses who worked with him have different opinions, one thing that is clear is that Hitchcock was a complex character who commented on his own impotence, made attempts at awkward kisses, misjudged situations, and had an Edwardian love of pranks. There are tales of his "blue" parties, where all the food and drink had been dyed blue, but also stories about how he spiked drinks for a laugh. He was introverted and shy, and if there was conflict or anger directed at him, he could be left anxious all day.

Along with filmmaking, Alma and his daughter Pat were the true loves of Hitchcock's life. A letter to a friend in 1978 reveals the sadness and "melancholy" he felt when Alma suffered a serious stroke, and how he still tried to bring her out of the house for their customary Thursday night meal at Chasen's.

Hitchcock paid tribute to his greatest heroine when he received his Lifetime Achievement Award from the American Film Institute in 1979, the year before he died. He praised "four people who have given me the most affection, appreciation, and collaboration. The first is a film editor, the second is a scriptwriter, the third is the mother of my daughter, Pat, and the fourth is as fine a cook as ever performed miracles in a domestic kitchen . . . and their names are Alma Reville."

Opposite: Grace Kelly and Alfred Hitchcock on the set of *To Catch a Thief*.

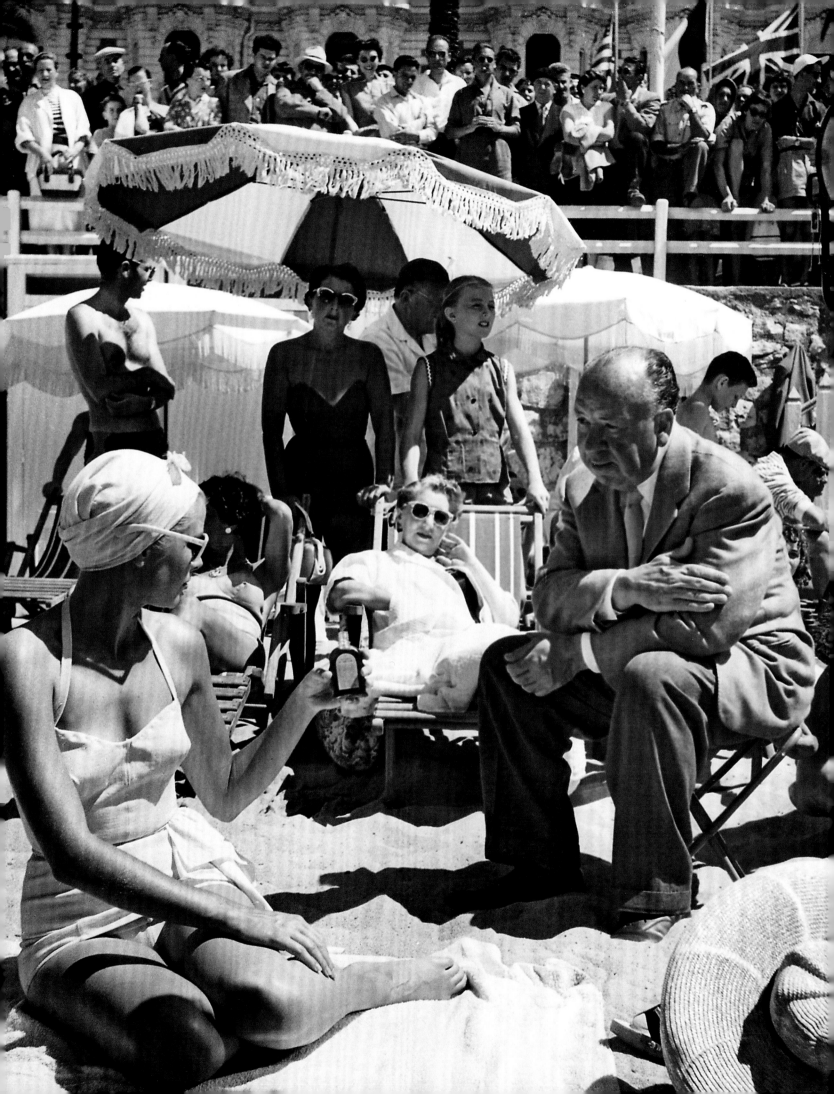

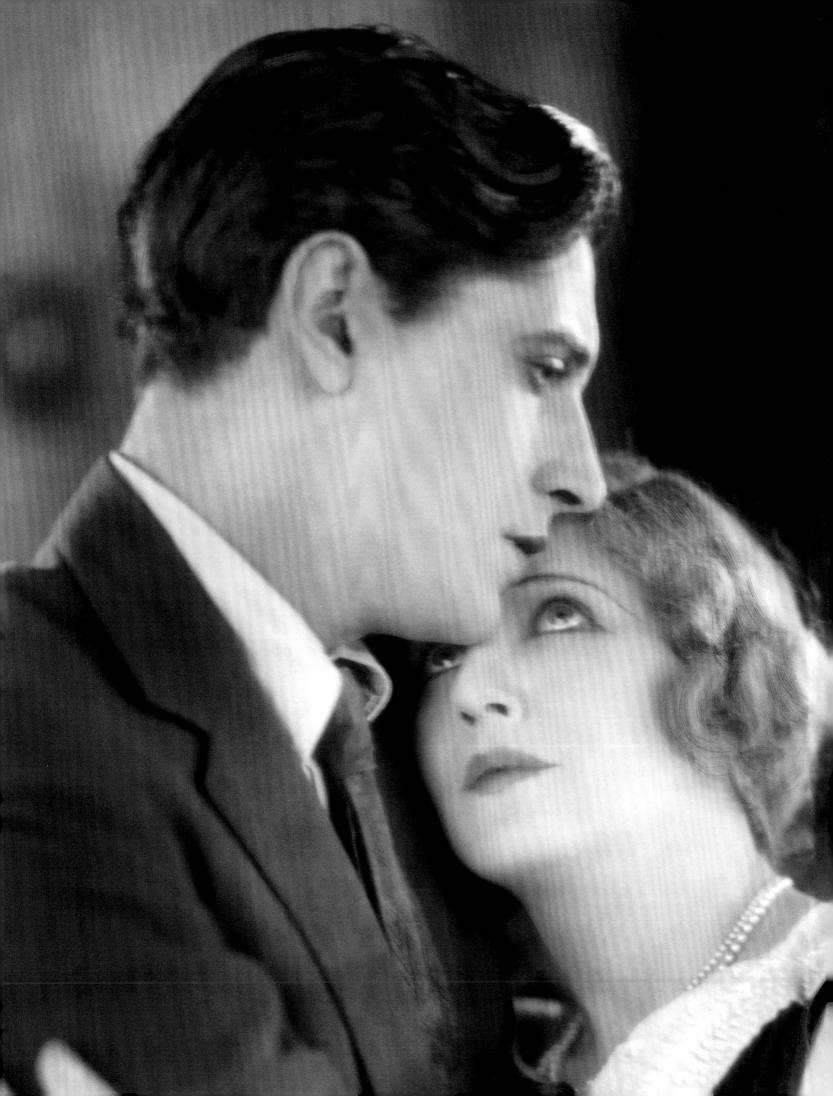

THE LODGER (1927)
JUNE HOWARD-TRIPP

June Howard-Tripp, often credited as Hitchcock's first blonde, stars in this silent movie as "Daisy" the daughter of Mr. and Mrs. Bunting who run a boarding house in London. Daisy's sweetheart is Joe, a policeman investigating the murders of several blonde women by a killer known as the "Avenger." When a mysterious man (Ivor Novello) rents a room at the house, Joe suspects he may be the Avenger. But Daisy is attracted to the lodger and strikes up a relationship with him.

Mrs. Bunting, fearing for her daughter, also suspects the lodger is the killer, and when a bag with a gun, a map plotting the location of the Avenger's murders, newspaper clippings about the attacks, and a photograph of a beautiful blonde woman is found in the lodger's room, Joe arrests him.

However, the lodger escapes. Daisy finds him and takes him to a pub where she learns that the woman in the photograph was actually the lodger's sister, and he has promised their mother to bring the killer to justice. But the pub locals grow suspicious of the pair and the lodger is set upon by an angry mob.

A paperboy eventually interrupts with news that the real Avenger has been arrested. The mob releases the lodger, who falls into Daisy's waiting arms. The film ends showing a recovered lodger and Daisy living together as a happy couple.

According to the director himself, _The Lodger_ was the first "true" Hitchcock movie in which he "exercised [his] style." Having spent time at movie studios in Berlin, he had been influenced by the German expressionism of silent horror films such as _Nosferatu_ and _The Cabinet of Dr. Caligari_. This was evident given the unusual camera angles, sinister shadows cast on walls and across faces like crosses, and foreboding staircases that would become signature motifs throughout his career.

It also featured the first of Hitchcock's blondes, whose hair color he considered made them vulnerable to violence. In the film's opening scene, the words "To-Night Golden Curls" flash up on the theater screen to indicate the killer about to strike, but the concept pervaded throughout the rest of Hitchcock's career. He became notorious for the blondes who featured in his pictures, but this reputation was partly driven by his own desire to create publicity around his films. He was often quoted as saying, "Blondes make the best victims. They're like virgin snow that shows up the bloody footprints."

The Lodger was the first script that he himself chose and was based on the best-selling 1913 novel _The Lodger_ by Marie Belloc Lowndes, which referenced the Jack the Ripper Whitechapel murders. Having grown up in turn-of-the-century Leytonstone, within London's East End, a young Hitchcock was spellbound by the story—particularly by the idea of a killer on the loose in London, putting fear in the hearts of the residents when the murders were gruesomely reported in the press.

While the novel tells the story from landlady Mrs. Bunting's point of view, Hitchcock felt the central character should be her daughter Daisy and that the film should focus on Daisy's relationship with the lodger. Hitchcock worked with his wife, Alma Reville, who served as assistant

JUNE HOWARD-TRIPP

June Howard-Tripp, born in 1901 in London, was the first Hitchcock blonde to marry into aristocracy. Known by her stage name June, she was a 1920s star of theater revues and worked on only a handful of films—the most famous of which was *The Lodger*.

June left the movie business to become a society lady when she married John Alan Burns, the fourth Baron Inverclyde in 1929. They lived at his ancestral home, Castle Wemyss, in Fife, Scotland, until their sensational divorce in 1933. Soon after, she married an American businessman, Edward Hillman Jr., and moved to New York. She only made a couple of further appearances on screen.

director on the film, and screenwriter Eliot Stannard to enhance the character of Daisy and play up the fears of the Buntings over who the lodger really is.

The film opens with a close-up of a woman screaming in terror, and then cuts to an electric sign with "To-Night Golden Curls" blinking on and off. The camera follows the process of creating news, with the press arriving on the scene and phoning in to their office, and information being sent over the wires, announced on the radio, and then splashed on billboards. It captures the foggy streets of London, the chimes of Big Ben, the taxi cars, and the dressing rooms of nightclubs, where the show-girls wear brilliant blonde, curly wigs that disguise their true hair color.

"Now we show the effect on various people," Hitchcock explained to François Truffaut. "Fair-haired girls are terrified. The brunettes are laughing. Reaction in the beauty parlors or of people on their way home. Some blondes steal dark curls and put them under their hats." One of the models announces backstage "no more peroxide for yours truly," as she reads the news with sadistic interest.

In one of Hitchcock's first examples of counter-casting to skewer audience expectations, handsome Ivor Novello was cast as the shadowy, vampiric lodger, just as Anthony Perkins brought boyish good looks to the part of Norman Bates in *Psycho*. Novello was a matinee idol and composer with hit West End musicals and songs, including "Keep the Home Fires Burning" from World War I. Novello, "considered the Robert Pattinson of his day," painted his face to enhance his profile and took on a soulful, romantic, and tortured appearance. Tall and thin, he first appears in top hat and cape, with a scarf over his mouth to highlight his kohl-rimmed eyes, and he glides like Nosferatu into the Buntings' home. The shadow of the lodger at the door contrasts with the homely scene in the Buntings' kitchen, as Mrs. Bunting rolls out pastry. But the cuckoo clock chimes as a forewarning of an intruder.

The studio wouldn't allow a popular star to play a murderer, so the script was changed to cast doubt on his villainy. "These are the problems we face with the star system," said Hitchcock. "Very often the storyline is jeopardized because a star cannot be a villain."

For the part of Daisy, Novello suggested June Howard-Tripp, a twenty-five-year-old musical comedy star who was simply billed as "June."

June was recovering in the South of France after having her appendix removed when Ivor Novello wired her in spring 1926 to ask if she would play opposite him in "an important film. No dancing required. You will act beautifully and we shall have fun."

In her autobiography, she called Hitch "a short, corpulent young man" and "his humour was salty or subtle, according to his mercurial moods, and his brilliance was patent."

Since she naturally had light-brown hair, Hitchcock requested that she wear a brilliant blonde wig to look like the type of girl who could be a victim of the Avenger. The idea of the murder of vulnerable blondes had been invented by the director and his writers, but Hitchcock also pointed out that blondes photographed better, standing out in black-and-white films. Another similarity June would share with future Hitchcock blondes was that she was slender. "Smallness is a definite asset," he wrote in a 1931 article. She was dressed in black gowns with contrasting white collars; Hitchcock often said black was his favorite color on a

Page 14: June Howard-Tripp, the first of Hitchcock's blondes, plays Daisy opposite Ivor Novello as the lodger.

Opposite: In a scene from *The Lodger*, show-girls wearing blonde wigs that disguise their true hair color read about the latest murder with sadistic interest.

Above: June Howard-Tripp, whose natural hair color was light brown, wears a blonde wig. According to Hitchcock, blondes are more vulnerable to violence; they also photograph better in black and white.

woman, and, in a black-and-white film, it often made more of an impact.

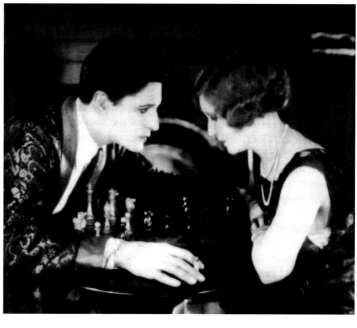

June was sweet and pretty rather than aloof and elegant, but her hair color is linked to her attractiveness throughout the film. Daisy's detective boyfriend says he is "keen on golden hair myself, same as the Avenger is," and, on his arrival at the Buntings', the lodger must turn over all the paintings of blondes so that they face the wall. When Daisy and the lodger play chess together, he picks up the poker from the fire, acting as if he is about hit her, but instead he reaches out to stroke her hair in a both tender and creepy moment: "Beautiful golden hair," he says.

June's glamorous image is important to the story, and an early example of Hitchcock's meticulous approach to the appearance of the women in his films. Daisy's costumes reflected the flapper fashions with knee-length hems that were very much in vogue in 1926. She is first seen in a shimmering gown, white fur coat, and pearls, but, when the camera cuts to a wide shot, it reveals that she is a department store model displaying fashions (referenced when the lodger later buys her a delicate beaded dress that she has modeled).

While a costume designer for the film was not credited, the two mannequin shows are believed to have used £10,000 worth of gowns designed by Jean Peron of Peron Couture. Biographer Gary Chapman believes that Dolly Tree may have designed some of the costumes of this sequence and even appeared as an androgynous model in a two-piece suit smoking a cigarette. Fashion shows were often inserted into movies of the 1920s and 1930s, particularly to appeal to female audiences who admired the fashions on screen, and this may have been the reason why these expensive set-pieces were included.

When Daisy strips down to her underwear to take a bath, the camera focuses voyeuristically on her—as it did Marion Crane in *Psycho*—and the steam drifts up to the lodger's window. Lured downstairs, he tries the door handle to get into the bathroom. The camera cuts to her toes in the bath, and then back to the lodger. But, this time —unlike in *Psycho*—the door is locked.

Above: When Daisy and the lodger play chess he comments on her "beautiful golden hair."

Opposite: Daisy is a department store mannequin. Having seen her model a delicate beaded dress, the lodger then buys it for her.

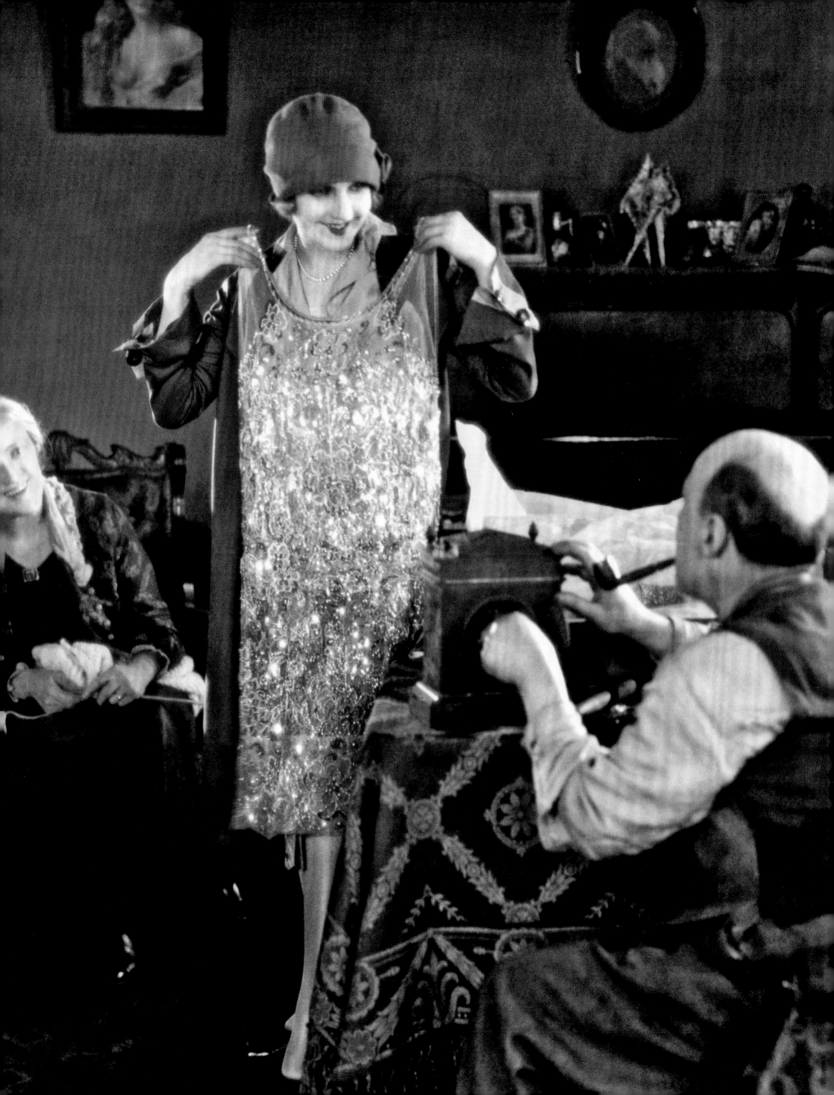

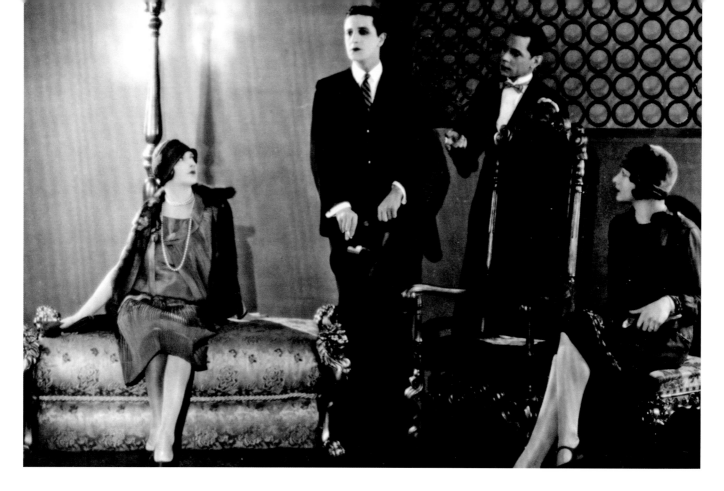

In addition to treating blonde hair as a Victorian fetish, Hitchcock introduced handcuffs as a link between love, marriage, and punishment, as explored in *The 39 Steps*. In *The Lodger*, Joe says he will place a ring on Daisy's finger as soon as he handcuffs the Avenger. "A brand new pair of bracelets for the Avenger," he jokes as he toys with them. Hitchcock told Francois Truffaut, "Psychologically, of course, the idea of the handcuffs has deeper implications. Being tied to something . . . it's somewhere in the area of fetishism, isn't it? There's also a sexual connotation, I think. When I visited the Vice Museum in Paris, I noticed there was considerable evidence of sexual aberrations through restraint."

Joe chases Daisy with the handcuffs and places them on her, despite her protests that it is hurting her wrists. This scene also took June by surprise, but it elicited the exact natural expression of shock Hitchcock had wanted.

All in all, June enjoyed working with Hitchcock, despite his meticulous approach and his pranks. She recalled having to carry a breakfast tray up three flights of stairs over and over again until she got the right expression of fear with the right light and shadow. She later said: "Fresh from Berlin, Hitch was so imbued with the value of unusual camera angles and lighting effects with which to create and sustain dramatic suspense that often a scene which would not run for more than three minutes on the screen would take a morning to shoot."

Top: June Howard-Tripp and Ivor Novello in *The Lodger*. The film was first screened at The Marble Arch Pavilion in Oxford Street, London. It was a huge commercial and critical success.

Above: Daisy and the lodger become engaged, although in the film his innocence is ambiguous.

But after having carried the tray up and down the stairs for an hour and a half, she recalled, "I felt a strange sickening pain somewhere in the region of my appendix scar but forbore to complain or ask for a rest, because delicate actresses are a bore and a nuisance, and in any case, this scene ended my work on the film."

While Hitchcock surely appreciated her perseverance, a few weeks later, while rehearsing a play in London's Gaiety theater, June became critically ill as a result of an infection in her intestines. Newspapers reported she was close to death, but she eventually pulled through.

the merits of an intensely golden wig she must wear in *The Lodger* . . . in other parts of the large studios were most 'sets' for the film, the lodger's bedroom, the basement kitchen, and the tall, steep staircases and landings."

On first viewing the studio thought *The Lodger* was not fit for showing, and it was put on the shelf. But when producers took a look at it a few months later, inserting the mannequin fashion shows, filmed in June 1926, and changing the title cards to include a triangular motif to represent the Avenger's calling card and the love triangle, it was finally determined to be ready for

"If I'd made the story again as a talker,
I would have wanted to do something different.
Perhaps, Jacqueline the Ripper." ALFRED HITCHCOCK

The Lodger ends when Ivor Novello's character, accused of being the killer, is chased onto a bridge by a frenzied mob and hung from the railings by his handcuffed wrists. But his name is cleared when the real Avenger is caught off screen.

Daisy and the lodger become engaged, but there is some ambiguity to his innocence—a looming reminder of the killer can be seen from the window as they kiss: the theater sign flashing "To-Night Golden Curls."

Such was the interest in his work that the Daily Mail in March 1926 paid a visit to Islington Studios to watch filming as "all kinds of intriguing work was in process. Mr. Alfred Hitchcock, the young director of whom so much is expected, was taking Mr. Ivor Novello through several short scenes . . . meanwhile Miss June appeared from her dressing room to discuss

release. *The Lodger* was first shown in January 1927 at the Marble Arch Pavilion on Oxford Street, and the film became a huge commercial and critical hit.

"Here is a British film which grips the imagination," wrote the Daily Mail. "Miss June is natural and pretty as the heroine . . . it is arresting without being in any way gruesome."

Hitchcock kept the rights for some years, hoping to do a Technicolor remake in the early 1940s. The Jack the Ripper theme piqued his interest throughout his career, and he finally made an updated version of the Ripper story in the form of *Frenzy* in 1972. Hitchcock told biographer Charlotte Chandler that "if I'd made the story again as a talker, I would have wanted to do something different. Perhaps, Jacqueline the Ripper."

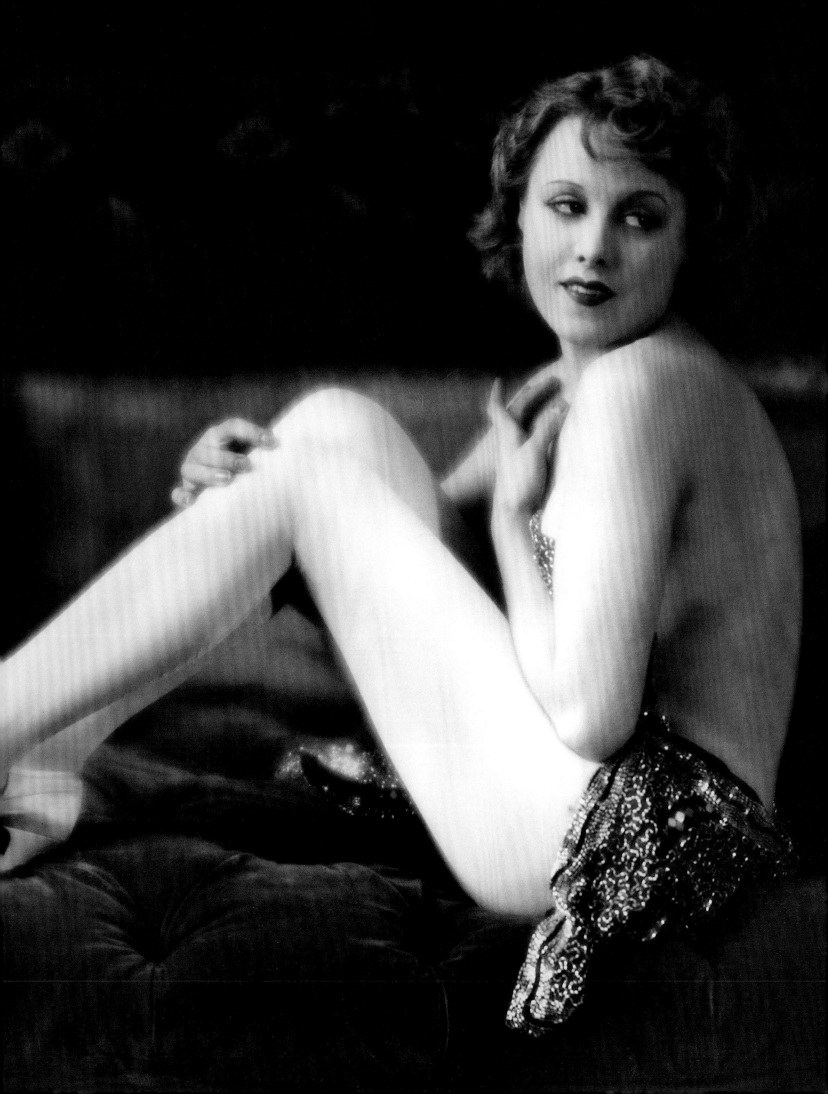

BLACKMAIL (1929)
ANNY ONDRA

Blackmail stars Czech actress Anny Ondra as Alice, the daughter of cockney shopkeepers, who is blackmailed after killing a man who tries to rape her. The film begins with Alice arguing with boyfriend Frank Webber (John Longden), a Scotland Yard detective, at a tea house. Fed up, she leaves with another man, Mr. Crewe (Cyril Ritchard), an artist who takes her back to his studio.

There she believes he will paint her in a dancer's outfit he has given her to model. But, when he forces a kiss on her, Alice becomes scared and wants to leave. As she is changing the artist attempts to rape her. In desperation, Alice grabs a nearby knife and kills him. She covers up her crime, but accidentally leaves her gloves behind. These are then found by Frank, who has been assigned the murder case. He hides the gloves and promises to protect Alice.

However, Alice was seen entering the artist's flat by petty thief Tracy (Donald Calthrop) who blackmails the couple. But his blackmail attempt falls short when he himself is fingered as a murder suspect; he was at the scene of the crime and has a police record. Tracy is arrested but escapes, and the film follows an on-foot pursuit culminating at the British Museum, where rather conveniently for Frank and Alice, Tracy plummets to his death.

Blackmail was originally a silent movie, but became a "talkie" halfway through production. Anny Ondra's heavy accent was a problem, and so the voice heard on screen is Joan Barry who read the dialogue off screen while Ondra mouthed the words on camera.

Hitchcock first directed blonde Czech actress Anny Ondra in *The Manxman* in the summer of 1928 and was so impressed by her that he requested her for his next film, *Blackmail*, before the screenplay had even been written. *Blackmail* was adapted from Charles Bennett's stage play, which starred Tallulah Bankhead in the lead and tells the story of a woman named Alice who kills the man who tries to rape her. It has a place in British film history not only as the beginnings of the "Hitchcock touch," but as the country's first "talkie"—although a silent version of the film was also made.

Anny Ondra was a favorite of Hitchcock's, as he found her both attractive and charming, and her innocent playfulness translated into the character of Alice, who was to be alluring as well as sympathetic to a female audience.

Hitchcock in a 1931 article entitled "How I Choose My Heroines," said: "The chief point I keep in mind when selecting my heroine is that she must be fashioned to please women rather than men, for the reason that women form three-quarters of the average cinema audience. Therefore, no actress can be a good commercial proposition as a film heroine unless she pleases her own sex." Alice can be seen as an early blonde Hitchcock heroine, but unlike the later cool and elegant blondes played by Madeleine Carroll and Kim Novak, she has an immature naivety and vulnerability as she transitions from fickle and flirtatious to dazed and shocked after having killed the painter.

Hitchcock also noted in the 1931 article that as well being "a thoroughly nice girl," the ideal heroine "must possess vitality, both in looks and in the quality of her voice. The reign of the purely pictorial heroine is over." Before the advent of sound, Ondra's strong Czech

ANNY ONDRA

Anny Ondra was born in 1903 in Austria-Hungary, and as the daughter of a Czech officer, her childhood was spent in Prague. Czech director and writer Karel Lamač, who she would marry, cast a teenage Ondra in his early films, launching her as a popular comedy star of German, Austrian, and Czech cinema, before crossing over to Britain. While Ondra shined in two Hitchcock films, her strong accent made it difficult to continue in British sound films.

In 1933 Ondra married German heavyweight champion boxer Max Schmeling and they were together until her death in 1987. Living in Germany, the glamour couple tried to resist the efforts of the Nazis to use them as political tools. Anny continued her career in German cinema but retired in the 1950s.

accent wasn't a particular concern for working in British silent films. However, the studio decided mid-production to make *Blackmail* a partial talkie by adapting some of the scenes with the new technology. Hitchcock recounted that he reshot more scenes with dialogue than had been specified, as he had a feeling producers would ask for more sound than they had originally.

As the character of Alice was a Cockney shopkeeper's daughter, Ondra's heavy accent was not going to work on screen at all, a scenario set up in both *Singing in the Rain* and *The Artist* decades later. Producer John Maxwell wanted to find a replacement actress, but Hitchcock was loyal to Ondra and instead worked tirelessly on finding a solution. Because there wasn't the option of dubbing in those early days of sound, actress Joan Barry (who was also directed by Hitchcock in *Rich and Strange*) was chosen to read the dialogue off camera while Ondra mouthed the words on camera. He managed to achieve almost perfect synchronization, although Barry's voice wasn't quite right for a working-class shopkeeper's daughter either—her accent typically belonged to a higher class.

In order for Ondra to understand why her voice wouldn't appear, Hitchcock arranged a sound test for her so that she could hear for herself how her accent would sound on screen. The screen test is available to watch through the British Film Institute, and it is a telling example of his relationship with a leading lady, where the natural rapport between them is evident.

"Now Miss Ondra, we are going to do a sound test. Isn't that what you wanted?"

"I don't know what to say. I'm so nervous!"

"Have you been a good girl? Have you slept with men?"

"No!"

"Now come right over here, Miss Ondra, and stand still in your place, or it won't come out right—as the girl said to the soldier."

This would, by many accounts from those who were directed by him, become a common tactic of Hitchcock's when conducting screen tests: his risqué humor offered a way of breaking down barriers and eliciting a more natural response.

24

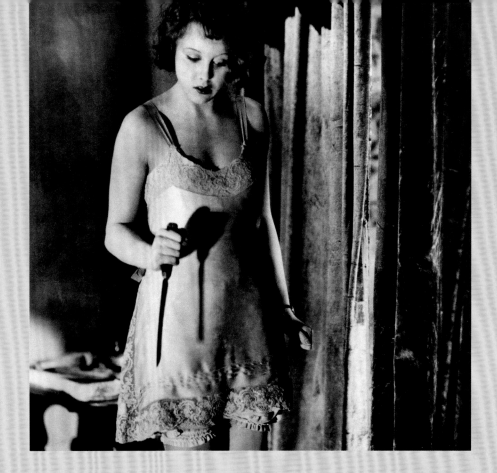

"Hitchcock adored her. Besides being adorable, she was funny, intelligent, down-to-earth."

PATRICK MCGILLIGAN, BIOGRAPHER

Page 22: Anny Ondra stars as Alice in *Blackmail*.

Above: Anny Ondra as Alice poised with knife on the set of *Blackmail*.

"Hitchcock adored her," said biographer Patrick McGilligan of Anny Ondra. "By all accounts, everyone did. Besides being adorable, she was funny, intelligent, down-to-earth. The director preferred a leading lady he could flirt with, and the ones that flirted back fared best with him."

Both Hitchcock and Alma enjoyed the company of Ondra, who was vivacious and fun, and they kept in touch with the actress over the years, visiting her at her home in Germany whenever they passed through. When she married Max Schmeling, Hitchcock, according to his biographer John Russell Taylor, sent "Anny a telegram asking her what terrible thing was this—she had married a boxer? To his amusement he received back a three-page letter of impassioned defence of her new husband, his gentleness, his charm, his lovability."

The sound wasn't the only problem when it came to the leading lady in *Blackmail*. Just as Ivor Novello in *The Lodger* couldn't be guilty of serial murders, Gainsborough Studios refused to let their female star be arrested for murder in the film, as her fate would conceivably be to be sentenced to death by hanging. The studio told Hitchcock that it would have been "too depressing," so he had to rework the ending.

"The girl would have been arrested and the young man would have had to do the same thing to her that we saw at the beginning: handcuffs, booking at the police station, and so on," Hitchcock told François Truffaut of the original ending. "Then he would meet his older partner in the men's room, and the other man, unaware of what had taken place,

would say, 'Are you going out with the girl tonight?' And he would have answered, 'No, I'm going straight home.'"

The film combined a detective story with suspense and quite sexual scenes. It was billed on the posters as "The Story of a Foolish Girl," with a picture of Anny Ondra holding her dress up to cover her under-wear-clad body. She rows with Frank, her detective boyfriend in the tearoom in order to cut a date short, as she has arranged a rendezvous with a more fascinating bohemian painter. When they meet, Alice and the painter climb the stairs to his Chelsea apartment, and, once inside, she playfully paints a head onto a canvas. He finishes the painting with a sensual body, indicating what his future intentions for her are.

Hitchcock used costume in *Blackmail* as a plot device for his link between sex and murder, with a ballet dress in the painter's studio acting as the tools for seduction.

Alice is convinced to change out of her black dress with its white lace collar and into the ballerina dress. When she begins to feel uncomfortable and wants to change back into her clothes, he hides her dress and leaves her unprotected in a lace slip. He attacks her, pushing her onto his bed, hidden by a curtain. We see her hand reach out to find anything to protect herself, and she grabs a gleaming knife on a cutting board. There's a struggle from behind the curtain, a deathly pause, and then his arm falls limp.

"This picture has a moral," said a reviewer at the time. "It is simply this: Never permit your love for cheese to persuade you to place a chunk of it at the head of your bed, and above all never leave a knife with it."

After the killing, Alice looks dazed and vulnerable in her slip as she pulls on her dress again and hides the evidence that she was ever in the painter's apartment. However, she accidentally leaves her gloves behind, and Frank, who is investigating the murder, discovers them and realizes that she is the killer.

Alice is a contradictory character, flawed and flighty, desirable and deadly, but also strong and steadfast. Ondra conveyed a perfect sense of guilt and confusion, and the audience wills her to get away with this murder. Alice, dazed and shocked, walks through the colorful London streets, pulling her coat tighter around her for protection, an action which reflects how costume serves Alice's journey through the film.

Nathalie Morris from the British Film Institute said: "The moment when Alice goes back to her home, to the newsagents', is really interesting in thinking about her character because we've only seen

her dressed up ready for a night out, and then you suddenly realize she's a dutiful daughter who works in the family shop. She takes off her black dress from the night before and puts on a very floral, pretty number and you become very aware of the two roles that she is performing."

Unlike many other directors, who were hostile toward the idea of sound, Hitchcock wanted to experiment with the new medium in the same way that he played with visuals. As Alice sits down for breakfast with her family, a gossiping neighbor discusses the murder. She keeps saying the word

Opposite: Ondra conveys a perfect sense of guilt and confusion and we will her to get away with this killing.

Above: Anny Ondra and John Longden as Alice and her detective boyfriend in *Blackmail*.

"knife," and as we hear it over and over, the film cuts to Alice's face and the bread knife in front of her, which she drops on the floor.

"Alice, you ought to be careful," her father says. "You might cut someone with that." This scene was particularly sensational, earning cheers from the audience and praise by critics.

The final climax took place at the British Museum. The crew re-created this setting in the studio using clever camera tricks to project images from the museum during the scene.

It would be the first of many of Hitchcock's set pieces to use spectacular monuments—the Forth Road Bridge in *The 39 Steps*, the Statue of Liberty in *Saboteur*, Mount Rushmore in *North by Northwest*.

In 1929 the *Times* wrote of *Blackmail*: "The story retells, even to the carving-knife, the Tosca-like theme of seduction which has served film and opera so faithfully . . . while the young Chelsea artist is entertaining the shopkeeper's daughter at his studio, the rhythm is so slow, the scene so artless, we never suspect the horror lying in wait behind the curtains."

With these early Hitchcock movies, the woman at the center of his films is just starting to develop. She is chosen to appeal to his female audiences, to be engaging, relatable, and attractive. He also noted, "I have to consider whether my potential heroine is sensitive to direction. In other words, whether she is the kind of girl I can mold into the heroine of my imagination." In *Hitchcock's Motifs*, Michael Walker notes of Anny Ondra: "If she is compared with the other main Hitchcock blonde of the English period, Madeleine Carroll, one can see two general types emerging: Ondra warm, sexy, open, vulnerable, and rather reckless; Carroll the more familiar type: cool, sophisticated, aloof. Daisy is somewhere in between."

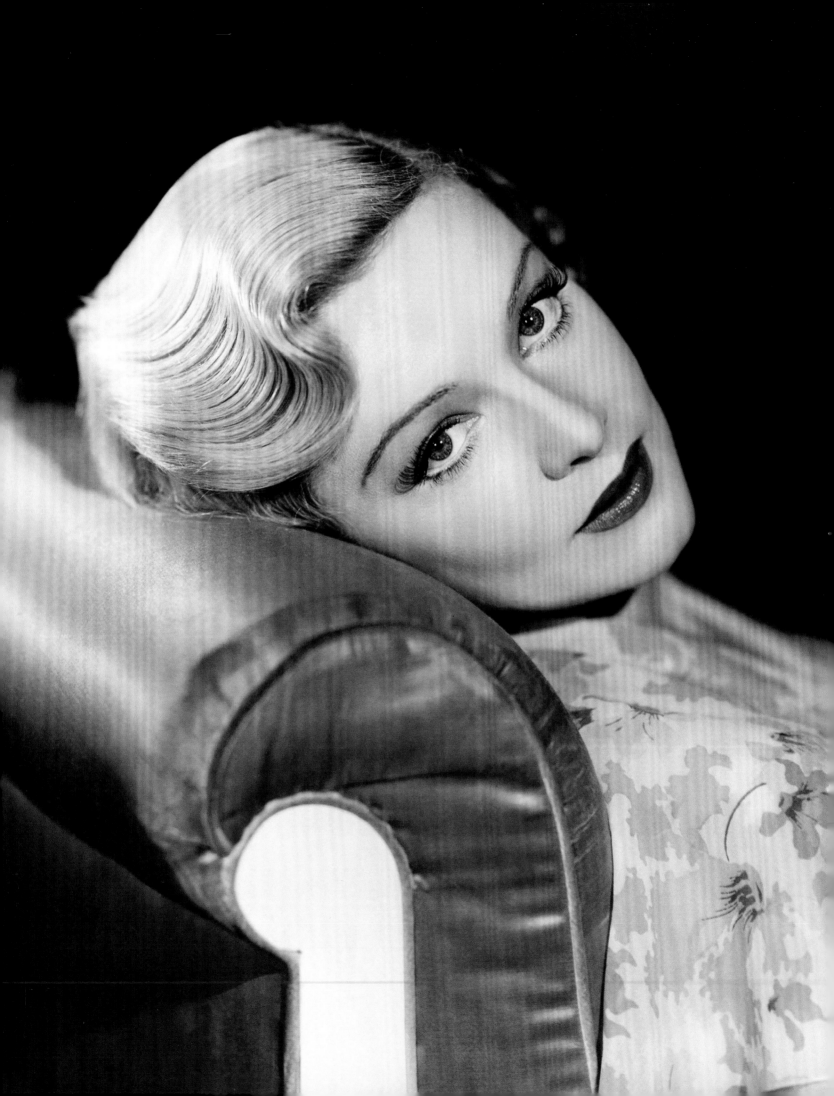

THE 39 STEPS (1935)
MADELEINE CARROLL

Richard Hannay (Robert Donat) meets Annabella Smith (Lucie Mannheim) at a Mr. Memory show. She is a counterspy on the run from secret agents and tells him she needs to go to Scotland to stop a plot to steal British military secrets. She mentions "thirty-nine steps," but does not explain their significance.

Later that night she is murdered. Hannay is the prime suspect and flees to Scotland by train. On board, he spots police searching for him and so kisses a female passenger—Pamela—(Madeleine Carroll) to escape detection. Unamused, she gives him up. Hannay escapes with the police following.

Hannay and Pamela cross paths again, and again she turns him over to the "police." But they are really secret agents in disguise. Realizing this, Hannay escapes onto the Forth Road Bridge with the police pursuing him.

After being forced to spend a night at an inn together, Pamela starts to believe Hannay and they return to London, to another Mr. Memory show. Here, Hannay deduces that the spies are using Mr. Memory to smuggle state secrets out. Mr. Memory also reveals the significance of "the thirty-nine steps."

Gaumont-British, eager to establish its films in the United States, spent much of the £60,000 production money on salaries for Donat and Carroll—both had made films in Hollywood and were known to American audiences. Carroll's role also established the template for future "Hitchcock Heroines"—blonde, ice cold, and elegant.

In her role as Pamela in *The 39 Steps*, Madeleine Carroll is often considered the first Hitchcock blonde prototype who is abused on and off the screen. John Russell Taylor, an authorized Hitchcock biographer, wrote that Carroll's role was "the first obvious instance of his normal treatment of cool blondes, into which all sorts of sadistic sexual motifs can be read."

But beyond a mistreated blonde, Pamela is typical of the 1930s depiction of a modern, independent woman. Like the characters played by Nova Pilbeam and Margaret Lockwood in two of Hitchcock's later 1930s suspense films, it is Pamela who takes control to solve the mystery. The film draws from the screwball comedy genre, which was characterized by a dominant female personality and romance built on initial dislike and sparring of insults.

John Buchan's novel *The 39 Steps* was first published in 1915, and Hitchcock read it around 1919. For many years, he hoped to adapt it to film. For Hitchcock, drama was "life with the dull bits cut out." Like Buchan's adventure stories, his tales allowed for "armchair adventures" through the eyes of the hero—in this case, Richard Hannay, on the run to clear his name. The story had suspense and thrills, but it also required a romance, missing from the novel. The theme of relationships is demonstrated by different couples in the film, including the unhappy crofter and his wife, the loathing then loving of Hannay and Pamela, and the link between handcuffs and marriage. Chained together like a metaphorical ball and chain, Hannay and Pamela must pretend they are wed in order to share a room at the inn.

Mark Glancy, in his guide to the film, says: "*The 39 Steps* is also a surprisingly sexy film. Its bedroom scenes, double entendres, and

MADELEINE CARROLL

Madeleine Carroll was a very British star of the 1930s with blonde elegance and an aristocratic air, who all but gave up Hollywood stardom for philanthropy. Born in 1906 in West Bromwich, near Birmingham, to an Irish father and a French mother, Madeleine Carroll graduated from Birmingham University with honors in French. She left her employment as a French teacher at a girl's school in Brighton to try a career as an actress, despite her father's disapproval. Her acting debut was as a French maid in a touring production, and she became one of Britain's most popular stars after *Guns of Loos*—a 1928 silent war film in which Carroll made her screen debut as Diana Cheswick. She moved to Los Angeles in the late 1930s, becoming one of the top-earning actresses in Hollywood. After her sister was killed in the Blitz, Carroll became directly involved in the war effort as a Red Cross nurse. She was awarded the French Legion of Honor and the civilian Medal of Freedom from the United States. Married four times, she later moved to Marbella, where she died in 1987.

moments of fetishistic revelation—ranging from the handcuffed couple in bed together to the film's obsessive interest in women's clothing—seem somehow to have escaped the scorn of the censors."

Jane Baxter was originally cast as Pamela, but she withdrew when it clashed with other commitments. Madeleine Carroll was well known in Britain and the United States, so she may have been selected, as the bigger star, to replace Baxter when it was decided that a romance with a female character should lie at the heart of the film. Hitchcock confirmed that once Carroll had been signed, the part of Pamela was "built up." He said: "It turned out to be considerably more important at the end than we had originally intended. For this, much of the credit must go to Madeleine Carroll herself for the way in which she played up to the part."

Carroll was described in an article in the *Times* in 1929 as a typical "English society girl. Tall for a film 'star' she is fair, slim, and elegant, with a certain aloofness of manner." The description sounded like the type of woman Hitchcock favored, and he was praised for creating a warmer, comedic role that was closer to her true personality than her brittle characters on screen.

"In plain terms," wrote *Film Weekly* in 1937, "Madeleine was getting nowhere in England, either as a star or as an actress. That is until she went to work for Hitchcock."

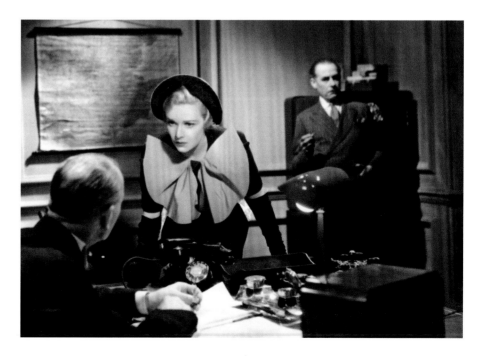

In 1935 Hitchcock said that the photographs of Carroll he had seen "were certainly beautiful, but so very cold. My word, they would almost chill a refrigerator!" Hitchcock had, in fact, known her since the 1920s, acknowledging her great sense of humor, which he felt could come out if people could see past her beauty. At their first meeting, Hitchcock advised her to be herself.

"Why not put yourself on the screen and cash in on your own personality?" he asked her. It helped that in the film, according to Hitchcock, "she has no time to be calm and serene. She is far too busy racing over moors, rushing up and down embankments, and scrambling over rocks."

Costume designer Joe Strassner was one of many German émigrés drawn to British studios in the 1930s and a key creative player on *The 39 Steps*. Costumes had to be glamorous enough to appeal to predominately female audiences, but Carroll was also to appear more down-to-earth than Annabella, the exotic-looking spy in the opening scenes. Carroll noted in 1931 that "the film heroine, if not ideal in behavior, is supposed to be ideal in looks and figure."

Large bows and exaggerated collars were fashionable around 1934, as seen in the extravagant work of Hollywood costume designers Adrian and Travis Banton. Joe Strassner added these details to two of Pamela's costumes, bringing attention to her face in close-ups. But as a woman traveling by train to a political meeting, she was also given a practical wool top and midi skirt. *Modern Screen* reported in 1935 on Pamela's "very attractive ensemble . . . The coat is made of the youthful swagger style that is typical of many of the younger fur fashions this season."

Our first impression of Pamela on the train is that she looks rather bookish in a prim black and white outfit and hat, wearing glasses as she reads the newspaper. Hannay, in a ploy to escape from the police, sweeps in to kiss her, and she drops her glasses and relaxes her body. Hitchcock often used glasses in his films as a device to show an unmasking or a sexual awakening; however, Pamela appears unaffected by the loss of her spectacles and turns Hannay over to the police.

Page 28: "Cool blonde" Madeleine Carroll. Hitchcock said photographs of her "were certainly beautiful, but so very cold."

Opposite: Around the time the film was made, there was a trend for large bows and exaggerated collars. The large bow seen here helps bring attention to Madeleine Carroll's face.

Above: Hannay (Robert Donat) is hand-cuffed to Pamela (Madeleine Carroll) as she removes her stockings. This and the earlier discussion of corsetry, fetishize women's clothing in *The 39 Steps*.

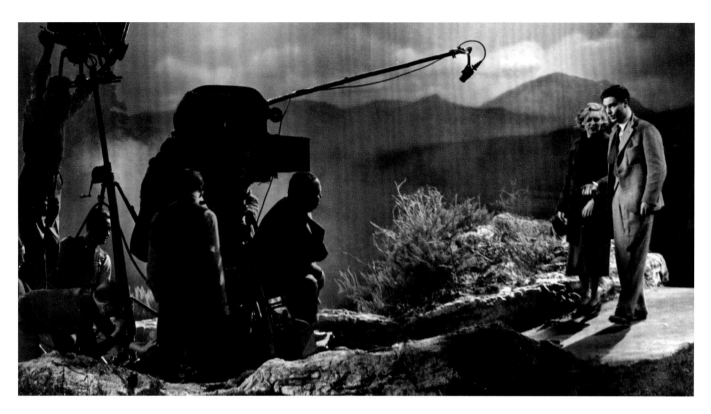

Pamela doesn't appear again until fifty minutes into the film, but from here she is crucial to the plot, as she is handcuffed to Hannay and dragged across the moors. They pretend to be newlyweds on the run so they can stay in the village inn, and, in screwball-comedy fashion, they banter and bicker all the while. Hannay helps Pamela dry her skirt by the fire, and they eat sandwiches as she takes off her stockings in a lingering shot of her legs. From these stockings to the discussion of corsetry by the two leering men on the train, women's clothing in *The 39 Steps* is fetishized.

Café Society director Edward H. Griffith said in 1939 that Carroll was "afraid of the camera." Hitchcock was aware of this self-consciousness, and he delighted in coming up with indignities for her to suffer during filming, which he said was all part of his plan to coax out the character. Carroll and Robert Donat, who played Hannay, had never met before the shoot, and on their first day filming the handcuff scenes, Hitchcock pretended to lose the key after the two stars were locked together. He thought it would help break the ice and create chemistry, but he later recounted the story as if it had been an accident. "One day I lost the key! There they were, inextricably bound—and they couldn't get away from one another until, providentially, I found it again." He also took to summoning Carroll on set by saying "bring on the Birmingham tart!" and referred to Robert Donat as "Mr Doughnut."

The script called for both Donat and Carroll to scramble over rocks and under waterfalls while handcuffed together. Carroll had a stunt

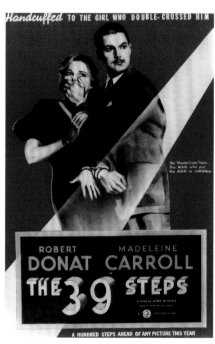

Top: Hitchcock directs Robert Donat and Madeleine Carroll in a challenging scene from *The 39 Steps* when they are handcuffed together.

Above: The handcuff story was used as a titillating angle to boost publicity and interest in the film as in this original poster.

double for some shots: Assistant Director Penrose Tennyson in a blonde wig, high heels, and a dress. Despite her humor about the situation and handling it like a "trouper," per associate producer Ivor Montagu, Hitchcock remembered: "I was determined not to 'let up' at all. Dignity or self-consciousness is impossible when you're being dragged along the ground, which I made Donat do to her. It was a challenge. She had to answer it. It completely killed any self-consciousness. Madeleine, with her natural sense of humor, appreciated the position. I remember, though, that

was married to Captain Philip Astley, a friend of the Prince of Wales, and she spent much time on their Kent estate making jam from the fruits of their orchard. Her ladylike elegance contrasted with the discomfort of some of the scenes, where it was reported her wrists were bruised from the handcuffs and her beautiful clothes destroyed by the wind and rain machines during the scenes set on the Scottish moors. Donat would forget they were handcuffed and lift his hands up or swing his arms, jerking her wrists and forcing her along. However, the screwball

> "I was determined not to 'let up' at all. Dignity or self-conciousness is impossible when you're being dragged along the ground." ALFRED HITCHCOCK

she had a friend watching on the set one day, who came up to me and reproached me for my rough handling of her!"

The handcuff story was used as a titillating publicity angle by the studio press office, which tied in with the screwball storyline of *It Happened One Night*, the hit film of 1934, where a bickering couple were similarly forced to spend time together. *The 39 Steps* was marketed as a romance rather than a boys' adventure, with posters highlighting Carroll's blonde beauty and slogans including: "The most charming brute who ever scorned a lady!" and "Fated to be mated with the one she hated!" There were also marketing opportunities highlighted in the press book for cinemas to create a "street ballyhoo with a boy and girl handcuffed together."

Like Claudette Colbert's character in *It Happened One Night*, Carroll was profiled as an upper-class lady with good social standing, as she

comedy narrative of the film was aided by the report of their growing fondness for each other.

The 39 Steps was the British hit of the year, and the *New York Times* said of Hitchcock: "A master of shock and suspense, of cold horror and slyly incongruous wit, he uses his camera the way a painter uses his brush."

Hitchcock is sometimes credited with fashioning Carroll into one of the most popular, top-earning stars of the 1930s by creating "a vital, living character on the screen." When asked if he would like to direct a film about the *Titanic*, he said: "Oh yes, I've had experience with icebergs. Don't forget, I directed Madeleine Carroll," a comment which enhanced the persona he created of himself as a Svengali bringing warmth to glacial blondes on screen. But throughout his career and the popularity of the female leads in his movies, Hitchcock often acknowledged her as "the first blonde who was a real Hitchcock type."

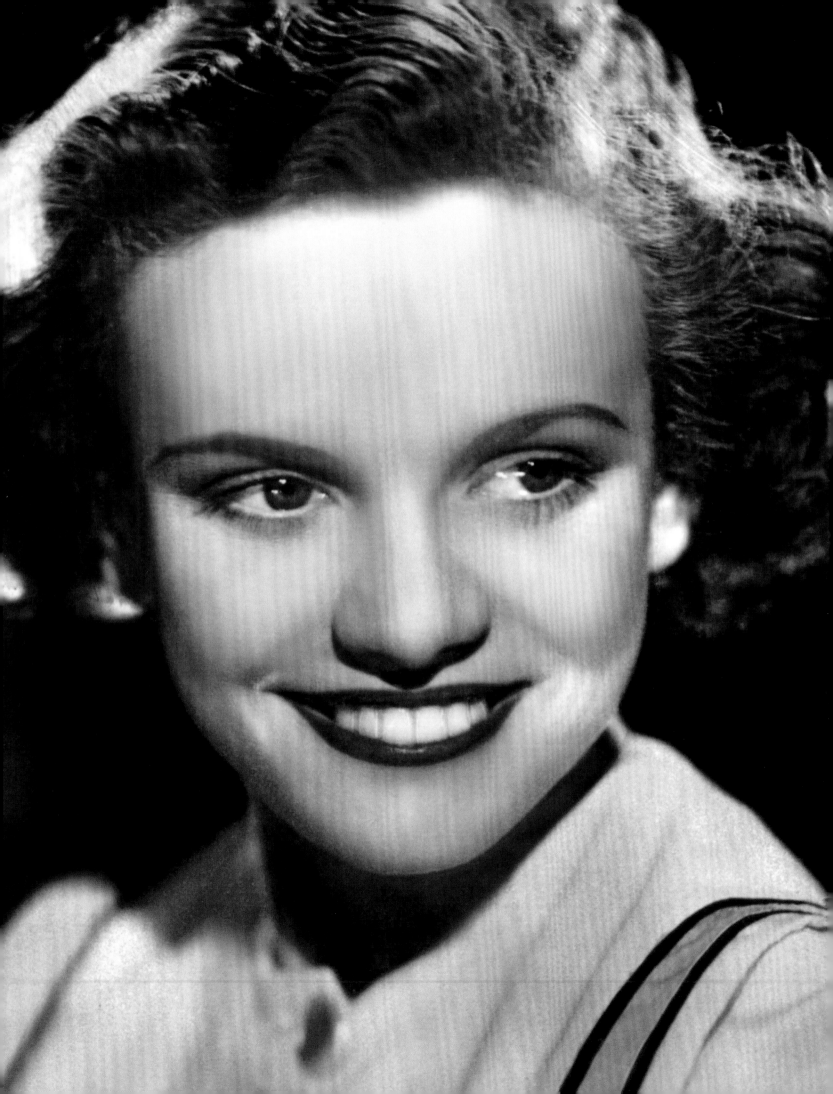

YOUNG AND INNOCENT (1937)
NOVA PILBEAM

A famous actress is strangled by her estranged husband, Guy (George Curzon). The next day her body is discovered by old acquaintance Robert Tisdall (Derrick De Marney) who becomes the main suspect in her murder.

Tisdall is arrested by police when it's discovered that the actress was strangled using the belt of a raincoat that belonged to him (but that he says was recently stolen from him), and that she had left him money in her will.

At the police station he meets Erica (Nova Pilbeam), the daughter of the local chief constable. Initially she is fearful of Tisdall, but eventually becomes convinced of his innocence and vows to help him. The two go on the run together and discover that the stolen raincoat was given to Old Will (Edward Rigby), a local vagrant, by a man with twitchy eyes, and that the belt was already missing. Old Will is wearing the raincoat and in its pocket is a box of matches from the Grand Hotel.

Erica and Tisdall head to the hotel where a memorable and elaborate crane shot devised by Hitchcock reveals the twitchy eyes of the true murderer.

Nova Pilbeam is one of Hitchcock's least remembered heroines, despite being cast in two popular Hitchcock movies in the 1930s and considered for the female leads in both *The Lady Vanishes* and *Rebecca*. Hitchcock had been impressed by Pilbeam's warm performance in *Little Friend*, a Gaumont-British production written by Christopher Isherwood, for which she received rave notices for a mature performance playing a child experiencing her parents' separation. Hitchcock later commented that "even at that time, she had the intelligence of a fully-grown woman. She had plenty of confidence and ideas of her own."

Pilbeam was only fourteen years old when she starred in 1934's *The Man Who Knew Too Much* as the daughter of a couple on vacation who is kidnapped by a criminal played by Peter Lorre. It was her role that provided a sense of the humanity alongside the darkness of Lorre's portrayal.

"The part I was offering her was smaller [than in *Little Friend*]," Hitchcock said of *The Man Who Knew Too Much*. "And she was fully aware of it." Like many of Hitchcock's actors, Pilbeam had plenty of her own ideas to develop her part. While Hitchcock rejected most of them, he did so in a politer way than usual, as he was fond of her and looked upon her in a fatherly way.

"Sometimes I had to 'persuade' her to do something she didn't believe in, like at the end when she's reunited with her parents," he said. "At that age, even a short separation seems a long time, so I wanted her to greet them almost as strangers. It turned out to be one of the most interesting moments."

After this performance, Hitchcock was confident enough in Pilbeam to cast her three years later in *Young and Innocent*, a romantic road movie

NOVA PILBEAM

Born in 1919 in Wimbledon, Nova was a child actress on stage as Marigold in "Toad of Toad Hall" at the Savoy, before being signed to Gaumont-British. After starring in *Little Friend* and *The Man Who Knew Too Much* at the age of fourteen, she won rave reviews as a heroic Peter Pan at the London Palladium in 1935 and on tour, and was a poignant Lady Jane Grey on screen in *Tudor Rose* (1936).

At nineteen she fell in love and married assistant director Penn Tennyson on *Young and Innocent,* only to lose her husband two years later in a plane crash. She continued in British cinema, acting in wartime propaganda films against Nazi Germany with *The Next of Kin* in 1942 and *Yellow Canary* (1943). In 1950 Nova married BBC radio journalist Alexander Whyte, giving up acting to raise her daughter.

Page 34: Nova Pilbeam plays Erica in *Young and Innocent.*

Right: Erica's costumes suited a young but practical girl and included a short-sleeved dress with diagonal stripes on the collar.

that centered around his favorite theme of an innocent man in the wrong place at the wrong time, similar to the narrative of films like *The 39 Steps*, *Saboteur*, *To Catch a Thief*, and *North by Northwest*. However, Hitchcock treated this film with a lighter touch than others of this theme. Pilbeam was eighteen at the time of filming, and the film was known in the United States as *The Girl Was Young.*

Based on a novel by Josephine Tey, the screenplay was written by Charles Bennett, with Alma Reville contributing, uncredited. Hitchcock's secretary, Joan Harrison, was promoted to script collaborator for *Young and Innocent*. Harrison was one of Hitchcock's most trusted associates. He thought she had a good eye and ear for a story, and he helped support her career in screenwriting and producing.

Young and Innocent was filmed in 1936, both at Pinewood Studios and on location in Cornwall for its idyllic English country scenes. Pilbeam plays Erica, the daughter of a police chief, who helps a wrongly accused man, Robert (played by Derrick De Marney), find the real murderer of a wealthy actress.

Pilbeam was given top billing; hers the only name above the title on promotional posters and perhaps an indication of Hitchcock's belief in her

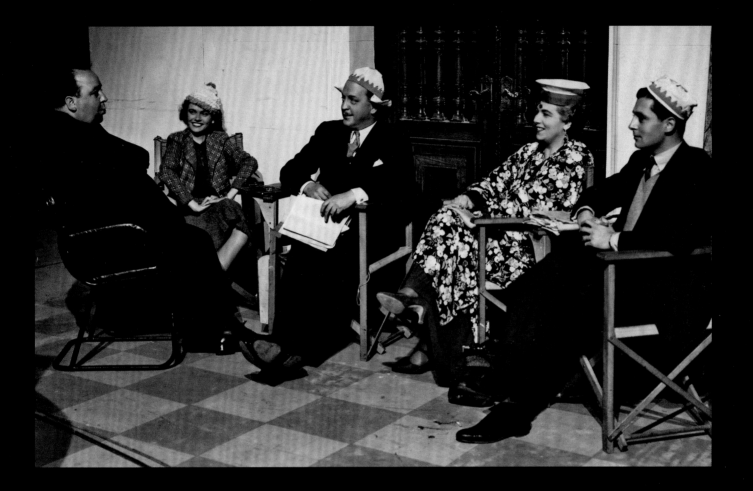

Above: Hitchcock relaxing off-camera with Nova Pilbeam and the other actors in the film, from left to right, Basil Radford, Mary Clare, Derrick De Marney, during filming of the blind man bluff scene.

potential as a star. Erica is plucky and independent, no doubt a character who female audience members could strongly identify with. After Robert passes out during his police interrogation, Erica takes control of the situation by slapping him and pulling his ear to bring him back around. When questioned on her techniques for reviving him, she replies that she learned them from "riding in the car with detectives" and "from a boxer's dressing room." She also manages to crank up a particularly difficult motorcar engine without help.

On the film posters, Nova's light brown hair was given a brilliant blonde recoloring to add a touch more glamour. Erica's costumes, created by a costume designer known simply as Marianne, suited a young but practical girl, and her costumes included a patterned jacket; wool skirt and top; a short-sleeved soft blue Rodier jersey dress with diagonal stripes on the collar, sleeves, and belt; and a dress with a pleated skirt and tie around the neckline, featured in the final scenes.

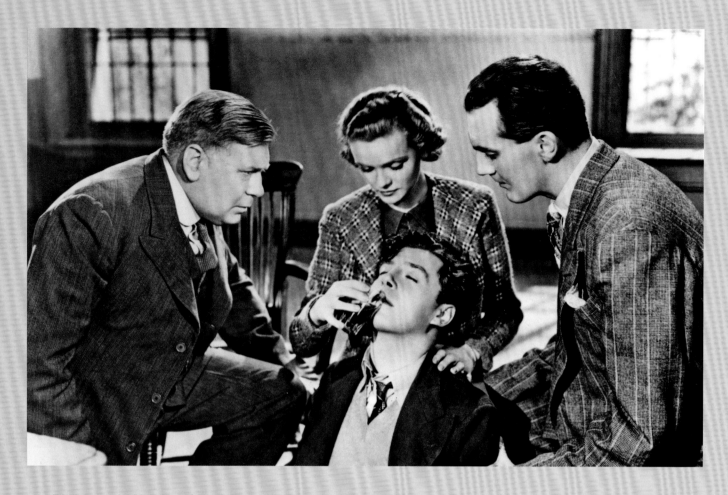

Pilbeam said *Young and Innocent* was "quite the sunniest film I was involved with." She said, "One was rather moved around and manipulated, but, having said that, I liked [Hitchcock] very much." De Marney commented that Hitchcock, who liked to spoil Pilbeam, treated her well both on and off the set. According to notes by the British Film Institute, Hitchcock worried that if he was tough with Pilbeam, she might lose the optimistic naivety of the role.

Both Hitchcock and Pilbeam were dog lovers, and Erica was given a pet dog that would appear in several scenes. They were both sad to see the dog finish its last scene, so Hitchcock broke his own rule of sticking to the film plan in his head and included a new sequence in which the dog would feature, which allowed them to play with him for several more days.

Hitchcock treated the girls and young women in his films—such as Nova Pilbeam and Teresa Wright—with kindness, while older actresses were often on the receiving end of harsher treatment. However, there was one scene in *Young and Innocent* that was quite difficult for Pilbeam, and which she felt Hitchcock intentionally drew out. In one of the most dramatic scenes of the movie, the car she is traveling in with Robert crashes into an abandoned mine. Robert and their other passenger jump from the car in time, but Erica is still trapped inside when it starts sinking

"I believed she had a brilliant future. She was fresh and natural-looking. Hollywood makeup people would have put a mask on her, but she didn't care a bit about Hollywood. I didn't, at the time, know why. The reason was love." HITCHCOCK ON NOVA

into the pit. She manages to hang on, and Robert grabs her by the hand to pull her from the car.

"I was terrified!" Pilbeam said. "But Hitch had this quirky sense of humor and made that scene go on and on, so that I thought my arm would come out of its socket."

Hitchcock believed that Pilbeam would be excellent as the second Mrs. de Winter in *Rebecca*, which was the subject of a huge talent search in 1939. *Rebecca's* producer, David O. Selznick, had been impressed with Pilbeam in *Young and Innocent*, and she had earned good reviews. The British Film Institute's Monthly Film Bulletin praised "an excellent performance" in *Young and Innocent*. "She is charming, sincere, and unaffected, half-child, half-woman with a sense of humor and some dignity," it wrote. But there were concerns that she was too young for the love scenes in *Rebecca*, and the role was given to Joan Fontaine.

"I felt she had great appeal for women," Hitchcock said of Pilbeam. "I believed she had a brilliant future. She was fresh and natural-looking. Hollywood makeup people would have put a mask on her, but she didn't care a bit about Hollywood. I didn't, at the time, know why. The reason was love." (Pilbeam was in love with, and later married, the film's assistant director Penrose Tennyson who held her arm in the car crash scene, rather than actor Derrick De Marney.)

In an interview in 1990, Nova Pilbeam looked back with surprise that *Young and Innocent* continued to be popular. "My daughter had never seen the film until it came to a little cinema in Camden Town recently, and she insisted on going to see it. I hate to watch my films, but I took a large sip of gin beforehand, and we went. What amazed me was that, firstly, the cinema was full and, secondly, it was full of young people. I would have thought that *Young and Innocent* was a very dated film, yet they seemed to find it fascinating."

Opposite: Nova plays Erica, a plucky and independent young girl who takes control when Robert (Derrick De Marney) passes out.

Above: Although she starred in two Hitchcock movies, Nova Pilbeam is one of his least remembered heroines.

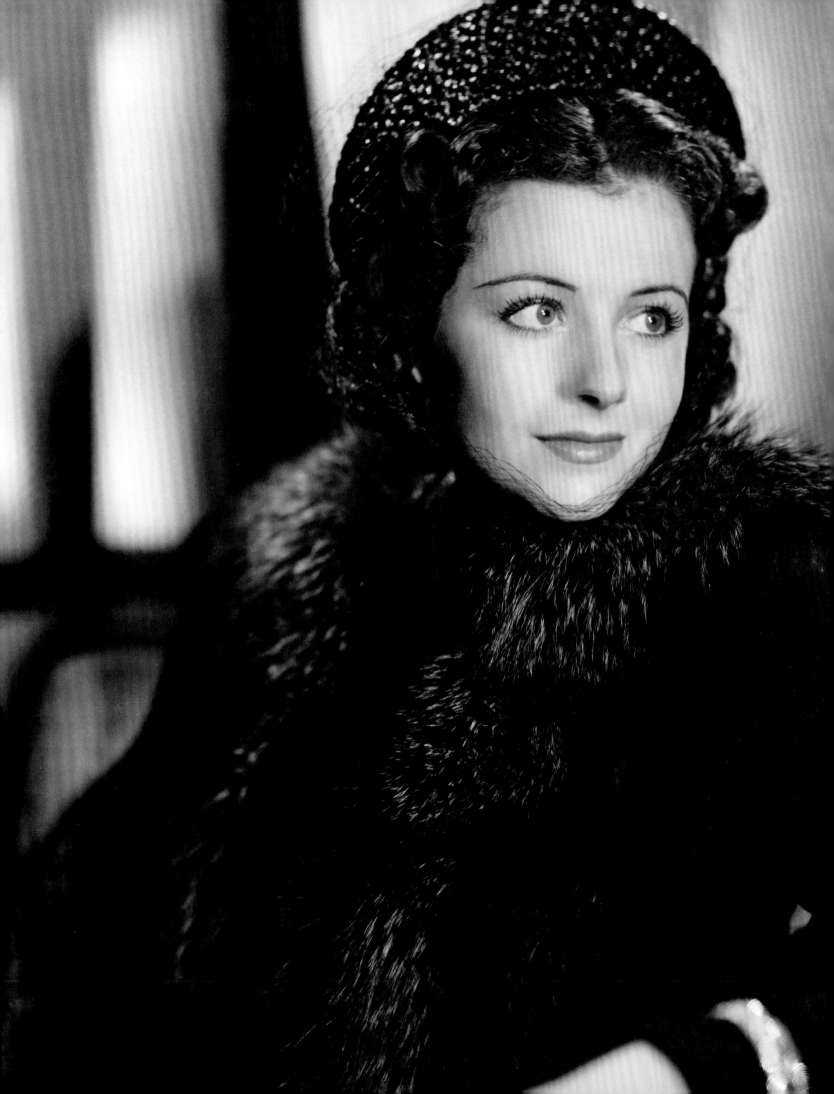

THE LADY VANISHES (1938)
MARGARET LOCKWOOD

Iris (Margaret Lockwood) is returning to London by train following a girls' skiing holiday in Europe. On board are fellow English passengers—Gilbert (Michael Redgrave), a folk music expert; governess, Miss Froy; cricket enthusiasts, Charters and Caldicott; and a lawyer, Todhunter, with his mistress. Due to an avalanche the train is delayed and they must all spend the night in a hotel.

Back on the train the next day, Miss Froy goes missing. Iris is alarmed, but the other passengers, not wanting to be further delayed, miss the cricket match or have a clandestine affair discovered, deny she was ever on board. Instead, they suggest that a bump Iris received to the head before boarding the train is causing her to hallucinate.

Iris is convinced something more sinister is afoot and with Gilbert's help discovers that Miss Froy has been kidnapped by a brain surgeon on board and disguised as his heavily bandaged patient. They help Miss Froy to escape and she tells them that she is really a British agent and needs to deliver an important message to the Foreign Office in London. The message is encoded in a folk tune, which Gilbert memorizes and delivers to London where he and Iris are reunited with Miss Froy.

The Lady Vanishes was Hitchcock's last British film until the 1970s; he relocated to Hollywood soon after its release.

The Lady Vanishes was the biggest hit of Hitchcock's career up until that point, earning him a reputation for thrilling films that combined suspense, comedy, and romance. Throughout Hitchcock's work, the paranoid fantasy is a frequent theme, and, in *The Lady Vanishes*, the heroine, Iris Henderson, is being "gaslighted" as she has to convince her fellow passengers that she is not deluded or hallucinating due to her head injury.

Written by Sidney Gilliat and Frank Launder—later known for the St. Trinian's films—the script was an adaptation of *The Wheel Spins* by Ethel Lina White, which was originally intended to be directed in 1936 by Roy William Neill, as *The Lost Lady*. But after a disastrous attempt at location shooting in the Balkans, production was delayed. The project was eventually given to Hitchcock, who added his own touches with continuity by Alma Reville. He was inspired by the story of an elderly lady who vanished from a Paris hotel during the 1889 Exposition Universelle because she had contracted the plague. This is referenced in *The Lady Vanishes* when the couple having the affair refer to having stayed "secretly in Paris last autumn," when "the exhibition was at its height."

Addressing the plot implausibility, Hitchcock said, "It's fantasy, sheer fantasy!" The Hitchcock MacGuffin on this occasion was a song memorized by an elderly lady in oatmeal tweed, Miss Foy (played by Dame May Whitty, one of the many British character actors involved). The train shootout was a nod to British complacency over troubles in Europe, as the English passengers are more concerned about teatime, cricket, and extramarital affairs than the events of the train.

Trainspotting is a peculiarly British pastime, and Hitchcock loved the excitement of the journey by rail. Many of his films involve romance and

MARGARET LOCKWOOD

Margaret Lockwood was born in Karachi, India in 1916. After her parents separated, she moved with her mother and brother to the London suburb of Upper Norwood.

In 1933 Lockwood enrolled at the Royal Academy of Dramatic Art, won the role in *Lorna Doone* and was signed to Gainsborough Studios. Lockwood shared the fine features and brunette hair of Vivien Leigh, but seemed less haughty – that is until Lockwood switched from heroines to villainesses in the 1940s, with roles in the *The Man in Grey* (1943) and controversial *The Wicked Lady* in 1945. Offered less movie roles once she turned forty, she switched to the theater and won platitudes on the West End. When her second husband of seventeen years left her for another woman, and with the death of her beloved agent, she gave up acting. She died in Kensington in 1990.

Page 40: Margaret Lockwood: a "pretty, petite, and sincere-looking actress."

Right: Margaret Lockwood posed for publicity shots for the film, where she modeled a variety of vacation clothing, including this swimsuit for summer.

Opposite: Margaret Lockwood and Michael Redgrave had only met briefly before filming and although they got along well, they remained suspicious of each other.

thrills upon a train, with passengers confined to a small space moving at speed. Adhering to Hitchcock's belief that plot devices should utilize what is available in the situation, the film is pulled along by the train almost mystically—a delay caused by an avalanche, the train whistle disguising screams, the steam from the engine offering a fleeting clue, and the tea label sticking to the window. The *Times* in 1939 said of *The Lady Vanishes*: "All through the film there is evidence of [Hitchcock's] unmistakable style, his love of the sinister and the bizarre, and his ability to perceive how tiny clues can lead to momentous discoveries."

When it came to casting, Hitchcock thought of Nova Pilbeam as his leading lady. He saw great promise in her after *Young and Innocent* and felt "she had great appeal for women," who were his primary target audience.

Gainsborough Studio persuaded Hitchcock to test their rising star Margaret Lockwood for the part of Iris Henderson. Convinced that she was a "pretty, petite, and sincere-looking actress," he cast her and gave her top billing. She had become one of Britain's most popular young stars after she starred in *Bank Holiday*, directed by Carol Reed. She had the presence to play a Mayfair socialite, but she was also down-to-earth enough to make her likeable. Twenty-one-year old Lockwood saw herself as "only a little suburban girl from Norwood," and her lack of affectation meant that every girl would be able to identify with her. At the time of the film's release, Hitchcock commented that "she has an undoubted gift in expressing her beauty in terms of emotion, which is exceptionally well-suited to the camera."

Hitchcock screen-tested stage actor Michael Redgrave, who had been receiving good reviews for his part in Anton Chekhov's *The Three Sisters*, for the role of the romantic lead, Gilbert, an expert in folk music. Redgrave was more comfortable in the theater, and,

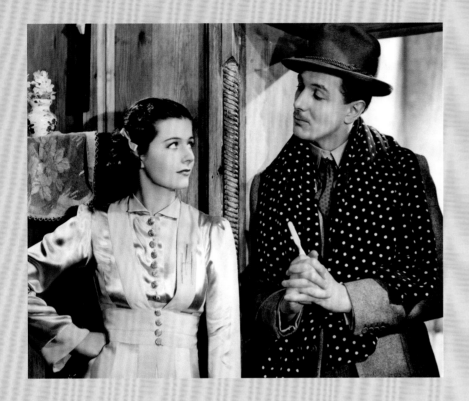

like many stage actors, saw filmmaking as inferior, much to the annoyance of Hitchcock. As John Gielgud, who starred in *Secret Agent*, commented: "In those days, it was considered beneath one's dignity, as a stage actor, to accept employment in films." Redgrave often thought Hitchcock's famous comment that "actors are cattle," which was said in his presence, referred to him and his attitude toward the medium. Looking back, Redgrave said, "I came to admire Mr. Hitchcock very much, but never his sense of humor."

This humor could refer to a mean trick Hitchcock played on cast member Mary Clare—the actress playing the sinister European baroness dressed in black—who didn't drink. At a cast party at Hitchcock's home on Cromwell Road, the director kept offering her fruit juices that had been spiked with spirits, until she was quite drunk.

Lockwood and Redgrave had only met briefly at a charity film ball at the Royal Albert Hall, as orchestrated by the Gainsborough publicity department, and were forced to dance together for publicity photos. "We were photographed in a tight embrace which suggested that, to say the least, we knew each other quite well," Redgrave recalled in his autobiography. The first scene they were to film together was the screwball comedy introduction between Iris and Gilbert. "After some initial parrying, Margaret and I got along well, though we remained suspicious of each other for some time," Redgrave said.

Lockwood's biographer, Lyndsy Spence, said: "Hitch tried to play with his leading man and woman by pitting them against one another and creating an odd atmosphere. It transferred on screen, but in reality Margaret did not rise to his tricks. Redgrave, however, was less confident. I guess this was another element as to why Hitchcock and Margaret shared an easy dynamic."

This initial suspicion between the two actors was perfect for the opening scenes, in which Gilbert invades Iris's room after she causes him to be evicted for playing loud folk music. Later, their mutual dislike turns to attraction. Disappointed when Iris reveals that she is engaged, Gilbert tells her in the dining cart: "You're remarkably attractive, has anyone ever told you?" Iris, as the strong 1930s woman, refuses to be moved by his flirting.

Picturegoer Weekly announced: "Margaret Lockwood, with Sally Stewart and Googie Withers, has one of her most ambitious roles to date as the Mayfair playgirl who gets mixed up in an international secret service war." The film portrays the three friends as well-dressed, with implausibly coiffed hair in Marcel waves, despite having arrived at the alpine village inn from skiing. The film lets us know that they are wealthy and fun-loving, with Iris's correction of the pronunciation of "avalanche" and their ordering of a magnum of champagne for their room.

In a voyeuristic scene typical of 1930s cinema, we see Iris and her friends in their slips as they get changed, the camera framing their legs as Iris stands on the table and Googie Withers bends over the changing screen. The gathering is a hen party of sorts, as Iris is back to London to marry the "blue-blooded, check chaser," and they pay tribute to the happy days of being a bachelorette. "I've no regrets," Iris says wistfully. "I've been everywhere and done everything. I've eaten caviar at Cannes, sausage rolls at the dogs; I've played baccarat at Biarritz and darts with the rural dean. What is there left for me but marriage?"

There was no costume designer credited on the film, so it's likely that Lockwood wore items that were part of stock studio wardrobe for the film. Her clothes suited that of a wealthy Mayfair girl—a silk dressing gown and negligee, a mink coat for traveling, a cardigan jacket over a luxury two-tone dress with a glittering brooch—and for the arrival back in London, a smart tweed suit, blouse, and fox fur. The costumes were recycled for Lockwood in *A Girl Must Live* (1939) and *Night Train to Munich* (1940).

Right: Margaret Lockwood with Sally Stewart and Googie Withers in *The Lady Vanishes*. The three friends are wealthy and fun-loving and despite having arrived for a skiing holiday sport perfectly coiffed hair in Marcel waves.

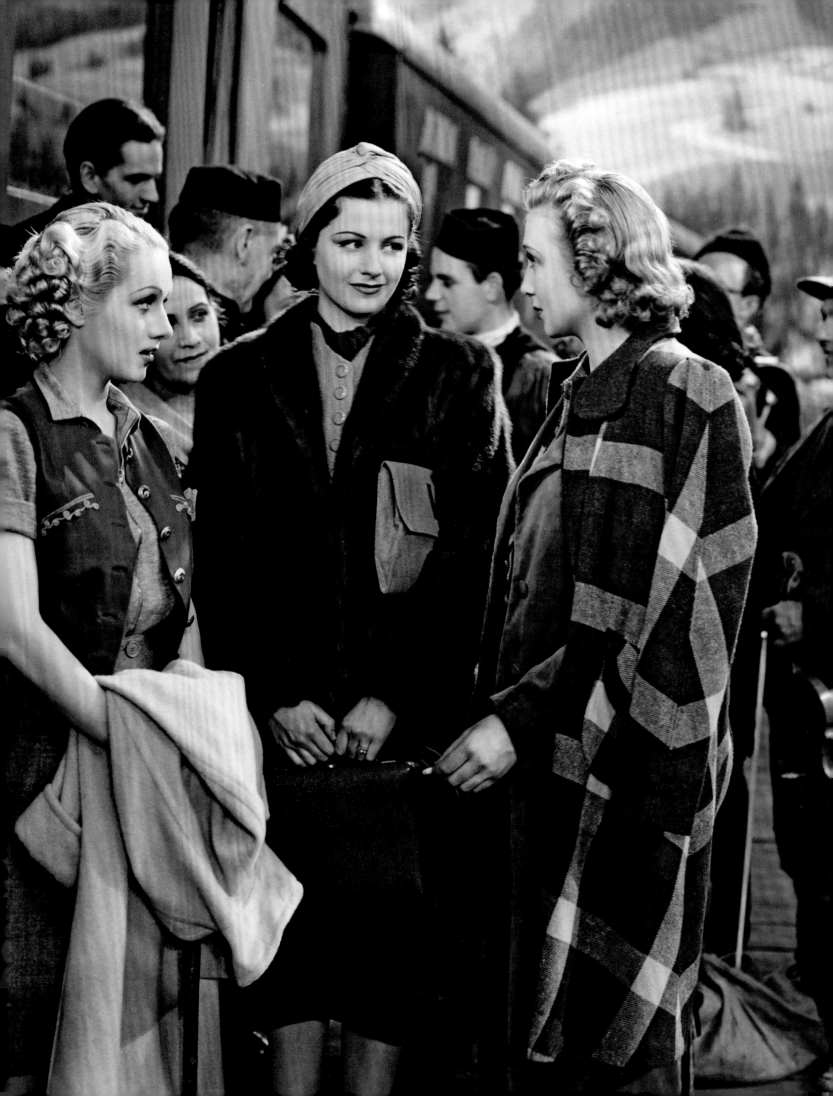

One particularly memorable moment reflected Hitchcock's perverse humor when it came to treating Catholic symbols with irony. Catherine Lacey played a nun whose high heels beneath her habit give away her identity, acting as a vital clue to the audience that she is not who she seems. Hitchcock said: "When you see her high-heeled shoes, that picture tells the story. No nun, this one. This kind of image may come out of my early days in silent film, or it may be just the way my mind works."

Lockwood found the set to be "a happy yet odd environment," particularly with Hitchcock's tradition of throwing his teacup over his

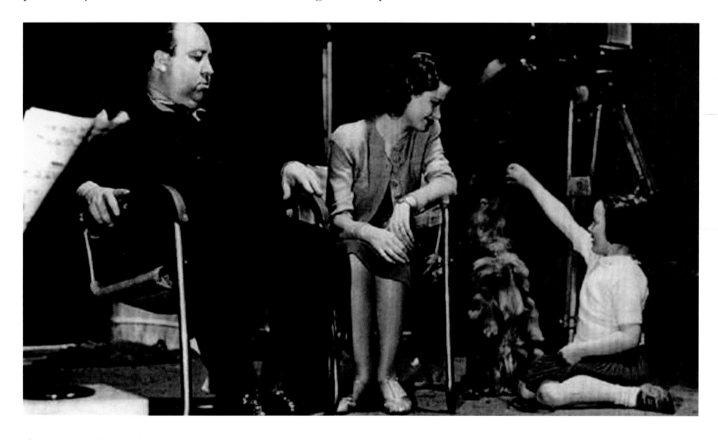

shoulder to signify it was time to get back to work after morning and afternoon tea. But she liked him. During the film, he gave the cast a lot of freedom, partly because he knew he would be heading to Los Angeles soon. In the middle of shooting *The Lady Vanishes*, he had received a cable from David O. Selznick confirming that he was to go to Hollywood to direct a film about the *Titanic*.

Lockwood recalled, "What surprised me most of all about Hitchcock was how little he directed us. I had done a number of films for Carol

Above: Margaret Lockwood with Hitchcock watches his daughter, Pat, play with a dog on the set of *The Lady Vanishes*.

Opposite: Margaret Lockwood and Michael Redgrave on the set of the train with Hitchcock.

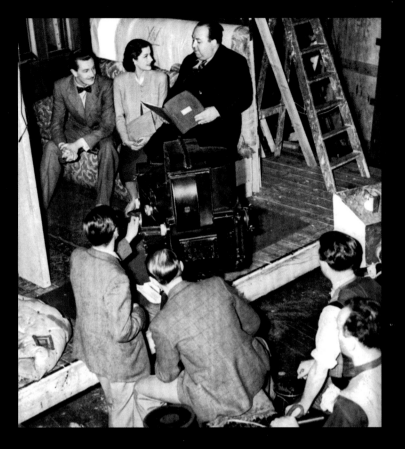

Reed, and he (Reed) seemed quite meticulous in contrast. Hitchcock, however, didn't seem to direct us at all, He was a dozing, nodding Buddha with an enigmatic smile on his face."

Lockwood was particularly impressed by Hitchcock's love for his daughter. One lunchtime, as a special treat for nine-year-old Pat, he cleared the Islington Studio set. He and Pat sat down at the dining car tables of the ninety-foot-long replica train to enjoy a special lunch he had planned, with fizzy fruit juice served in champagne glasses and musicians playing in the background.

Lyndsy Spence said, "What stands out for me is how Margaret seemed to admire Hitch and his parenting skills. She did not have a father figure in her life and so she was curious as to how he treated Pat, and I think that endeared him to her. I think he came to admire Margaret because above all else she was very easy to work with, she was not neurotic or temperamental, and in the 1930s she was very much an ordinary girl from the suburbs and was happy to do as she was told. I think that, in a way, she did not attract his curiosity or feed his imagination in ways the likes of Kim Novak and Grace Kelly did."

"He was a dozing, nodding Buddha with an enigmatic smile on his face." MARGARET LOCKWOOD

The film was a huge success, and Lockwood was praised for a sparkling performance. After *The Lady Vanishes* was sold for American distribution, she was signed to be lured to Hollywood. For a while, there were plans to capitalize on the chemistry between Lockwood and Redgrave by turning them into a romantic double act, like William Powell and Myrna Loy. But, in the end, these plans did not materialize: Redgrave joined the Navy when World War II broke out, and Lockwood returned to act in British films.

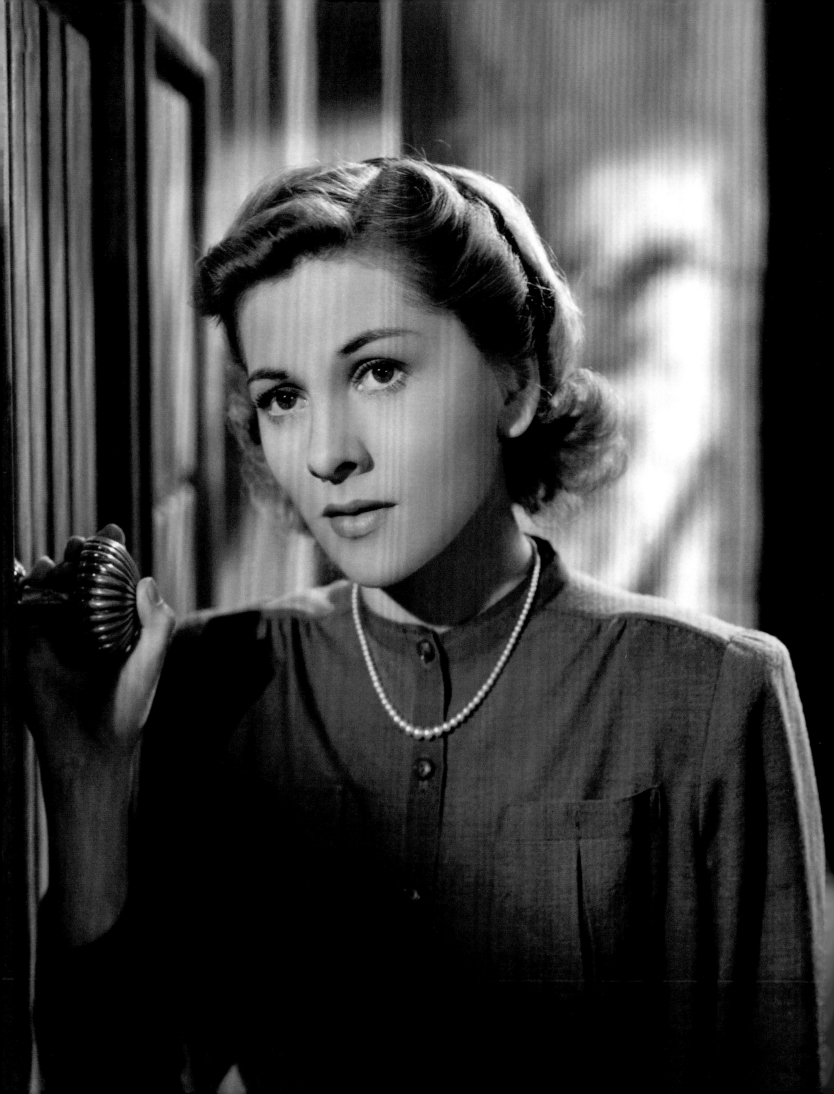

REBECCA (1940)
JOAN FONTAINE

A shy young woman (Joan Fontaine) meets Maxim de Winter (Laurence Olivier) in Monte Carlo. They fall in love and are married within two weeks. She is now the second Mrs. de Winter.

They return to Manderley, Maxim's country house in Cornwall. There the new bride meets Mrs. Danvers, the housekeeper who is still obsessed with Rebecca, Maxim's first wife. She intimidates the new wife who begins to doubt her husband's love for her, convincing herself that he is still in love with his first wife.

However, during a nearby shipwreck rescue, a sunken boat is found with Rebecca's body inside. Maxim admits to his new wife that his first marriage was actually a sham and following an argument where she revealed she was pregnant by another man, she fell, hit her head, and died. He then concealed her body in the boat.

Now assured of her husband's love, the second Mrs. de Winter helps him to conceal the truth. However, a doctor's report reveals that Rebecca was not actually pregnant but suffering from late stage cancer. A verdict of suicide is recorded.

Rebecca was Hitchcock's first American project. It won two Academy Awards, Outstanding Production and Cinematography, out of a total 11 nominations.

Rebecca was also the opening film at the first Berlin International Film Festival in 1951.

Rebecca **was Hitchcock's first Hollywood film after signing with producer David O. Selznick and moving to California in May 1938.** Selznick had planned to make *Titanic* with Hitchcock, but his attention soon turned to Daphne du Maurier's *Rebecca*, a gothic romance with strong similarities to *Jane Eyre*. The story could be considered a fairy-tale piece, in which, as Hitchcock said, "the heroine is Cinderella, and Mrs. Danvers is one of the ugly sisters." This gothic narrative heralded the darker mood of the 1940s.

Despite being occupied with *Gone with the Wind*, Selznick still had to have the final say in production. This resulted in friction with Hitchcock, who was used to having autonomy. "It's not a Hitchcock picture; it's a novelette really," he told François Truffaut. "The story is old-fashioned; there was a whole school of feminine literature at the period, and though I'm not against it, the fact is that the story is lacking in humor."

The novel was the talk of celebrity parties on its release in 1938, and when Joan Fontaine and Selznick were seated next to each other at a dinner held by Charlie Chaplin that summer, she spoke enthusiastically of the novel to him, saying that it would make a "fascinating, unusual movie." Coincidentally, Selznick informed her, he had just bought the movie rights. It was said that Selznick fell into unrequited love with Joan Fontaine after that meeting. She was a pretty, young star who hadn't broken into the big time and was considered a bit humorless, despite a flighty, comedic part in George Cukor's *The Women*. It would take many auditions for her to win the crucial role of the second Mrs. de Winter, who remains nameless throughout the book and film, and whose self-doubt and insecurity lies at the heart of the tale. Fontaine told

Modern Screen: "Mrs. de Winter is myself in practically every respect, just as I was a few years ago. Why shouldn't I do the part with feeling?"

The role was much sought after, and just as he had created huge publicity for his talent search for *Gone with the Wind*, Selznick tested almost every actress in Hollywood. "I think he really was trying to repeat the same publicity stunt he pulled in the search for Scarlett O'Hara," Hitchcock said. "He talked all the big stars in town into doing tests for *Rebecca*. I found it a little embarrassing, myself, testing women whom I knew in advance were unsuitable for the part."

Hitchcock had hoped for Nova Pilbeam, who he was very fond of, but she was young and unknown outside of Britain. He ran through the list of potentials, providing caustic and witty comments to Selznick on whether they were suitable, perhaps in a dig at his talent search. In his comments, Jean Muir was "too big and sugary," Miriam Patty was "too much Dresden china. She should play the part of the cupid that is broken—she's so frail," and of Joan Fontaine, he wrote "possibility. But has to show fair amount of nervousness in order to get any effect."

Hitchcock envisioned Robert Donat as Maxim de Winter, but Selznick's attention turned to Laurence Olivier, who was known for his Shakespearean roles on stage and had become a star after his brooding performance in *Wuthering Heights*. With Olivier on board, his future wife Vivien Leigh was now desperate to play "I," but her initial tests did not hit the right note "as to sincerity or age or innocence."

Later in August 1939, Hitchcock ran further tests of the final three, Anne Baxter, Joan Fontaine, and Margaret Sullavan for Alma Reville and Hitchcock's assistant, Joan Harrison. Anne Baxter's age and lack of experience were problems, as "she would not be able to play love scenes," but Alma and Joan's opinion was that "Fontaine was just too coy and simpering to a degree that it was intolerable."

Both Selznick and his wife, Irene, favored Fontaine. She was on her honeymoon with her new husband Brian Aherne in Oregon when she received a telegram congratulating her for winning the role. Conflicted as to whether she wanted to give up acting to be the dutiful wife, she recalled in her memoirs that she was "stunned, I could only murmur that I wasn't sure I still wanted a career."

"He wanted total control over me, and seemed to relish the cast not liking one another, actor for actor, by the end of the film." JOAN FONTAINE

Page 48: Joan Fontaine plays the second Mrs. De Winter in *Rebecca*.

Opposite: Joan Fontaine with Hitchcock on the set of *Rebecca*. She called the English actors, including Laurence Olivier pictured standing behind Hitchcock, a "clique" lot.

Alma Reville and Joan Harrison worked with Hitchcock on the treatment for *Rebecca*, but Selznick was horrified at the deviations from the book, particularly with the creation of a pluckier, less simpering second Mrs. de Winter. Scriptwriter Robert E. Sherwood was brought in to shape it to Selznick's vision. Perhaps Hitchcock had imagined her more in line with the heroines of his films up to that point, but Selznick wrote to Hitchcock that "the tiny things that indicate her nervousness and her self-consciousness and her gaucheries are all so brilliant in the book that every woman who has read it has adored the girl and has understood her psychology, has cringed with embarrassment for her, yet has understood exactly what was going through her mind."

There were continued concerns as to whether, in Selznick's words, Fontaine was "capable of the big moments," and that "it takes time to get the performance out." Hitchcock used his skills to coax a performance out of her and on one occasion even slapped her, at her own request, to bring on the tears for a particularly emotional scene. Fontaine recounted that he purposely isolated her from the rest of the cast to make her feel alone and insecure. She said: "He wanted total control over me and seemed to relish the cast not liking one another, actor for actor, by the end of the film."

JOAN FONTAINE

One of Hollywood's most popular stars in the 1940s, Joan Fontaine specialized in romantic melodramas. She was famous for her rivalry with her sister Olivia de Havilland, whom Fontaine beat to an Oscar for her role in *Suspicion* in 1942. Born Joan de Beauvoir de Havilland in 1917 in Tokyo to English parents, she moved to California with her mother and sister after her parents divorced.

She was an ill child, and during times spent confined to bed, she developed an active imagination and love of acting.

Signed to RKO in 1935, she was credited as Joan Burfield in *No More Ladies*, but failing to make an impact, her contract was cancelled in 1939. Her career dramatically turned around after *Rebecca*, and she followed it up with hits like *Jane Eyre*. When her film career faded in the 1960s she moved to stage and television work. She was married and divorced four times and died in Carmel Highlands, California, in 2013 at the age of ninety-six.

Opposite: Joan Fontaine as the second Mrs. de Winter and Laurence Olivier as Max in *Rebecca*. Off-set, Laurence tormented and intimidated Joan in vengeance for his wife, Vivien Leigh, not being given the lead female role.

Fontaine called the English actors—Olivier, Gladys Cooper, Judith Anderson, George Sanders—a "clique lot." It was said that Hitchcock purposely didn't invite them to a surprise party for her, although it seems unlikely that he would have had that much control over such strong-minded cast members. During the first week of filming, in September 1939, war was declared on Germany, which sent shockwaves through the English cast and crew and may have affected their mood. According to Donald Spoto, Fontaine didn't help her own case by boasting to the English cast members that her grandmother was the first lady of Guernsey.

Disappointed that Vivien Leigh hadn't won the role, Olivier made sure to torment Fontaine by whispering obscenities. When he found out that Fontaine was newly married to Brian Aherne, he dismissively replied, "Couldn't you do better than that?" It was a quip that ultimately destroyed her belief in her husband, as, from then on she couldn't look at Aherne in the same way. Olivier's "attitude helped me subconsciously," she said in her autobiography. "His resentment made me feel so dreadfully intimidated that I was believable in my portrayal."

Biographer Patrick McGilligan, who wrote *Alfred Hitchcock: A Life in Darkness and Light*, stated that Hitchcock was "Pygmalion" to Fontaine. But it was Selznick who really controlled the way she looked, through wardrobe, hair, and makeup, firing off his famous memos to ensure that she looked as he envisioned: "as pretty and appealing as she could as long as she was not glamorous."

Selznick was horrified to see Fontaine with overly plucked eyebrows that didn't suit the sweet girl she was playing. More natural "Ingrid Bergman" brows were also coming into vogue. Selznick told makeup man Monty Westmore: "In one of the most important close-ups in the picture, the one in today's rushes where the character is almost driven to suicide, she has on eyelashes that compare with Miss Dietrich's at her worst . . . what can I do to get you makeup men to throw away your kits and your tweezers? The public is so far ahead of you all."

There was no screen credit for the costume design for the film, despite its importance in charting the growth of the second Mrs. de Winter. One reason for wardrobe being uncredited was that Selznick drastically reduced the wardrobe budget to save money. Ed Lambert from Western Costume Company was charged with sourcing suitable

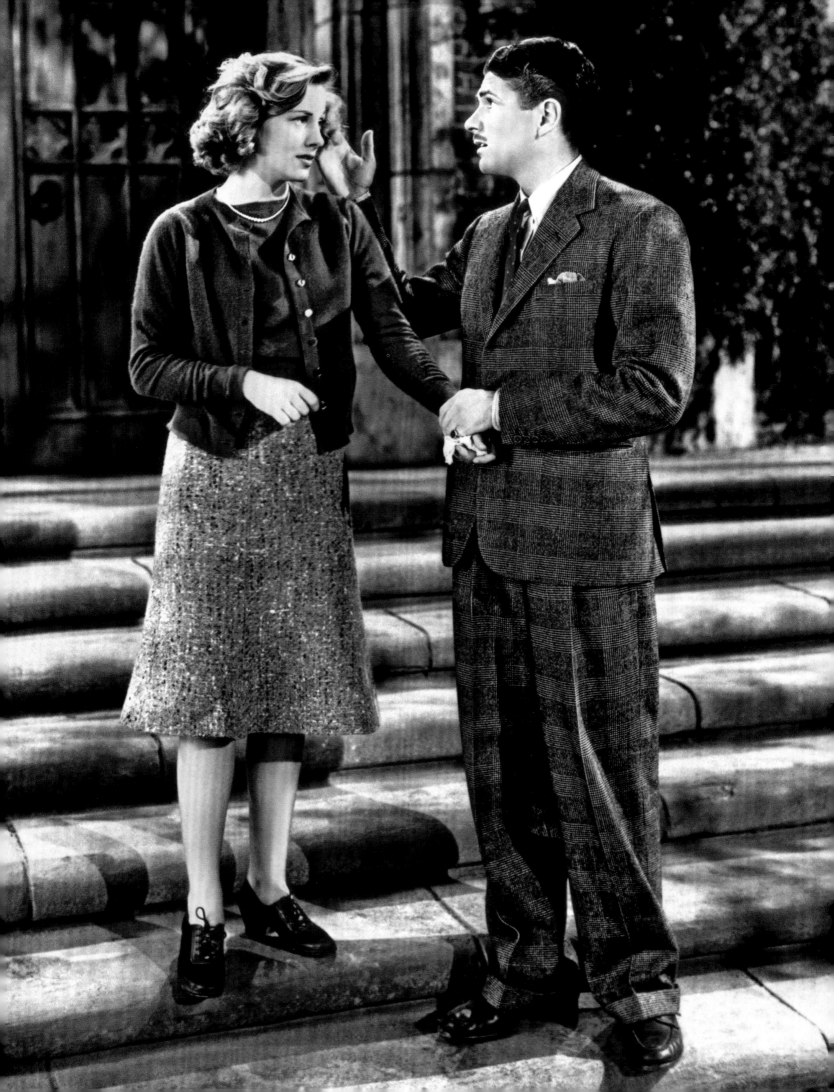

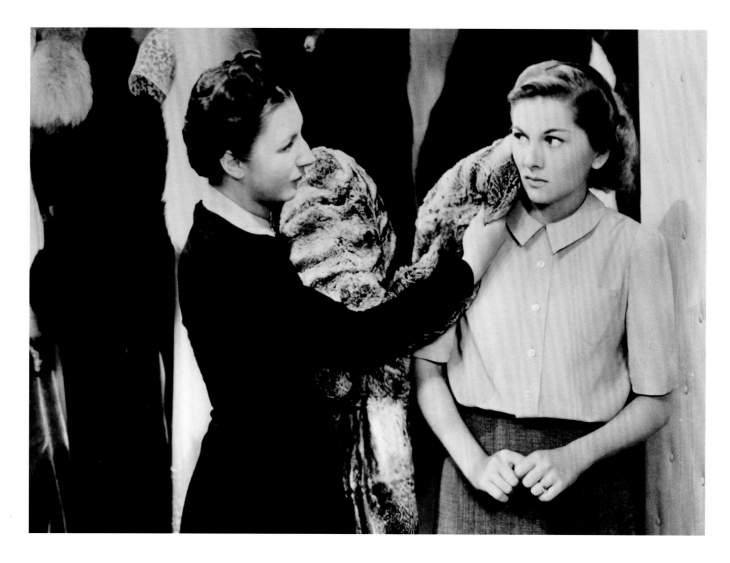

pieces from existing stock, and Selznick instructed him: "I don't think we ought to have to build a single costume for this picture. The lead should be outfitted entirely from stock things purchased around town, and the other costumes also ought to be stock. I feel that there is a possible saving of between $5,000 and $7,500 in Ladies' Wardrobe." There have been rumors that Irene Lentz was commissioned to design costumes, but since the prospect of hiring Travis Banton was dismissed as too expensive (he was charging $150 per sketch), it is unlikely Irene was brought in.

The heroine's awkwardness is what initially attracts Max, and he wishes for her never to change from her cardigans and sweaters. Selznick thought her dresses in Monte Carlo should have a low waistline and suggested that Lambert "try some shop that carries clothes for extremely young girls which we can

see along with the sketches which I understand you are preparing." As she feels she must compete with Rebecca, the girl tries to dress in a more sophisticated fashion, but it is treated comically, as she doesn't hit the right note.

The gown for the masquerade ball was also a major plot point. When sketching her costume for the ball, she at first considers a Joan of Arc warrior uniform, but ends up going for a frilled, feminine dress that would be nonthreatening and in line with the luxurious clothing she has seen in Rebecca's room. Ed Lambert referred

Above: Mrs Danvers intimidates the new bride by showing her Rebecca's finery, bolstering her belief that she must compete with Max's dead, first wife.

Opposite: Laurence Olivier and Joan Fontaine playing Max and Mrs. De Winter in *Rebecca*.

to the pages of the book when sourcing a suitable gown. It said, "I always loved the girl in white, with a hat in her hand. It was a Raeburn, and the portrait was of Caroline de Winter . . . those puffed sleeves, the flounce, and the little bodice."

When it came to adapting the Mrs. Danvers character, the nature of her relationship with Rebecca was embellished. Danvers goes through Rebecca's belongings, stroking her furs and satins and underwear made by "cloister nuns." She was also to look old-fashioned, retaining the Edwardian parlor maid costume. "Mrs. Danvers was almost never seen walking and was rarely shown in motion," said Hitchcock.

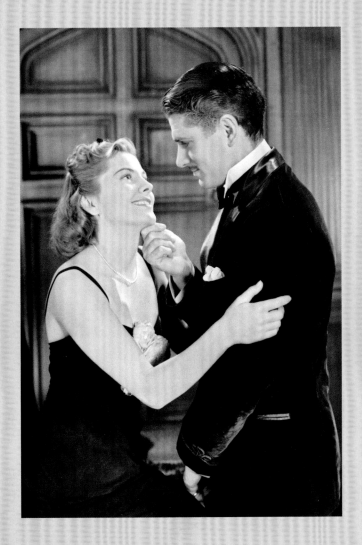

"If she entered a room in which the heroine was, what happened is that the girl suddenly heard a sound and there was the ever present Mrs. Danvers, standing perfectly still by her side. In this way, the whole situation was projected from the heroine's point of view."

While Fontaine's costumes were not to be too fashionable, the wardrobe for the deceased Rebecca was used in promotions to attract fashion-conscious women. Selznick's assistant Katharine Brown negotiated a deal with fashion designer Kiviette and hat designer Robert Dudley to create a luxury Rebecca wardrobe, based on the myth of Rebecca. It was tied in with a poster that showed a silhouette of a woman with the caption, "THE MOST GLAMOROUS WOMAN OF ALL TIME!"

Kiviette designed a midnight blue negligee and dressing gown embossed with the letter R, which would only be seen briefly in the bedroom in the scene where Mrs. Danvers obsessively goes through all of Rebecca's finery. Selznick asked for the nightgown and negligee to "be exotic and very sophisticated, but . . . be careful they don't look like Mae West." Selznick liked them so much that he wanted to keep them to "hang them in (his wife) Irene's Christmas stocking!" As part of the promotion in department store windows and in the fashion shows, mannequins would wear masks, and "Kiviette has decided to use navy blue hair to give the mannequins an unreal quality."

Rebecca was released in spring 1940 and was a huge hit that won Best Picture at the Academy Awards and accolades for Joan Fontaine. Upon the film's release, Fontaine praised Hitchcock for being "marvelous. I can't say enough for him. He was practically a Svengali to me. I could read his mind, know instantly what he wanted in a scene, just watching his face."

MR. AND MRS. SMITH (1941)
CAROLE LOMBARD

Ann (Carole Lombard) and David Smith (Robert Montgomery) are a married couple living in New York. They regularly have fights that last for days. One morning Ann asks David if he would marry her again if he had to do it over. He replies "no." Later that day, David discovers that due to a technicality they are not legally married. Ann also discovers this, but doesn't let on that she knows. When David fails to ask Ann to marry him again, Ann kicks him out of their apartment vowing to never, ever marry him.

David's friend and law partner agrees to convince Ann to reconsider, but instead ends up dating her and they become engaged. They go on holiday together to a ski resort where David has rented the cabin next door.

David pretends to be sick to win sympathy from Ann, while Ann pretends her relationship with Jeff is more intimate than it is. Both are furious to discover each other's pretense. They argue and Jeff, realizing that they are meant to be together, withdraws his offer of marriage.

Mr. and Mrs. Smith was the only pure comedy Hitchcock made in America, and he claimed that he did it as a favor to Lombard.

As the top comedic actress in Hollywood in the 1930s, Carole Lombard held considerable clout. She had ambitions to be a producer, and when RKO Pictures bought the script for *Mr. and Mrs. Smith* on her behalf, she was given de facto producer status. It was Lombard who campaigned for Hitchcock as director, selected the crew, supervised the budget, and insisted on luxury designer Irene to create her wardrobe.

Having recently arrived in Hollywood, the Hitchcocks met Carole Lombard and her husband, Clark Gable, socially through David O. Selznick. When Hitchcock mentioned that he was looking for a place to live in Los Angeles, Lombard rented them her English cottage-style home in Bel Air as she was moving to Gable's Encino Ranch. She and Clark ruled Hollywood as a power couple who were also completely in love. Hitchcock was charmed by Lombard's good humor, and she and Gable offered a fitting welcome to Los Angeles life. "She had a bawdy sense of humor and used the language men use with each other," Hitchcock said. "I'd never heard a woman speak that way. She was a forceful personality—stronger, I felt, than Gable."

Lombard was desperate to star in a new screwball comedy written by Norman Krasna, director of *Bachelor Mother*, provisionally called *Who Was That Lady I Seen You With?* and *No for an Answer*, so she asked Hitchcock if he would consider directing her. Hitchcock had used elements of screwball comedy within his British films *The Lady Vanishes* and *The 39 Steps*, but they also came with a healthy dose of suspense. *Mr. and Mrs. Smith* would be pure American comedy designed to appeal to an American audience.

While Hitchcock didn't think it was one of Krasna's best, he liked the idea of working with the "Queen of Screwball." He had also been loaned

out by Selznick to RKO for two films and made a deal with the studio that he would direct Lombard if he could adapt Francis Iles's novel *Before the Fact*, which was much more to his taste. He seemed to just go through the motions when directing her, although there were some Hitchcock touches, such as the camera swooping into a close-up of her face as she lies in bed.

"I adored Carole Lombard," said Hitchcock. "So much, in fact, that she was able to persuade me to do something outside my type, a bedroom farce called *Mr. and Mrs. Smith*. She had a tremendous sense of humor, but there was nothing for me to do with that film except to take the script and direct it. I had nothing to contribute." He also told François Truffaut: "Since I really didn't understand the type of people who were portrayed in the film, all I did was photograph the scenes as written."

The first choice to play opposite Lombard was Cary Grant, which could have placed it in film history as the first Hitchcock and Grant pairing, but his schedule was booked solid. Robert Montgomery was cast, with the hopes that he and Lombard could do some married-couple sparring along the lines of Katharine Hepburn and Spencer Tracy.

The film depicted Ann Smith and David Smith as wealthy New Yorkers living in a beautiful apartment with a sleek, modern kitchen, serviced by maids. Carole Lombard wanted to wear beautiful, luxurious clothes on screen, and so she requested that her friend, fashion designer Irene, who also designed Lombard's personal wardrobe, be hired.

Mr. and Mrs. Smith is often considered a separate entity to Hitchcock's usual style. While Hitchcock would gain a reputation for his specification on what his leading

"I adored Carole Lombard. She was a forceful personality— stronger, I felt, than Gable." ALFRED HITCHCOCK

ladies would wear, for *Mr. and Mrs. Smith* it was Lombard who took control of her own wardrobe. The costumes were designed to make the star look as beautiful and appealing as possible. Women in the 1930s and 1940s often specifically chose to see a film in order to see what their favorite star was wearing.

"Irene made clothes women wanted to wear, whereas other designers created costumes for the whole film and looking at the whole character," says her biographer Frank Billecci. "Irene wasn't a costume designer, rather she created beautiful clothes for women, and many were major film stars. She had a whole list of women, a who's who of Hollywood, who wanted her to design their clothes."

In 1941 *Photoplay* stated: "It is the first time in three years that (Lombard) has worn modern clothes in a picture. The cameraman nearly fainted when Hitchcock told him they would not need to make the customary dress test . . . Miss Lombard knows clothes too well. She is one of the most skillfully dressed women in the world."

The magazine reported that Lombard "goes into a huddle with the famous designer Irene. They plot outline, color . . . there's a certain symmetry and blending in her wardrobe that makes it outstanding and she probably has started more vogues than any two women in the world." In *Mr. and Mrs. Smith*, Lombard wore three-quarter length coats because, she was "tired of short jackets" and wanted "to do something different with them . . . thus the high fashion in three-quarter length coats was born."

Page 56: Carole Lombard wanted to wear beautiful, luxurious clothes on screen. After persuading Hitchcock to do the film, she insisted that her friend, fashion designer Irene, design the costumes.

Opposite: Carole Lombard took control of her own wardrobe. Costumes, such as this elegant, spaghetti strap gown, were designed to make her look as beautiful as possible.

Above: Carole Lombard sits in front of Irene's costume sketches in an outfit from the opening scene of *Mr. and Mrs. Smith*.

CAROLE LOMBARD

Born Jane Alice Peters in 1908 in Fort Wayne, Indiana, Carole Lombard began her career as a Mack Sennett "bathing beauty" in many of his comedic films in the late 1920s. She was signed to Paramount in 1930, and as a beautiful, vivacious, and tomboyish star, she excelled at comedy in hit films like *Twentieth Century* (1934) and *My Man Godfrey* (1936). After her marriage to actor William Powell ended in divorce, she married Clark Gable and they quickly became the most beloved of Hollywood couples. She was also one of the most powerful women in the film industry. Her life was tragically cut short at the age of thirty-three when she was killed in a plane crash in 1942, after raising millions in war bonds. Gable was left bereft for many years, and she was posthumously named "the first heroine of the Second World War."

Above: Carole Lombard in *Mr. and Mrs. Smith*; her last film released before her tragic death. Had she lived Hitchcock believed she might have become a director.

Photoplay described her "devastating black satin pajamas with white coin dots, neatly topped with a black velvet robe," worn in the opening scene. They also praised a Mandarin-style dressing gown over a luxurious silk nightgown. She posed for publicity photos in front of Irene's costume sketches, wearing the three-quarter black satin overcoat with contrasting vertical stripes, which she wears in the scene in which she gets stuck on the fairground ride.

At the nightclub, Mrs. Smith in her elegant black spaghetti-strap gown and up-do contrasts with the two inelegant and vulgar women Mr. Smith has brought on a double date. There's a comical moment in which he pretends the beautiful, glacial woman next to him is his date— mouthing his words as if speaking to her, only to be caught in the act.

While Ann Smith is feisty and independent and can hold her own, there were also touches that were very much of the time. She pretends to be unmarried in order to work as a shop girl in a department store, as the store's policy is to only hire single women. Looking back on the film in 2015, *Film Comment* wrote: "Lombard essentially plays a number of roles: she is a spiteful wife in the bedroom, a merry mistress in the ballroom, a working girl in a department store, and a passionate lover at a ski resort. All of these, for her husband's eyes and ears and the audience's pleasure."

pen with three young calves. They were decorated with ribbons that had the three stars of the film on them—Lombard, Montgomery, and Gene Raymond. In addition, filming took place in 1940 during the height of the presidential elections, and as Lombard was a long-time Democrat and Montgomery a Republican, she plastered pro-Roosevelt stickers all over his car on a daily basis.

Hitchcock agreed to let Lombard direct his signature cameo, with a long shot as he strolls past the studio. She was up to the task, making him do it over and over again until it was just right. It turned

"She might have become a director one day. She had the personality for it." HITCHCOCK ON CAROLE LOMBARD

In their luxury ski chalet, Ann tries to get away from her husband by putting on her skis, as she is attracted to the single life as well as the traps of marriage. One Hitchcock touch, which is on par with his handcuff metaphor in *The 39 Steps*, is the final image of the crossed skis. David pushes his wife onto the armchair, which leaves her trapped by her skis—or so she thinks. When her feet come free of the straps, she places them back inside again, pretending to David that she is still stuck. This form of bondage encourages her to forgive him and embrace him.

Since both Lombard and Hitchcock were known for their practical jokes, their pranks were much reported on. Every time Lombard messed up a line, Hitchcock would chalk a line on an "idiot" board he had created especially for her. In response to his infamous "actors are cattle" comment, and as a publicity stunt to get the movie magazines talking, Lombard brought onto the set a miniature cattle

out better than he had expected, and he later said, that if she had lived, "She might have become a director one day. She had the personality for it."

Hitchcock completed filming *Mr. and Mrs. Smith* in six weeks, and it became a huge success upon its opening at Radio City Music Hall in January 1941. Although the film was the type of screwball junk food that becomes forgettable once consumed, it was a step toward confirming Hitchcock as an American director. "Its risqué banter and intimate intrigue will evoke the double entendres Director Alfred Hitchcock intended," wrote *Hollywood* magazine in May 1941, and "is a good antidote for the country's current day war jitters."

Hitchcock recalled that he agreed to do another film upon the urging of a beautiful actress: "As a favor to another actress, I made the same mistake again. Ingrid Bergman suggested *Under Capricorn*. Who could say no to Ingrid?"

SUSPICION (1941)
JOAN FONTAINE

Lina McLaidlaw (Joan Fontaine), a dowdy English lady, meets playboy Johnnie Aysgarth (Cary Grant), on a train. They fall in love and elope. After a whirlwind honeymoon and returning to a lavish house, Lina starts to discover Johnnie's true character.

He gambles wildly and has no job, hoping instead to live off of her wealthy father.

His lies become increasingly elaborate and when his friend, Beaky, dies on a trip to Paris, Lina suspects that Johnnie is the murderer. She begins to fear that he will attempt to kill her for her life insurance as he has been questioning her friend, a writer of mystery novels, about untraceable poisons.

To escape, she tells him she wants "to stay at her mother's for a few days." But, Johnnie insists on driving her. On the way Johnnie speeds recklessly and when the door to the car flings open, Lina is sure he is going to push her out. However, he stops the car and tells her he had in fact been planning to commit suicide after he had dropped her at her mother's house, but has since decided that suicide is cowardly and that he will take responsibility for his problems. Convinced, Lina tells him that they will face the future together.

For her role as Lina, Joan Fontaine won the Academy Award for Best Actress in 1941—the only Oscar-winning performance in a Hitchcock film.

Hitchcock referred to *Suspicion* as "the second English picture I made in Hollywood." He explained, "The actors, the atmosphere, and the novel on which it's based are all British." Based on the novel *Before the Fact*, by Frances Iles, *Suspicion* shared similarities with *Rebecca* as a gothic story with a timid female lead who suffers anxiety over her husband. Both films tapped into a late 1930s and early 1940s genre that depicted women who felt threatened by their own fears and insecurities.

"The Gothic woman's film, as a particular 1940s phenomenon, responded to the social changes caused by the upheavals of the Second World War," wrote film scholar Sharon Tay. It was a darker time when women were anxious over marriage, the men in their life and security in the world. Through the female's point of view we see her paranoia and passive sexual desire, and these gothic films allowed for articulation of these fears. In *Suspicion*, Lina is tortured by both the thought of her husband, Johnnie, trying to murder her, and the thought of him leaving her. Her love is consuming and obsessive, and she tells him: "I couldn't stop loving you if I tried."

As Lina becomes more fearful, the film is styled with the dark shadows of German expressionism cast across walls. Johnnie is depicted as a dark, menacing figure walking up the stairs to the tune of Strauss's "Vienna Blood Waltz," carrying a glass of milk that glows ominously from the poison it could contain (an effect achieved by placing a lightbulb inside the glass).

Joan Fontaine seemed to specialize in weak, romantic characters that were quite different from the typical Hitchcock blonde, who was cool and assured. In 1943 she starred in *Jane Eyre* opposite Orson Welles, continuing her role as an anxious, haunted character, much like in

Rebecca. Like Fontaine's character in *Rebecca*, Lina is a mousy brunette, whose hair is at first only casually styled and represents her homely, awkward qualities.

Hitchcock had initially hoped for French actress Michèle Morgan, a refugee from Nazi-occupied France, to play Lina. However, RKO Pictures was concerned about her accent and preferred Joan Fontaine, who had become a big star after *Rebecca* but hadn't appeared in a film since.

After taking a year's "sabbatical" after her marriage to Brian Aherne, Fontaine was to appear in a film called *Back Street* with Charles Boyer but refused to take the part. There was speculation that she was waiting for Hitchcock to guide her once more. While it is often thought that Fontaine had a miserable time doing *Rebecca*, she was very keen to work with the director again.

Having read a copy of *Before the Fact* with "avid interest," she wrote to Hitchcock to beg for the part. In her letter, she said: "I must do that picture, Oh, please, dear darling Hitch—I'm convinced it will be another *Rebecca* and if anything, I find my enthusiasm even greater for films . . . I am even willing to play the part for no salary if necessary! I'm sure with you at the helm I would not regret it."

Alma Reville and Joan Harrison worked on the treatment and initial script, and Samson Raphaelson was hired to complete it. Harrison and Reville were referred to as "Hollywood's only female writing team," and Hitchcock relied firmly on these two women. He insisted on their credit in the film—acknowledgment for Reville and career-furthering for Harrison. Reville described how Harrison "boiled the novel to its 'plot bones'" in a one-page synopsis, then made a rough storyline. Next, both women "batted ideas back and forth with Hitchcock, and in about two months completed the screenplay."

In the film, Johnnie is a rakish gambler, womanizer, and proven liar, and the question of whether he is capable of murder hangs in the air as he switches between hero and villain throughout the film. "My villain?" Lina's mystery-writer friend, Isobel Sedbusk, says to her. "My hero, you mean! I always think of my murderers as my heroes." This was what Hitchcock wanted—for his villain to be charming and debonair rather than monstrous.

> "I must do that picture, Oh please, dear darling Hitch— I'm convinced it will be another *Rebecca*."
>
> JOAN FONTAINE

Page 62: Joan Fontaine as weak and anxious Lina differs from the usual cool and assured Hitchcock blonde. Seen in this white overcoat with sequined motif, it appears as if the hands of fear are clasping her.

Opposite: The film's costume designer, Edward Stevenson, talks through his sketches with Joan Fontaine.

Cary Grant was excited about playing a killer, as the character is depicted in the novel, but the studio and the production code would not allow their star to be villainous. The film's ending was changed to what the studio deemed a happy ending, in which all of Lina's suspicions were paranoid, neurotic imaginings.

With the change in ending, the film needed a new title. A number of ideas were considered, including simply Johnnie, which would ensure that Grant was the star of the show. Also among the dozens of titles considered were Murder by Hypnosis, Bewitched, False Face, Death in a Dinner Jacket, and Lina Finds Her Match. Ultimately, *Suspicion* was chosen, as it reflected Lina's paranoia, rather than the idea of Johnnie as a killer.

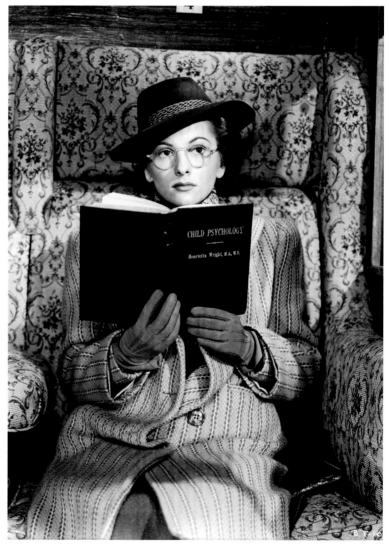

Fontaine had deep respect for Hitchcock, and hoped he would mentor her through the role. But this time he gave little feedback, leading her to feel neglected and believe that he had lost interest in her. But perhaps it was the opposite, and he was less hands-on because he trusted her skills more than in *Rebecca*, in which he saw her as "a little self-conscious," with a tendency to "overdo the shyness."

Motion Picture magazine reported that, to get Fontaine in the right mood for a scene, Hitchcock would call her "dopey," his nick-name for her, and move closer and closer to her until she was nervous enough to be in character. Raphaelson provided feedback to Hitchcock that in one scene she "should rise to an ecstasy unprecedented in the acting career of Miss Fontaine at the second beat when she fully realizes Johnnie didn't kill Beaky."

Great care was given to how the character should transform from gawky, shy waif to a more sophisticated married woman. Designing

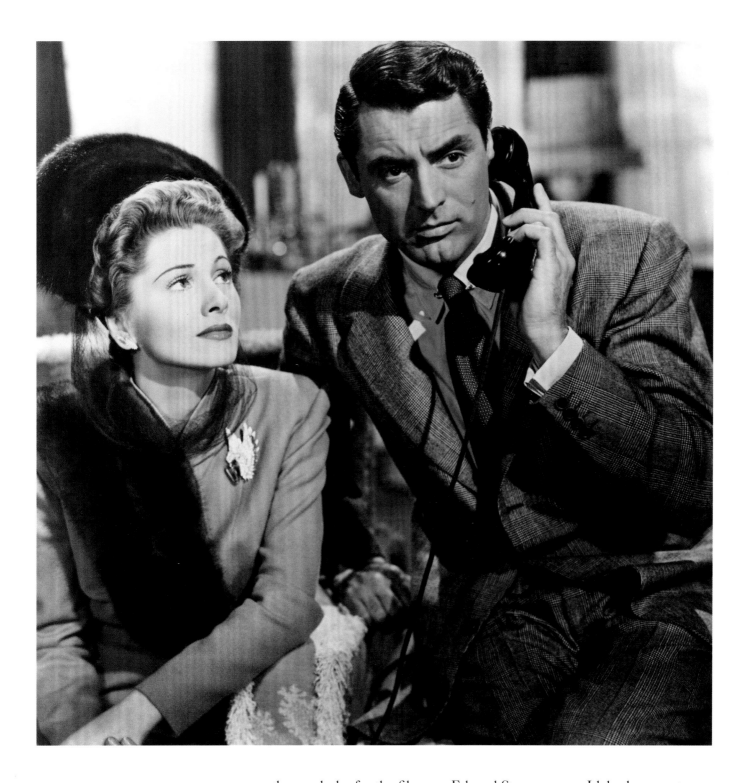

Opposite: Lina is first seen as an uninteresting girl in bulky coat, reading glasses, and brogues.

Above: Lina wears a Verdura winged bird brooch on her lapel. Bird symbols often indicate something ominous is about to happen in a Hitchcock film.

the wardrobe for the film was Edward Stevenson, an Idaho-born costume designer who began his Hollywood career as a sketch artist in the 1920s. He replaced Bernard Newman as head designer at RKO Pictures and designed for the studio's top films, including *Citizen Kane* and *It's a Wonderful Life*. A decade later he would work exclusively for Lucille Ball on her sitcom *I Love Lucy* until his death from a heart attack in 1968.

In the film synopsis, Lina was described as "a fair-haired girl with prim face, glasses, and sturdily-shod feet." Johnnie is the "ne'er-do-well

son of a noble family in the county" and at first "thinks Lina a dowdy, uninteresting girl but changes his mind a few days later at a country horse show when he recognizes a trim, habited rider, as the girl in the train."

On the train, the camera scans up Lina's body as Johnnie assesses her, from her lace-up brogues to her bulky, striped suit jacket and skirt, glasses, and hat. She is frumpy and bookish, reading up on child psychology. Like Madeleine Carroll in *The 39 Steps*, she wears reading glasses, which not only disguise her beauty, but come to represent a sexual awakening once removed. Donald Spoto said: "For Hitch, the removal of eyeglasses, of course, discloses a partially concealed beauty, but the gesture can also render the wearer vulnerable and somewhat isolated, removed from a situation. The glasses, in other words, become Hitch's modern version of the Venetian mask."

We next see her deftly riding a horse, in figure-hugging riding gear, and the camera zooms in as Johnnie is struck, unable to believe she's the same girl from the train. Her appearance, and her accessories in particular, illustrates their courtship, firstly as she takes off her glasses as soon as he arrives at her door. When we see them grappling on top of a windy hill, her handbag, according to film historian Sarah Street, is used as a Freudian device to protect her from Johnnie's advances. Rather than trying to kiss her, Johnnie claims he was only trying to fix her hair, as "it is all wrong, but it has such wonderful possibilities," and gives her a little antenna with her plait, calling her "monkey-face."

She elopes with Johnnie in the same outfit from the train, but this time the glasses are gone and she is now in heels. From a montage of travel stickers, the audience sees that they have been on honeymoon, and when she comes back, her wardrobe has changed to a beautifully tailored suit with a halo of fur. Fontaine told *Modern Screen*: "Eddie used beige as the color to give a note of lightness and gaiety. In this scene I'm supposed to be making my first entrance into my home after returning from my wedding trip. He trimmed the suit with sable to let the audience know I'm playing a woman wealthy enough to afford the very best."

It seems unlikely that Fontaine's character can go from a frumpy eternal spinster to an impeccably dressed wife, but her suits retain the

utilitarian style of the war era, when fabric was rationed. She wears a Verdura winged brooch on the lapel—a Hitchcockian bird symbol to indicate something ominous is going to happen, and in a later scene she wears a claw-like brooch over her heart.

Black becomes the predominant color of her suits and dresses as she grows more fearful. She wears a black suit with contrasting white ruffle around the neck for a tense moment with Johnnie, and after spelling out the word "murder" during a game of Scrabble, she faints and the black velvet dress spreads out around her. She is convinced that her husband means to kill his friend Beaky, but on arriving back home to find Beaky still alive, she sheds her black coat to reveal the lighter suit with geometric design.

For dinner at the writer Isobel's house, Lina wears a white, lace full-length gown, which contrasts quite beautifully with the tuxedo worn by the other female guest. The dazzling white coat Lina wears over the dress has a sequined motif on one shoulder and the waist, as if the hands of fear are clasping her, and she faints once more from the belief that Johnnie really is going to poison her.

Lina also wears a variety of extreme hats throughout the film. In a CBC television interview with Joan Fontaine in 1991, she recalled in the last car scene: "I wish I hadn't worn that silly hat, but I know why—because the hair was blowing in the wind . . . I noticed Hitchcock got that hat off as soon as possible as I got out of the car."

On release, *Suspicion* received mixed reviews, particularly for the ending, which "suddenly and unforgivably reverses all the points [Hitchcock] has been at such pains to make." However, Joan Fontaine was widely praised, with the *New York Times* calling her "one of the finest actresses on the screen, and one of the most beautiful, too." It went on to say that "her development in this picture of a fear-tortured character is fluid and compelling all the way."

Suspicion was the most profitable film of 1941 and was nominated for an Academy Award for Best Picture. Joan Fontaine was awarded the Oscar® for Best Actress in February 1942—the only actor in a Hitchcock film to ever win one. It was considered a late prize for *Rebecca*, which many believed she should have won.

Opposite top: Once married, Lina wears a beautiful tailored suit trimmed with sable to signify her new wealth.

Opposite bottom: As Lina, Joan Fontaine wore an array of extreme hats throughout the film.

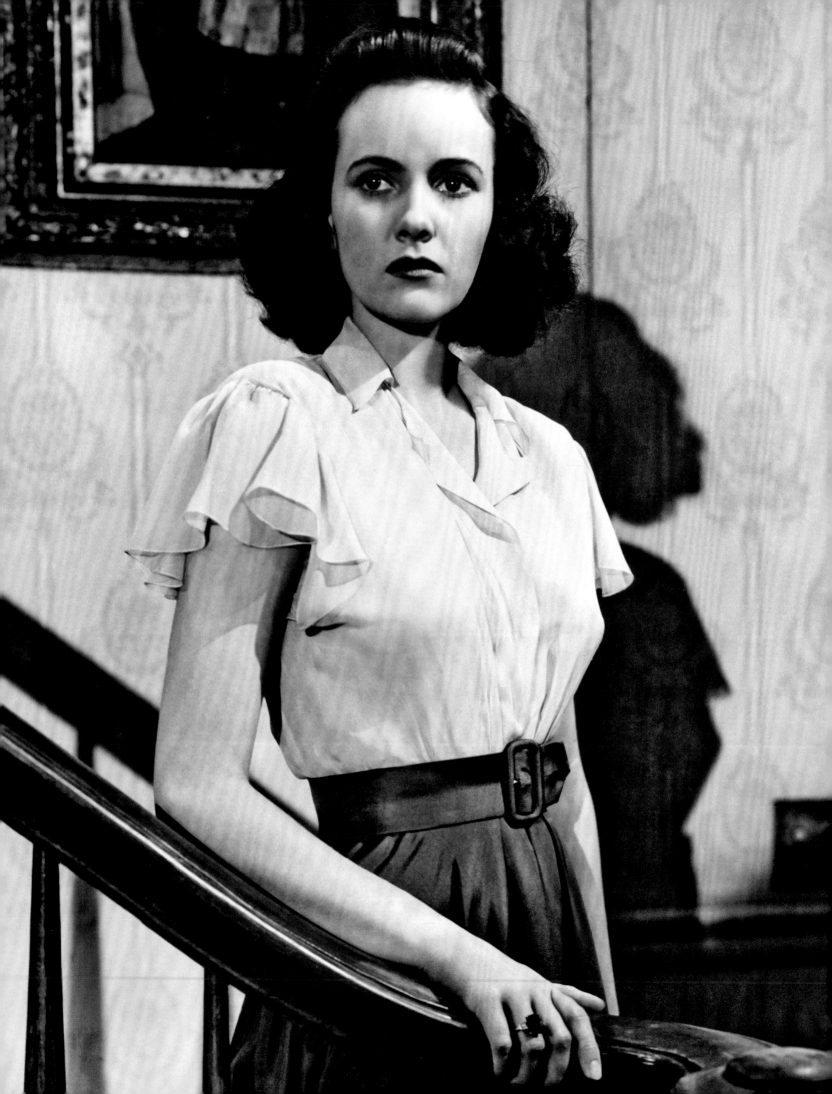

SHADOW OF A DOUBT (1943)
TERESA WRIGHT

Charlotte "Charlie" Newton is a bored teenager when her mother's younger brother (her namesake), Charlie Oakley, comes to stay.

During his stay, two men posing as national surveyors visit the family pretending to collect census information. They take a photo of Uncle Charlie which makes him angry. The younger of the two "surveyors," Jack, asks young Charlie to dinner. He then explains that her uncle is one of two suspects who may be the "Merry Widow Murderer."

Charlie initially refuses to believe him, but then Uncle Charlie starts acting strangely; initials engraved inside a ring he gave her match those of one of the murdered women. And during a family dinner he reveals his hatred of rich widows.

News breaks that the other suspect has been killed and is assumed to be the murderer. Uncle Charlie is delighted, but young Charlie knows his secrets and he cannot relax. He leaves for San Francisco, boarding a train with a rich widow, Mrs. Potter.

When young Charlie goes to see him off, Uncle Charlie tries to kill her. In the struggle, he falls in front of an oncoming train and is killed.

Charlie confesses to Jack that she withheld information that could've led to Uncle Charlie's arrest. He understands she did it to spare her mother and they both agree to keep the crimes a secret.

Shadow of a Doubt was said to be Hitchcock's favorite film.

Teresa Wright once said of *Shadow of a Doubt* that it was "the picture I have taken with me all my life. I wasn't Charlie. I was an actress. But I think maybe in some ways after that, Charlie journeyed with me all my life. More people ask me about that film than about all the others put together."

The film showed the corruption of an innocent American town and the coming of age of a bored, restless girl whose hero-worship of her Uncle Charlie is shattered by the discovery that he is a murderer. *Shadow of a Doubt* was revived in the 2013 American gothic film *Stoker*, but it couldn't match the sinister undertones of small-town America in Hitchcock's imaginings.

Similarly, Hitchcock confirmed that *Shadow of a Doubt* was his favorite film in a 1959 interview for the BBC's Desert Island Discs "because this film combined many elements: the element of suspense, the element of the local atmosphere of a small town and quite an amount of character, and also the enjoyment of having worked with Thornton Wilder."

The initial idea for the film came from the novelist husband of Margaret McDonell, head of Selznick's story department. Over lunch one day, Gordon McDonell discussed the plot with Hitchcock, and they came up with the outline of the story for him to purchase. Hitchcock then hired playwright Thornton Wilder, the author of the much-admired play *Our Town*, to complete the script and provide the color of small-town American life.

With a US wartime government cap on the cost of building movie sets, it was necessary to shoot on location, and so Hitchcock and Wilder scouted locations together throughout northern California. As a wine

lover and gastronome, Hitchcock knew Napa Valley well and had bought a home close to a small town called Santa Rosa. Built around a main square, it seemed to have the innocent, quaint American way of life that Hitchcock appreciated as an outsider to the United States. Hitchcock didn't want his town to look too old-fashioned; instead he wanted it to be very modern, with influence from "movies, radio, jukeboxes, etc. In other words, life in a small town lit by neon signs."

With Thornton Wilder having enlisted in the army, three female writers contributed further to the dialogue and characterization. Hitchcock hired Sally Benson, writer of *Meet Me in St Louis*, for her sympathetic touch in her writing for children. Alma Reville also contributed, and Teresa Wright confirmed that Patricia Collinge, the actress who played her mother, helped rewrite the dialogue for the love scene in the garage when Hitchcock was unhappy with it. Collinge was a writer as well as an actress, and while uncredited for this, she contributed to the script for *Lifeboat*, the following year.

Hitchcock initially had Joan Fontaine in mind to play the smart, complicated Charlie. He sent a wire to her Pebble Beach home in June 1942 that read, "Dear Joan, do you want to play the lead in my next—confidentially S [Jack H Skirball, producer] does not know I've telegraphed you, love Hitch." However, when she was unavailable, Thornton Wilder suggested Teresa Wright, who had played Emily in his stage play *Our Town* and who was signed to a five-year contract with Samuel Goldwyn. She played girl-next-door types, small town innocents and loyal sweethearts.

"I'm no sweater girl and I know it. I just want to be an actress," she was quoted as saying, mirroring Charlie, who is told she is "an ordinary little girl living in an ordinary little town." It was right for the character that Charlie was a brunette, as she was serious and brooding, the smartest girl in her class and also protective of her family. Brunettes, for Hitchcock, were often linked closely to home and were less frivolous than his blondes.

Wright insisted on a unique clause with her Goldwyn contract where she refused typical "cheesecake" shots of posing in a bathing suit or shorts, and "playing with a cocker spaniel . . . holding skyrockets for the fourth of July . . . wearing a bunny cap with long ears for Easter,"

"I'm no sweater girl and I know it. I just want to be an actress."

TERESA WRIGHT

Page 70: Teresa Wright in a key scene from *Shadow of a Doubt*. The ring she wears sparks fear in her uncle and forces him to leave.

Opposite: Teresa Wright with Hitchcock on the set of *Shadow of a Doubt*. He considered her one of the most intelligent actresses he worked with.

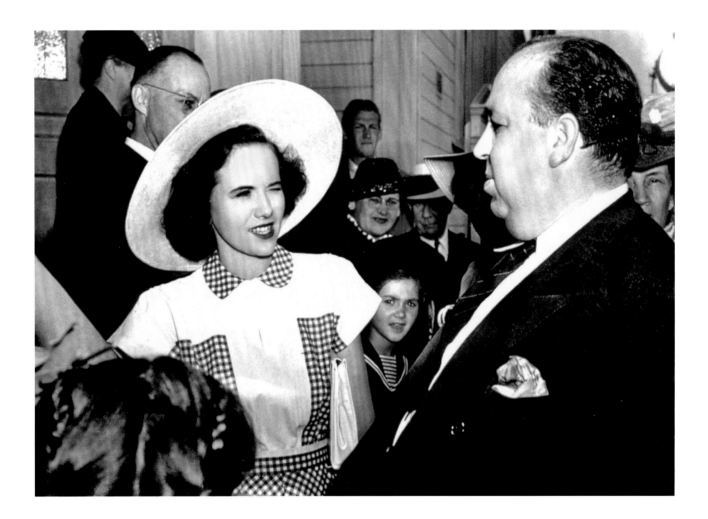

among others. *Photoplay* in 1943 wrote of her: "Teresa Wright is not the most beautiful girl in the world, nor in Hollywood either. She is not gorgeous like a Petty peach, or voluptuous a la Venus. She is just a pretty, dainty, typical American girl with green eyes, loose dark hair, and a swell smile, who can act like nobody's business."

In 1942, Wright had recently completed a number of plays and films in quick succession—plus she was newly married and was setting up home with writer Niven Busch—but the offer of a Hitchcock film was too appealing to turn down. She met the director in late June to discuss the film, but rather than give her an audition, he talked her through the whole story, from every sound effect to every action of the characters. She said he "described it as if he were seeing it in his mind. The way I think of him is that he had a little projection booth up in his head. On the set, he never raised his voice. I never felt any tension. He would tell

TERESA WRIGHT

The only actor to be nominated for an Academy Award for their first three films, Teresa Wright was an intelligent and charming actress who refused to be defined by her looks. Born Muriel Teresa Wright in 1918 in New Jersey, she moved to New York in 1938 to pursue acting, winning a stage role in Thornton Wilder's *Our Town*. After seeing Wright in *Life With Father*, Samuel Goldwyn signed her up. Her debut movie role was in *The Little Foxes*, opposite Bette Davis, followed by *Pride of the Yankees* and *Mrs. Miniver*. While *The Best Years of Our Lives* director William Wyler called her the most gifted and promising actress of her generation, Wright's refusal to be the glamour girl eventually led to Goldwyn terminating her contract in a highly publicized row. In the 1960s she returned to Hitchcock with parts in two episodes of *The Alfred Hitchcock Hour*. She was married to Niven Busch for ten years, and in 1959 married playwright Robert Anderson, divorcing in the 1970s. She died in 2005 at the age of eighty-six.

Opposite: Teresa Wright, in a costume designed by Gilbert Adrian, wears two bird brooches on her lapel. Hitchcock's heroines often wore bird motifs during moments of tension, warning of impending danger. The two brooches also signify the twinning of the Charlies.

you what he wanted without too much instruction, and you would know exactly what to do."

According to Donald Spoto, just before Wright went to do a scene, Hitchcock would whisper obscene comments to her about being a "young bride on a honeymoon," as a way of creating tension before a difficult scene. But Wright publicly remembered instead the family atmosphere and the word games they would play and puns they would make between takes.

"There was very much a family feeling," recalled Wright. "When you are on location you are much closer to each other than when you are in the studio, coming from your own home to work. All of that lent itself to the film. A lot depends on things that go on behind the scenes." On the weekends in Santa Rosa, Hitchcock held dinners at the Occidental Hotel for his selected guests, where he oversaw the menu and insisted on martinis beforehand.

Hitchcock considered Wright one of the most intelligent actresses he worked with, helping her to bring warmth and strength to the role of young Charlie. In the film, Charlie is suffering from teenage angst and bored of her small town life. "How can you talk of money when I'm talking about souls?" she tells her father. But, once her uncle comes to stay, she becomes fearful, like Lina in *Suspicion*, that her loved one holds a dark secret. Teresa doesn't overdo the sweetness of the character but reflects the growth of a girl as part of a coming-of-age drama, as well as a thriller.

While Vera West, head designer at Universal, created costumes for the other cast members, Teresa Wright's gowns were designed by Gilbert Adrian. It was common for a contract leading actress to have her costumes specially designed and would have been insisted on by Samuel Goldwyn. Adrian, the former head designer at MGM, utilized some of his key touches such as a block-colored geometric design on dresses, padded shoulders on military-style jackets, large buttons, and unusual collar detail. Charlie's costumes reflected a fashion-conscious young woman with romantic touches, and owed a similarity to costumes Adrian designed for Katharine Hepburn in *The Philadelphia Story*. The dress Charlie wore in the church scenes, with gingham Peter Pan collar and skirt, even shared the same fabric as a gingham dress worn by Hepburn.

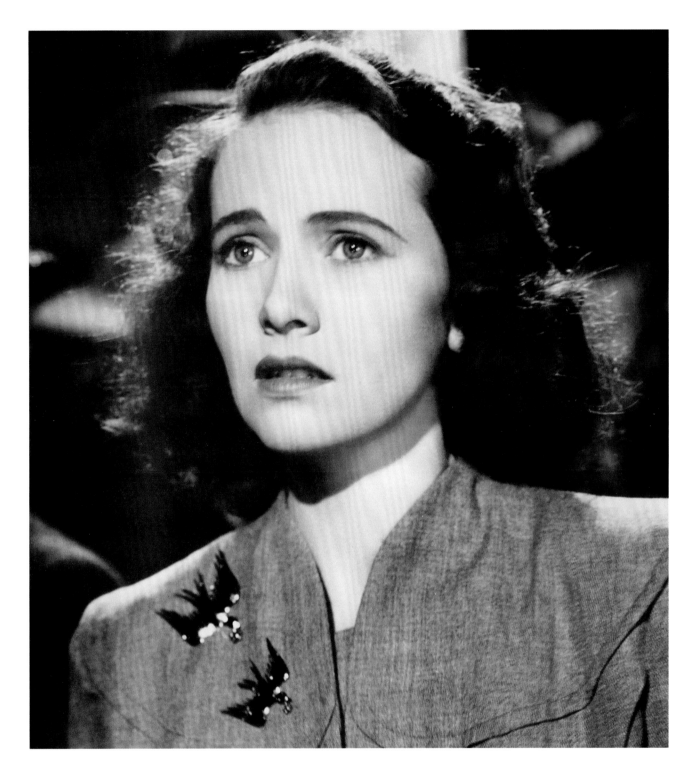

She also wore a pale, floor-length organza gown with lace detail, which her uncle admired and bought for her, and for the dramatic scene in the garage, a long skirt with deep pockets, worn with a blouse.

When she goes for dinner with the detective and he reveals the truth to her about her uncle, Charlie wears two bird brooches on her lapel. Hitchcock heroines often wore bird pins during moments of tension, but

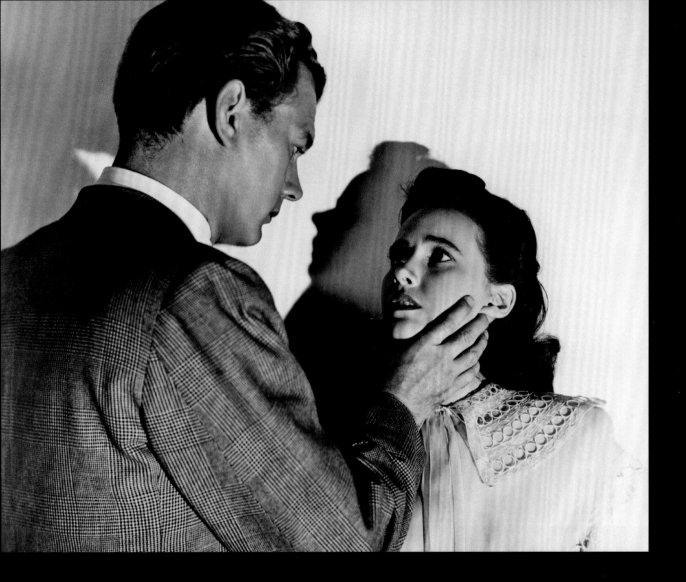

the use of two represented the twinning of the two Charlies throughout the film, such as the mirrored poses of both lying on their beds in the opening scenes.

There are hints at an incestuous relationship, such as her uncle placing the widow's ring on her finger, but like the "doppelgängers of German expressionism," it is more of a psychic bond, where Charlie has the "Merry Widow Waltz" going around in her head. This music was used throughout with the image of spinning dancers to remind us of the Merry Widow Murderer. Hitchcock said, "All the irony of the situation stemmed from her deep love for her uncle . . . the girl will be in love with her Uncle Charlie for the rest of her life."

face is set in fatigue and bitterness." The dandyish looks and charming personality contrast with a bitter misogynist and misanthrope, who speaks with hatred of the "faded, fat, greedy women" living off their husbands' money, and tells his sister, "Women are fools. They fall for anything."

Hitchcock called Uncle Charlie "a killer with an ideal; he's one of those murderers who feel that they have a mission to destroy. It's quite possible that those widows deserved what they got, but it certainly wasn't his job to do it . . . Uncle Charlie loved his niece, but not as much as she loved him. And yet she has to destroy him. To paraphrase Oscar Wilde: You destroy the things you love."

Hitchcock's films are often seen to reflect patriarchal order, where women are subject to violence. Feminist scholar Diane Carson argued that *Shadow of a Doubt* depicted women stuck in a world of domestic tyranny against which they are unable to rebel. Even the widows are murdered as punishment for breaking free and enjoying their lives without men.

But young Charlie can be seen as a feminist figure. Her uncle tells her: "You're the head of the family, Charlie, anyone can see that," and she becomes the enforcer by threatening and blackmailing her uncle to leave town. Both Charlies need to kill the other in order to protect their family's romantic illusion of Uncle Charlie's goodness.

Charlie's most powerful moment comes when she walks down the stairs with the emerald ring on her finger. As Sabrina Barton writes in her essay "Hitchcock's Hands": "Women on staircases in 1940s gothics tend to appear either as visual objects or as non-credible investigators soon to be victimized." But for Charlie, the ring catches her uncle's eye and causes such fear that instead of staying in town, he announces he will be leaving.

Shadow of a Doubt contains strong family themes and was quite personal to the director. Young girls in Hitchcock's films were often smart and in glasses, bearing a resemblance to his beloved daughter. Charlie's mother, Emma, shared the same characteristics as Hitchcock's own mother, also named Emma: Both were warm and trusting characters and with a habit of shouting down the telephone. Hitchcock said: "I suppose that if we think about a character who is a mother, it is natural to start with one's own. The character of the mother in *Shadow of a Doubt*, you might say, is a figment of my memory."

Opposite: The two Charlies. Teresa Wright as young Charlie and Joseph Cotten as Uncle Charlie.

Above: Teresa Wright (L) prepares to film a scene from *Shadow of a Doubt*. Filmed on location in Santa Rosa, it was cited by Hitchcock as his favorite film.

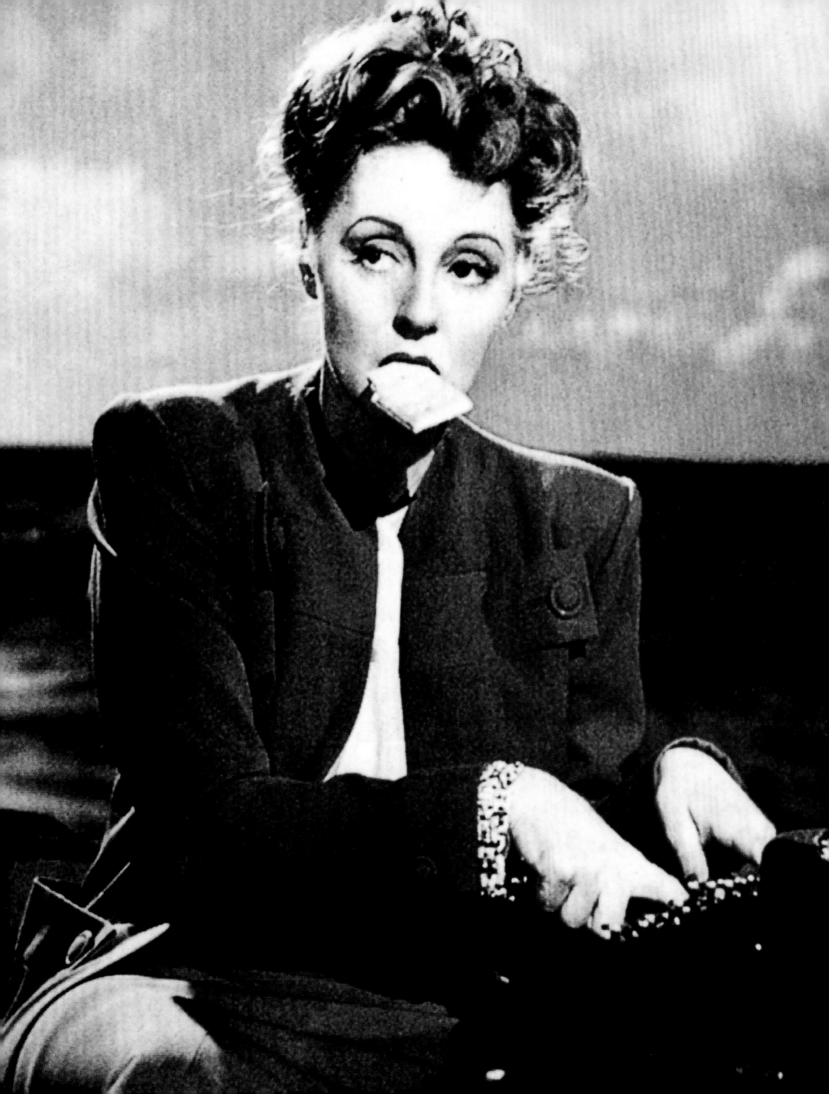

LIFEBOAT (1944)
TALLULAH BANKHEAD

Connie Porter (Tallulah Bankhead) is a newspaper columnist who is the first one aboard a lifeboat following combat between the ship she was on and a German U-boat. She has managed to bring all her luggage, including a typewriter, mink coat, and diamond bracelet and initially her only concern is a run in her stockings. More survivors join her, including Kovac (John Hodiak) who thinks another man, Willi (Walter Slezak)—a German survivor—should be thrown overboard as he suspects he is the captain of the U-boat. However, the other survivors persuade him to let him stay.

As they plot their course to Bermuda, Kovac takes charge, rationing their food and water. But during a storm Willi wrestles control away from him and changes the boat's course to a German supply ship. The lifeboat inhabitants become increasingly desperate and dehydrated. When they discover that Willi is sweating they find a hidden flask of water on him and he is thrown overboard.

The German supply ship they have been heading for is then gunned down by allied forces. A frightened German seaman is pulled aboard the lifeboat and the surviving passengers debate whether to keep him aboard or throw him off.

Lifeboat is the first of Hitchcock's "limited-setting" films and was shot in a huge water tank at 20th Century Fox. It is his only film for them. Production was plagued by illness with Tallulah Bankhead suffering two bouts of pneumonia while filming.

"Isn't a lifeboat in the middle of the Atlantic the last place one would expect Tallulah?" Hitchcock once asked of his lead actress in the claustrophobic World War II survivor story *Lifeboat*. "It was the most oblique, incongruous bit of casting I could think of."

On his trips across the Atlantic by boat and plane Hitchcock had thought about the fate of people stranded at sea, with German U-boats often torpedoing ships. Hitchcock had a complicated relationship with Germany: He had been shaped by German cinema in the 1920s, but he hated the atrocities carried out during the two wars and was scared for the safety of his family during the London Blitz. *Lifeboat* was an allegory of Germany, with the U-boat captain as the deceitful, strong force of the Nazis. Hitchcock also liked the technical and visual challenge of shooting in a confined space, and the idea of how survivors would react to being stranded together in danger.

John Steinbeck wrote the initial novelette on which the film was based, with writers including Jo Swerling and Alma Reville tightening the story up for film. In a meeting with Steinbeck, Hitchcock outlined the story, and he had one clear detail: The wealthy lead female character would have a piece of diamond jewelry that could be used as a fishing tackle.

Once Steinbeck had completed his novelette, the Hitchcocks met with him in New York to discuss the story further over dinner at The 21 Club, but Steinbeck was heading overseas as a war correspondent and seemed unwilling to make changes. Hitchcock guided the story through multiple rewrites with many different writers, including Alma Reville and Patricia Collinge (of *Shadow of a Doubt*), until he felt he had something cinematic. While the final product was very different from Steinbeck's vision, he was still credited as the original writer, with Jo Swerling as screenwriter.

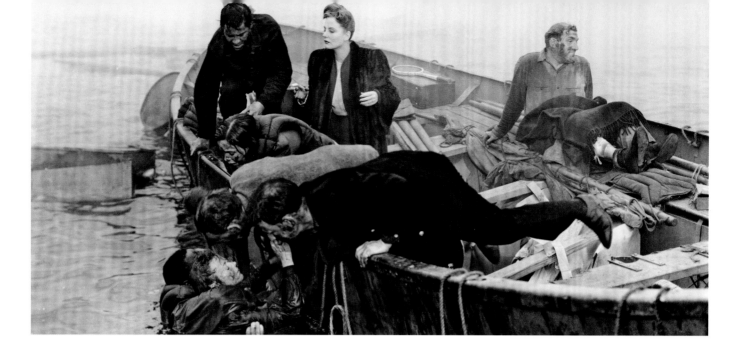

In terms of casting, Hitchcock hoped for Gary Cooper or Henry Fonda as the moral compass of Kovac, but settled for John Hodiak, a cheaper unknown. Mary Anderson, who had a small role in *Gone with the Wind*, was the Red Cross nurse Alice, while Hitchcock's good friend Hume Cronyn was also cast. Cronyn recalled: "The notion that Hitch was not concerned with his actors is utterly fallacious. I never knew how actors and people could say that. For *Lifeboat*, we began by sitting around a table for days in long read-throughs, as we would do in the theater," but "he expected us to know our jobs. That was why he had hired us. I don't consider that being unconcerned with your actors."

Hitchcock knew from the start that he wanted forty-one-year-old Tallulah Bankhead, who had made a comeback on Broadway as an immortal temptress in *Skin of Our Teeth*. He was aware that she had played Alice in *Blackmail* on stage, and he admired her as a legendary actress and humorist. She was offered $75,000 for the part—accepting her first film role in eleven years as she needed the money for home renovations. "Mr. Hitchcock is the largest screen director alive," wrote Tallulah in her auto-biography. "For all I know he may be the best. He has the equipment for his job. He learned it the hard way, through trial and error. He directed the first two good pictures turned out in English studios: *Blackmail* and *Murder*. *Blackmail* was that stinker in which I played in London. In making a first-rate film of it, Hitchcock displayed something akin to genius."

Southern belle Tallulah was sharp-tongued and a great wit, and by the time of *Lifeboat* her voice was husky and whisky-soaked, delivering her lines with great authority, particularly when speaking and translating German. "She gave a good performance, almost rivalling some of her stage successes. The screen almost captured her emotion and her temperament," wrote *Picturegoer*.

"She gave a good performance, almost rivalling some of her stage successes. The screen almost captured her emotion and her temperament."
PICTUREGOER 1945

The character of Connie Porter grew from Steinbeck's novelette in the script redrafts to replace Kovac as the main character. Steinbeck described Connie Porter as a onetime stage actress who was "kind of pretty when she's fixed up," but Hitchcock, Alma, and Jo Swerling changed her to a cynical newspaper reporter at the top of her game, who calls people "dah-ling"—a Tallulah Bankhead signature—and is in control of her own sexuality.

Connie Porter was believed to be based on Elizabeth Japp Fowler, an American who was cast onto a lifeboat after the ship she was traveling on in 1942 was torpedoed. She had to suffer cold, hunger, and the threat of sharks, but what she was most upset about was the loss of her Burberry coat. The glamour of Connie became the focus of Swerling's opening scenes, whereas Steinbeck chose realism in his description of Connie completely covered in oil from the torpedoed ship.

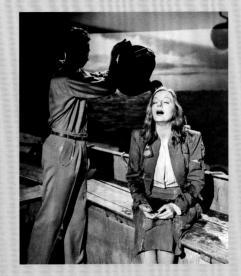

"She's a kind of blonde, but you couldn't tell that until later because she's so covered with oil now. Her hair's all full of oil and hangs down around her shoulders," he wrote. Swerling included precise descriptions of her costume—a Revillion Freres mink coat, a Hattie Carnegie suit, an alligator-skin case, a Mark Cross purse (the same label as Grace Kelly's in *Rear Window*), a Tiffany gold cigarette case, a Dunhill jeweled lighter. These are the elements a sophisticated, wealthy woman would possess.

The camera pans over the wreck of the ship until we come to focus on Connie, alone in the lifeboat, and looking immaculate but bored. "Connie, did you come from the freighter or the Stork Club?" asks one of the passengers as they clamber on board. More concerned about creating news with her Brownie 16mm camera than the human cost of the torpedoed ship, she complains of the ladder in her stockings, the busted clasp on her bracelet, the broken fingernail, and her camera being knocked into the sea. Connie is one in a line of haughty Hitchcock heroines who unravel on screen—Melanie in *The Birds* also sits poised on a boat in a fur coat, yet by the end of the story she is broken, bandaged, and bloody. By the end of *Lifeboat* Connie has lost all her possessions, as her typewriter, which traveled around the world with her, also goes overboard, as do her coat and bracelet. Connie gives the mother character her mink coat to keep warm. "It's a beautiful coat, is it real mink?" asks

Page 78: Tallulah Bankhead as Connie Porter seen here with her typewriter and diamond bracelet; two of her possessions that end up overboard.

Opposite: The character of Connie was believed to be based on Elizabeth Japp Fowler—an American who was cast onto a lifeboat after the ship she was on was torpedoed.

Above: Tallulah is given a soaking on the set of *Lifeboat*. She caught pneumonia twice.

TALLULAH BANKHEAD

The famously uninhibited Tallulah Bankhead, known for her husky voice and shocking wit, was born in 1902 in Alabama to a politically active family. At fifteen, she moved to New York after winning a competition with *Picture Play* magazine. She soon became entrenched in the nightlife and as part of the elite, artistic Algonquin Round Table group. She shocked with her stories of alcohol, cocaine, and lesbianism. Her wild reputation followed her when she moved to London, where she became the toast of the West End stage, most famously with *The Dancers*. She moved to Hollywood in the 1930s, but failed to repeat her stage success until 1939 with Lillian Hellman's *The Little Foxes*. After winning acclaim for *Lifeboat*, she had further success throughout the 1940s, particularly with her Broadway revival of Noel Coward's *Private Lives*. Such was her fame that Tallulah became a caricature of herself, and Bette Davis famously based the character of Margo Channing in *All About Eve* on her mannerisms. Her addictions impacted her health, and Tallulah died in New York in 1968, at the age of sixty-five, from pneumonia.

Opposite: *Lifeboat* was filmed in a huge water tank and used water spray and wind machines to create the seascape and storms. Much of the cast caught colds with Tallulah suffering two bouts of pneumonia.

the young mother, stroking it. "I've always admired mink. It's the most ladylike fur there is . . . so warm, and comfortable." When she realizes her baby has died and was given up to the sea, she drowns herself, taking Connie's coat with her.

The diamond bracelet is precious to Connie, as it transformed her life when she was given it fifteen years before. It was "my passport from the stockyards to the gold coast, it got me everything I wanted, up to now," she said. "I wouldn't take if off for anything." The practical German sees it as just a piece of carbon, and Connie eventually sacrifices it for survival so that they can use it as bait to catch fish.

One interesting line in the film addresses the issue of "the right kind of woman," as opposed to the "easy" woman. Gus is worried that his girlfriend, who loves to jitterbug, will leave him because his leg is amputated. But Connie reassures him: "I know women. Some of my best friends are women. And one of them is that kind of a . . . well, an independent creature who lives her own life, with a heart of gold. And she gives it away." Connie herself is cool, unphased, and cynical. She's an older woman who is still sexual, completely able to be casual when it comes to kissing Kovak, writing on his chest with lipstick, splaying herself over his lap as if unconcerned for their predicaments.

The wardrobe was designed by Fox Studios' Swiss costume designer René Hubert. While each character only had one change of clothes, multiple versions of each costume were required because of the different stages of wear and tear each outfit went through. The costumes reflected the utilitarian nature of the Second World War where characters were dressed in uniform, and even Connie Porter's tailored suit followed wartime austerity.

Lifeboat was filmed in a huge water tank on the 20th Century Fox backlot, where the seascape and storms were created with the use of back projections. The cast had to climb up ladders on the side of the tank to get into the lifeboat. It was an uncomfortable shoot, with the cast subjected to wind machines, soakings from water spraying machines, and then drying under hot lights. It was no surprise when they came down with colds during filming, but for Tallulah it was worse—she caught pneumonia twice. The *New York Times* in December 1943 interviewed a pale Tallulah, "still recovering from an illness brought on by a sixteen-

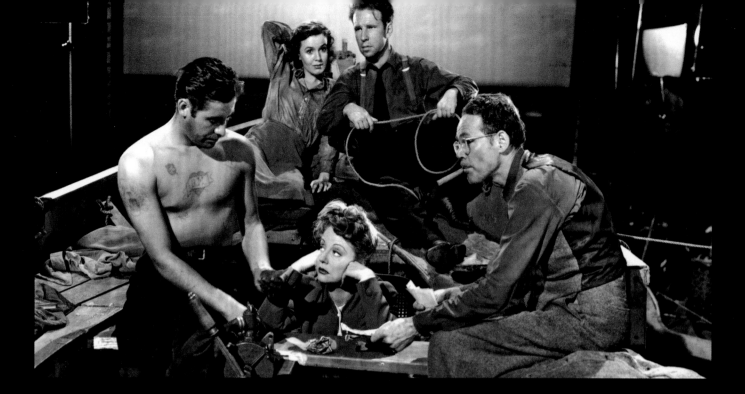

week stint in *Lifeboat*. But even as a convalescent, Miss Bankhead still packs nearly as much explosive energy as a two-ton blockbuster."

Tallulah liked to drink, was witty, and had the mouth of a sailor—just the kind of woman Hitchcock enjoyed spending time with and they were on good terms. Hitchcock may have been obsessed with the glacial beauty of Tippi Hedren and Grace Kelly, but the women he liked and got along with best, Carole Lombard, Bankhead, were strong characters who shared his sense of humor. "She had no inhibitions at all. Now some people can take this, others can't," said Hitchcock of Tallulah, who was known to strip down in front of people and to go to the bathroom with the door open. He admired her humor and the way they could equally compete with their telling of filthy jokes.

Bankhead spoke highly of Hitchcock and when he gave her a Sealingham dog as a gift during the making of *Lifeboat*, she named it Hitchcock. Asked by the BBC in 1964 if *Lifeboat* was miserable to film because of the cramped, uncomfortable filming conditions, she said: "Not at all. It was divine. Because Hitchcock was so divine. Every Saturday night I'd dine with him and his wife Alma and Patricia, his daughter, who was darling, and I was very happy with that."

As unconventional as Tallulah was, one story in particular was recounted by many involved in the film. When the actress would climb up the ladder on the water tank to get into the lifeboat, she would hike up her dress to avoid it getting wet. But she preferred not to wear any underwear underneath, and exposed herself to everyone below. A journalist from *Good Housekeeping* was on the set one day, and when she caught full sight of Tallulah, she was so outraged that she complained to the front office. Hitchcock was told to speak to Tallulah, but not wanting to get himself involved, he suggested that perhaps the hairdressing department might be able to help. In the end, no one had the nerve to tell the actress to wear her underwear.

The film was not a success, and it took double the allotted time to make, but Hitchcock was nominated as Best Director at the Academy Awards. Tallulah was praised for her performance and was rewarded by the New York Film Critics Circle, which named her the Best Actress of 1944. She later commented in her autobiography: "Did I get an Academy Oscar? No! The people who vote in that free-for-all know on which side their crêpes Suzette are buttered. I wasn't under contract to any of the major studios, hence was thought outlaw."

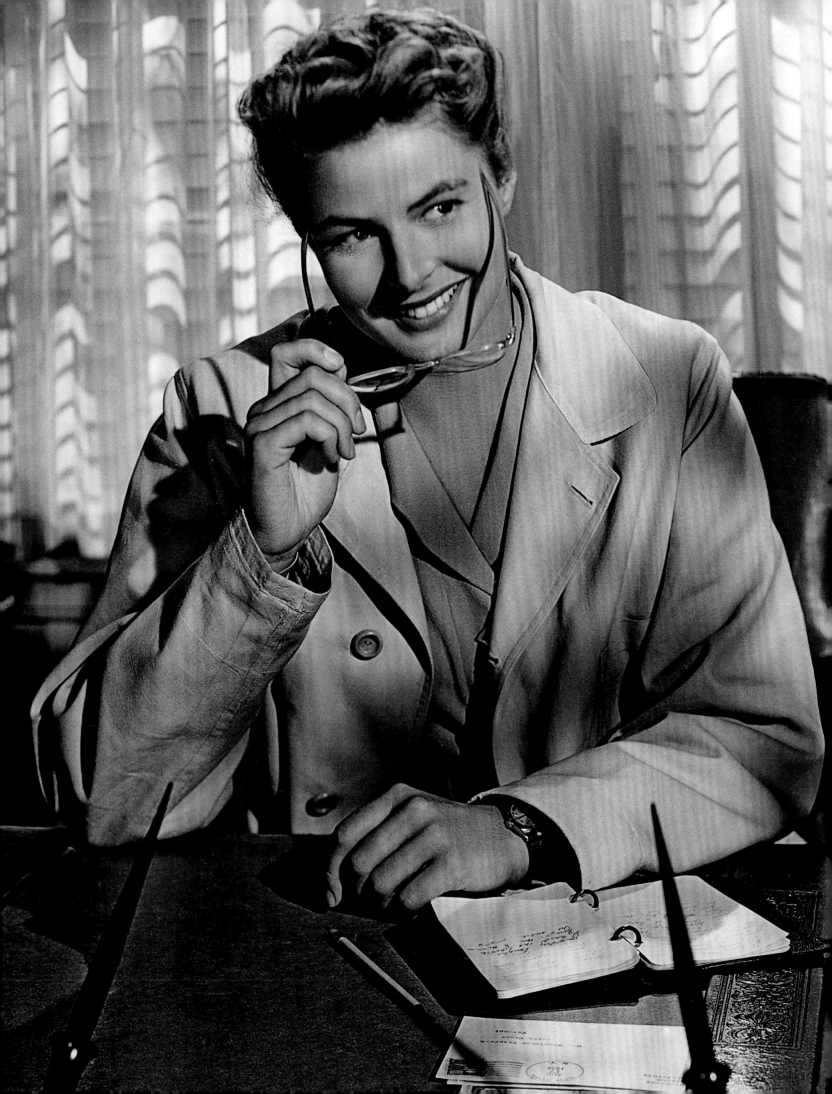

SPELLBOUND (1945)
INGRID BERGMAN

Dr. Constance Petersen (Ingrid Bergman) is a psychoanalyst. The director of the hospital (Dr. Murchison) where she works retires, and a young "Dr. Edwardes" (Gregory Peck) replaces him.

Petersen discovers that Edwardes has a peculiar phobia of parallel lines on a white background. She also realizes that he is an imposter and not the real Dr. Edwardes. He confides to her that he killed the real Dr. Edwardes but he has amnesia and Dr. Petersen believes he is innocent and suffering from a guilt complex.

She uses her psychoanalytic training to analyze a dream of his and discovers that he knew the real Dr. Edwardes. They went skiing together, but somehow Dr. Edwardes died. Petersen and the man (now calling himself John Brown) visit the ski resort and he remembers that Dr. Edwardes fell to his death from a precipice. This, combined with a traumatic childhood event, has resulted in his guilt complex. He also remembers his real name, John Ballantyne.

Ballantyne is about to be exonerated, but then a bullet is discovered in the body of Edwardes and instead he is convicted of murder and sent to prison.

Returning to the hospital, Petersen discovers Dr. Murchison is once again the director. He lets slip that he didn't like Dr. Edwardes and Petersen deduces that it was him who shot Edwardes. She confronts him and he threatens to shoot her. She reminds him that he will face the electric chair if he does, so he allows her to leave but then turns the gun on himself.

Like Alfred Hitchcock later in his career, David O. Selznick wanted to create a star. When he signed Swedish actress Ingrid Bergman to a personal contract in 1938, he toyed with the idea of completely transforming her, as was common practice for starlets in Hollywood. But Bergman refused to have her teeth fixed, her eyebrows plucked, and her name changed. Instead, Selznick came up with a novel idea: She would be "the first natural actress" and he wouldn't change a thing.

Bergman was walking through Selznick's studio one day when Hitchcock noticed her and remarked that she would be good in his next picture. She and Hitchcock were Selznick's two most valuable assets, and he supported the idea of them working on a film together.

Selznick thought an adaptation of H. Rider Haggard's *She* "could be something sensational in Technicolor with Ingrid . . . half fantasy and half melodrama," he wrote to Hitchcock in 1944. But attention turned to *The House of Dr. Edwardes*, a 1920s novel about an asylum for which Hitchcock had bought the rights. This idea particularly appealed to Selznick, as he was seeing a psychoanalyst at the time, which was a new fashion for rich Americans. While the original story was a surrealist tale of a madman taking over an asylum, Hitchcock wanted his version to be a love story with thrills. "I wanted to do something more sensible, to turn out the first picture on psychoanalysts."

Ben Hecht, known as the Shakespeare of Hollywood, took over scriptwriting from Angus MacPhail, a friend of Hitchcock's. Hecht was equally enamored with Freudian dream analysis. The director and writer visited mental hospitals in New York to create a script that brought together social anxiety and loneliness with dream analysis and new forms of psychiatry. It was a romantic, psychological thriller that was ahead of its

time, although Hitchcock dismissed it as "just another manhunt story wrapped up in pseudo-psychoanalysis."

Hitchcock and Bergman developed a strong and intense friendship from their first meeting. Donald Spoto called it an "acute, unrequited passion," but it was mutual respect, and both saw each other as outsiders who were locked in contracts with Selznick. Bergman said that Hitchcock created the impression that he didn't have much time for actors, with his well-quoted "actors are like cattle" line, but for Hitchcock the fun was in the preparation, the planning, the writing, and creating of his vision.

"He doesn't much talk about acting," she said.

revolutionary—when many other actresses didn't have that opportunity. She was considered to be one of the most talented of actresses and Selznick frequently loaned her out, allowing her to choose her roles, whereas other contract players were given less choice. The part of psychoanalyst Constance Petersen was just right for Ingrid as, like the actress herself, it was a character who wasn't fussed with wearing makeup or fancy clothes. But Bergman struggled with the logic of a highly intelligent, analytical doctor falling in love so quickly and willingly throwing away all that she had studied and worked so hard for. "Love isn't logical," Hitchcock

"He doesn't talk much about acting. I think he chose Grace Kelly and Tippi Hedren because of what they looked like, the same with me." INGRID BERGMAN

"I think he chose Grace Kelly and Tippi Hedren because of what they looked like, the same with me." Bergman had light brown hair rather than blonde, and her height required many of her leading men to wear elevated shoes—but she quickly became Hitchcock's perfect muse. She was relaxed and dedicated, and she enjoyed good food and a martini. Hitchcock invited Bergman and husband, Petter Lindström, to his new home in Bel Air, California, before shooting began. "I had the impression that Hitch was very exclusive and chose his friends very carefully. Cary Grant was there, and Teresa Wright and her husband . . . Hitch didn't mingle a lot with people—he was polite, but I think there was a little bit of the snob in him, and a fear of social rejection, too."

Bergman enjoyed being able to play many different roles—from Joan of Arc to a nun to a

reminded her. He also gave her the advice that she felt was the most valuable to her: If she didn't believe it, then "fake it, Ingrid. It's only a movie."

Dr. Constance is dressed in a doctor's white overcoat for much of the film, and her costume suits the practical character. Howard Greer was uncredited for his work designing her wardrobe, and while he was one of Hollywood's top designers, the clothes couldn't be too showy.

A conservative dark suit and beret are worn as she goes on her journey to discover the truth about Dr Edwardes, while a dressing gown was designed to have vertical lines on a white background, which serves to trigger John Ballantyne's flashback of the skiing incident.

After viewing costume designer Howard Greer's initial sketches, Selznick was dissatisfied. He felt

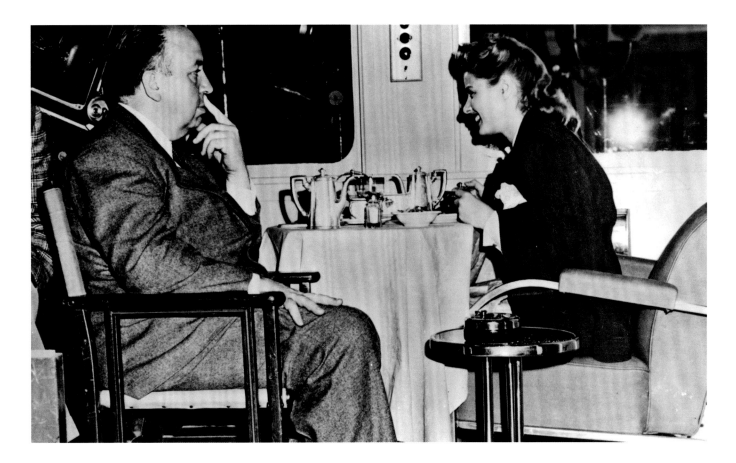

they didn't suit the character, who was in her late twenties, disinterested in frivolity and romance, and devoted completely to science. Clothes had to match the budget of a woman in her first year as a member of staff, yet she was also to have pride in her appearance and look groomed. "Let's not have her dressed as though she were a movie star, either as to the richness of the costumes, or as to the way in which hopefully they have been tailored," said Selznick. "And please be sure that the clothes are reasonably aged before they are worn in the film."

In the film, Petersen suffers through insults to her gender, advisement to loosen up as a woman, and when she falls in love, being told by her mentor: "We both know that the mind of a woman in love is operating on the lowest level of the intellect."

Page 84: Ingrid Bergman as Dr. Constance Petersen in *Spellbound*.

Above: Hitchcock with Ingrid during the filming of *Spellbound* on the set of the train. They developed a close friendship.

Initially, Petersen has no intention of taking off her glasses, letting her hair down, and being seduced by her work colleague. But she is immediately drawn to this "Dr. Edwardes," and her hair becomes undone throughout the film, particularly as they go for their countryside walk.

Hitchcock was very patient with Bergman on set, going through the character and hosting a party to celebrate her wedding anniversary on the first day of shooting in July 1944. Gregory Peck, who was very new to acting at this point, felt he was left to develop his role on his own. When he asked Hitchcock what his character's motivation was, Hitchcock replied, "Your salary."

Hitchcock, according to Peck, was constantly nodding off, but when he woke up he seemed to know "exactly what was going on." Peck recalled, "He had the entire picture in his head, in his mind's eye. Every shot and every frame was rolling through his head."

Hitchcock used the camera to swirl around Peck and Bergman, indicating their hypnotic love affair, and lit

INGRID BERGMAN

Winner of three Oscars, two Emmys, four Golden Globes, and a Tony Award, Ingrid Bergman acted in German, Swedish, American, Italian, and French films.

Born in 1915 in Stockholm to a German mother and Swedish father, Ingrid Bergman lost both her parents at a young age and was passed on to different relatives throughout her childhood. After attending drama school in Stockholm she won leading roles in Swedish films. David O. Selznick, impressed by *Intermezzo*, signed her for a Hollywood remake and she moved to Los Angeles with doctor husband Petter Lindström and daughter Pia. With roles in *Casablanca*, *Gaslight*, and *Joan of Arc*, she became the most popular star of the 1940s, considered a dutiful wife and mother.

But when she left her family for Italian director Roberto Rossellini, she moved to Rome and raised three children, including actress Isabella Rossellini.

She made a triumphant Hollywood comeback with *Anastasia* (1956). After divorcing Rossellini, Bergman moved to Paris and alternated between European and Hollywood films and stage roles. Bergman died from cancer in 1982 at the age of sixty-seven.

Bergman with warm lights to show her falling in love. He also included details such as seven doors opening after their first kiss, as the preface tells us psychoanalysis is a means "to open the locked doors of the mind."

Hitchcock had admired 1929's surrealist film *Un Chien Andalou*, designed by Salvador Dalí and directed by Luis Buñuel, and he wanted Dalí to create the dream sequence for *Spellbound*. Hitchcock wrote to Angus MacPhail in a telegram: "Girl to discover all details of her man's past and eventually lead her to the ski run through interpretation of a

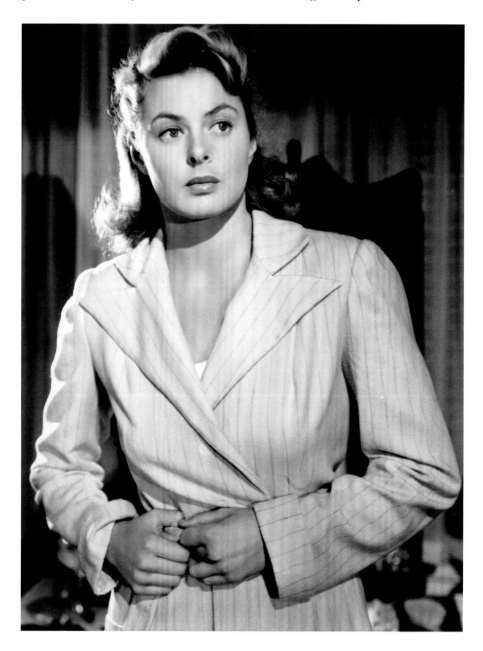

dream which I am hoping that Salvador Dalí will design for us." Hitchcock said that Selznick "probably thought I wanted his collaboration for publicity purposes," but what he wanted was for the surrealist master to create a vivid representation of dreams.

Dalí's agent, Felix Ferry, wrote to Selznick that Dalí was anxious that "his work in his first American picture should be perfection." But Selznick slashed the dream budget from $150,000 to $20,000, and many of these sequences had to be scrapped. However, the signature motifs of Dalí, such as distorted clocks and eyes cut by giant pairs of scissors, as inspired by the graphic scene in *Un Chien Andalou*, were all retained.

One sequence that didn't survive the cut was a scene in which Bergman turned into a statue and ants crawled from the cracks. Dressed in a Grecian gown, the actress was molded with papier-mâché and a pipe placed in her mouth for breathing. Once it set, she was to burst out of the mold and then the film was run backwards, to make it look like she was turning into a statue.

Hitchcock said: "Underneath, there would be Ingrid Bergman covered by the ants! It just wasn't possible."

Gregory Peck recalled on set that Hitchcock seemed to be lovesick or nervous around her. "Whenever he was with her, I had the feeling there was something ailing him, and it was difficult to know exactly the cause of his suffering, although some of us had our suspicions." Ingrid never hinted at any inappropriate action on Hitchcock's part, only that

Opposite: Ingrid Bergman wears a dressing gown with vertical stripes that trigger John Ballantyne's flashback to the skiing accident.

Above: Ingrid Bergman as a statue in the dream sequence directed by Salvador Dali. This scene was eventually cut from the final film due to budget constraints.

he was one of her closest friends. "I knew Hitch liked working with me," she told biographer Charlotte Chandler. "I could feel it, and I felt that way about him. He was a wonderful director, so sensitive. There were actors who said he wasn't a good actor's director, but something was wrong with them. He was so sympathetic."

Hitchcock was known to have recounted a tale in which Bergman tried to seduce him one evening, but many have dismissed this as fantasy. Biographer Patrick McGilligan doesn't completely doubt it: "Don't actresses fall in love with their directors all the time? He was no longer so grossly overweight—and wasn't he devilish and charming?" She did, after all, marry Roberto Rossellini, an older, creative director.

Bergman enjoyed Hitchcock's "delicious sense of humor," and she particularly liked that he could say something shocking "at some inappropriate moment when one wasn't expecting it." To pass some of the time on the set she took up knitting and constructed a jumper for her director. According to Bergman, "He would wear it as his 'Spellbinding sweater,' and he would wear it next to his heart. He said, 'I will also wear it against my stomach, and that will require too many balls of yarn. But since we shall do many films together, there will be time, and I shall go on a diet.'"

Spellbound was one of the most successful films of 1945, and Bergman was praised widely. The *Times* wrote: "Her performance reflects the film's honorable compromise between emotion and intelligence." Despite the simplicity of Constance's costumes, there was a "*Spellbound*" line advertised on the film's release, with a display at the Carnegie Hall premiere. The film was also advertised with noirish posters that said: "Will he kiss me or kill me?" and "The maddest love that ever possessed a woman." It is remembered as a Hitchcock film that conveys dizzying love in a claustrophobic background, with a sympathetic and intelligent heroine.

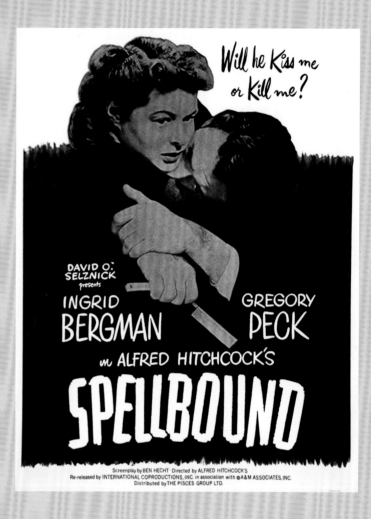

Above: *Spellbound* was one of the most successful films of 1945, with Bergman's performance given particular praise. It was advertised as a film noir.

Opposite: Ingrid and Hitchcock developed a strong and intense friendship from the start. There was a mutual respect between them and they both saw each other as outsiders.

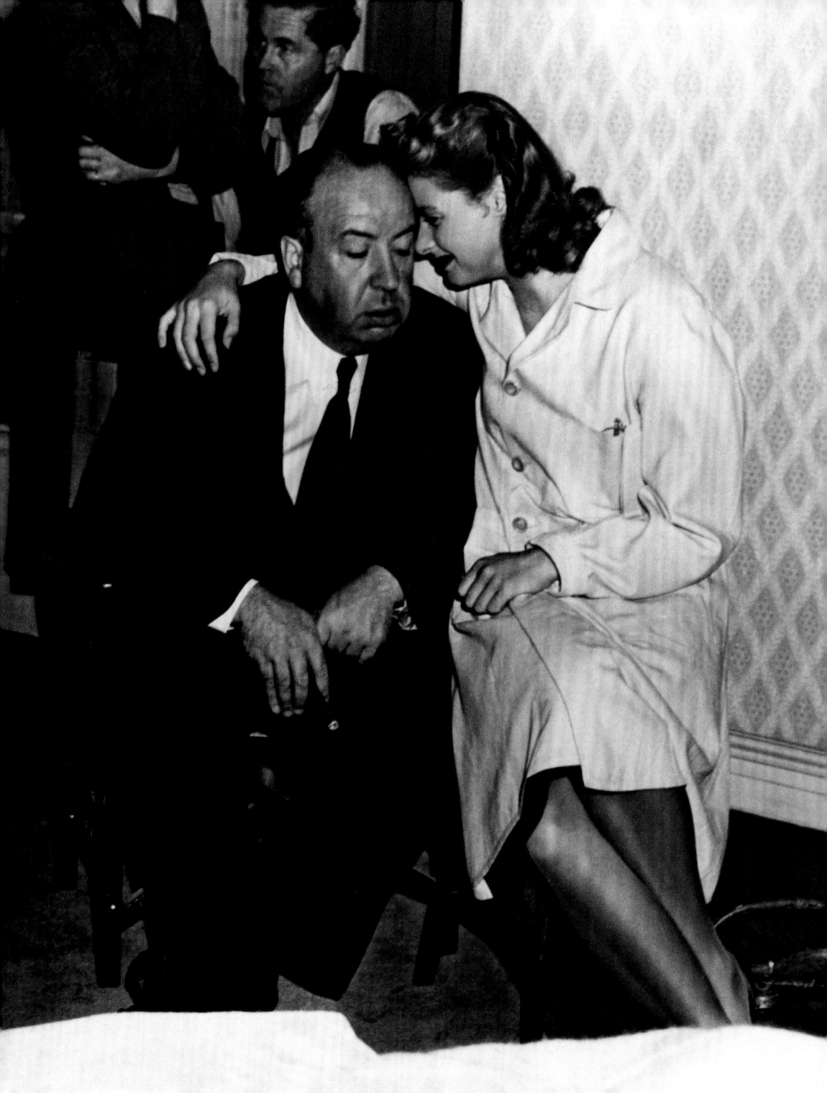

NOTORIOUS (1946)
INGRID BERGMAN

Alicia Huberman (Ingrid Bergman) is the daughter of a convicted Nazi spy. She is recruited by government agent T. R. Devlin (Cary Grant) to infiltrate a Nazi organization.

While waiting for her assignment to begin, she and Devlin fall in love. However her mission is to seduce a friend of her father's (Sebastian) who is a leading member of the Nazi group. When Devlin shows little upset at this, Alicia concludes that he was merely pretending to love her. Alicia and Sebastian marry. Following their honeymoon she realizes that the keyring her husband gave her lacks the wine cellar key. She also recalls an early episode where a dinner guest of theirs became distressed at the sight of certain wine bottles.

Stealing the key from Sebastian, Devlin and Alicia search the cellar and discover that the bottles are filled with uranium ore.

Realizing that his wife is on to him, but wary of exposing her as he will inevitable be killed, Sebastian consults his mother. Together they poison Alicia. She quickly falls ill and is taken to her room.

When Alicia fails to turn up to a meeting, Devlin sneaks into her room and confesses he loves her. He carries her out, past Sebastian's Nazi friends, insisting she needs to go to the hospital. Sebastian goes along with Devlin's story and once outside begs to go with them. Devlin and Alicia drive away, leaving Sebastian to face his friends.

After *Spellbound*'s success, David O. Selznick reunited Hitchcock with Ingrid Bergman and screenwriter Ben Hecht for an adaptation of the magazine serial *The Song of the Dragon*, which was about an actress who is recruited to seduce a double agent. Hitchcock heard many real-life accounts of espionage and spies in Hollywood, and as the war ended, the director was fascinated with the yet-unknown fate of Nazi sympathizers.

Hitchcock had heard from a friend about secret atomic goings-on in New Mexico, which inspired the uranium MacGuffin a year before Hiroshima. Selznick thought an atom bomb plot device was a foolish idea and sold the whole project to RKO Productions, allowing Hitchcock to shape it as he wished. He said the film "was simply the story of a man in love with a girl who, in the course of her official duties, had to go to bed with another man and even had to marry him."

When Bergman found out that the film would be set in South America, she had hoped it would involve some location shooting to help escape the fakery of Hollywood's sets. "When I did *Notorious*, I had asked Hitchcock 'Couldn't we go to South America, where it is set, and film there?' He had said, 'No, it has to be on the backlot.'"

By 1945 Bergman was Hollywood's top leading lady, but she was becoming disillusioned with her life in Los Angeles. She learned a lesson while arranging her first housewarming party: that the top tier of Hollywood would not mix with lesser crew members. As Selznick's star, she had to socialize at his pool parties with their huge buffets, butlers, servants, and ladies who threw their mink coats onto a pile in the bedroom, as was the fashion among ritzy Hollywood circles in the 1940s.

For Bergman, Hitchcock provided a refuge from this elitism. "Thank goodness, there was the Hitchcock group," she said. "Hitch and Alma mixed a lot with the actors they liked, and they didn't care if they were stars or not. He would never invite more than eight people at a time. 'More than eight is an insult to my friends,' he would say." Bergman and her husband, Petter, often enjoyed dinner prepared by Alma, followed by dancing to the radio and playing Scrabble and other board games. Hitchcock called Ingrid "the human sink," as she was always willing to knock back the martinis he loved to make.

Notorious was the second of Cary Grant's Hitchcock films, and he was given the role of cold, robotic government agent Devlin, a man who wears a good suit like it is armor, until he is melted by Bergman's Alicia Huberman, recruited to spy on a group of Nazis. Bergman wrote to a friend in Sweden: "Perhaps Hitchcock's the one who's best at bringing things out in me that I hadn't a clue I possessed, like mixing seriousness with humor, comedy with drama, and I was convinced that Cary Grant would be a conceited and stuck up man, but it turns out he's one of the absolute nicest co-stars I've had."

Page 93: Ingrid Bergman as Alicia Huberman in *Notorious*.

Above: Hitchcock directs Cary Grant and Ingrid Bergman. Initially wary of Grant, Ingrid became fond of him, calling him "one of the absolute nicest co-stars I've had."

Opposite: The "new Bergman" look was featured by many style magazines heralding her "all be-glamoured" costumes that were subtle and elegant with hardly any ornamentation.

In an early draft, Alicia was more like a Tallulah Bankhead character, and Selznick described this iteration as "horribly coarse without being witty." So Alicia was shaped into an interesting, complex, and flawed woman. She is fast with men, drink, and driving, and she is world-weary and promiscuous as she tries to escape the disappointment she feels in her Nazi father, sentenced for his war crimes. While she is used by the CIA as a state-sanctioned prostitute, she finds she can redeem herself through patriotism.

Having formed a great working relationship on *For Whom the Bell Tolls* and *The Bells of St. Mary's*, Ingrid requested costume designer Edith Head for *Notorious*. This was the designer's first chance to dress her "properly." The film called for twenty-two different costume changes. While the outfits were more glamorous than Ingrid had worn in previous films, they were also understated enough to suit Ingrid's preference for simplicity. In regards to jewelry, Ingrid confessed, "I've never been excited by that. It never thrilled me to have a diamond bracelet."

Much was made of her look in the film. She was described as a "new Bergman" and "all be-glamored," and her costumes were featured in style magazines. In 1946 *Women's Wear Daily* heralded the "open neckline, open midriff, cover-up sleeves" and the "varying degrees of formality" for a selection of her gowns.

"The job was tricky," Head said in 1945. "The star's clothes couldn't be smart in the ordinary sense. They had to avoid the fussy and the

extreme. And they had to be right for her. Some
women need accessories galore—jewels, furs,
feathers, silly hats—to look glamorous—all the
things she hates. Miss Bergman's clothes must
have simplicity, skillful design, and practically no
ornamentation. This is elegance in the subtlest
sense. For a costume designer, an Ingrid Bergman
picture is an education—an education in restraint."

It was Edith's first time working with Hitchcock,
marking the beginning of a thirty-year collaboration.
One of her talents was knowing how to please both

director and star, and she was aware that Hitchcock
was very specific and would indicate clothing and
color within the script. Alicia was to be believable as
a secret agent, so the clothes were not to dominate. He
also specified a palette of all black and white, with
its contrasting combination used to achieve different
effects, like making her stand out in a scene.

In the opening courthouse scene, among
different shades of gray, we first see Alicia in a
gleaming white jacket, sparkling from the beads
on her black top and hat which frames her face as

flashbulbs pop around her. At the party, Alicia is in the background against the silhouette of Cary Grant's head, but the viewer's eye is drawn to her vivid zebra patterned top with sequins and an exposed midriff. "In a black-and-white film the eye is immediately attracted to the stark contrast of black-and-white, since other colors become various shades of gray," said Head. "Visually, she became the most important woman in the room."

Our eyes follow her as she moves animatedly through the party, topping up her guests' drinks, with Cary Grant in the foreground as a still silhouette with

in Rio," she says, hoping she can lead a quiet life with Devlin.

Once she is with Alexander Sebastian, her gowns become sleeker and more controlled than the zebra-print. Head said, "In other dramatic scenes, she was dressed either in pure white or solid black, and true to Hitchcock's form, these colors reflected her mood."

Alicia's white crepe dinner gown, with white fur and diamonds like bars around her neck, was designed to be pristine. When she tells Devlin she is to marry Sebastian, she wears a hat that resembles a black halo with a gray suit and striped bow, demonstrating

"In a black-and-white film the eye is immediately attracted to the stark contrast of black and white, since other colors become various shades of gray." EDITH HEAD

his back to the camera. In an interesting reversal of the male gaze, Laura Hinton, in her essay in *Framework*, wrote that Alicia "turns the spotlight of female visual desire on Grant, and she relays her desire to the female spectator." The outfit and its revealing bare midriff was also treated with humor. "Don't you need a coat?" Devlin asks her. "You'll do," she replies.

Alicia says that all she wants is "good times and laughs with people I like," but like the hairpiece that has fallen out in the night, she must shed that artifice with the help of Devlin. Once signed up as a spy, she wears her hair neat and a saintly buttoned, black coat with a checked collar. "I won't be seeing any men

feelings of confusion. For the climactic party scene she wears a dramatic long black gown with plunging neckline, and the lack of jewelry around her neck creates a sense of exposure. As she clasps the key in her hand, Hitchcock used a famous crane shot where the camera descends from up high to focus right in on her hand.

Another famous scene was the kiss between Grant and Bergman, which Hitchcock, who loved to find ways to get around the rules, made five times longer than accepted by the Hays Code. He broke up the accepted three-second kiss with objects coming between them and talk of preparing dinner as the camera follows them through the room, like a third-person voyeur. "We did other things: We nibbled on each other's ears, and kissed a cheek, so that it looked endless, and became sensational in Hollywood," Bergman said. For this love scene, Alicia was dressed

Opposite: Ingrid, dressed in the zebra-patterned top, visually becomes the most important woman in the room.

glass on her bedside table. There is uranium hidden in the wine bottles. When Alicia becomes ill after drinking poison, Devlin assumes she is hungover. Hitchcock mimicked Grant's role in *Suspicion* as his dark figure is seen from the viewpoint of Alicia in bed, before coming into view in a romantic scene as Devlin saves Sleeping Beauty, first from self-destructive behavior and then from being poisoned, as he sweeps her from danger down a grand staircase.

Hitchcock and Bergman had a close friendship, and Hitchcock had hoped that there would be many more films after their last together, *Under Capricorn*. "My husband and Ingrid had a very special bond, mutual admiration, and a love of practical jokes," said Alma Reville. "They were two of a kind, those two. Of all the beautiful actresses my husband worked with, Ingrid was the one he had the greatest rapport with."

Later Hitchcock would say she was "so beautiful, so stupid." Maybe it was a reference to her throwing away her Hollywood career to marry Roberto Rossellini. Hitchcock spoke of being in "mourning for the films I would have made with Ingrid Bergman, the films that never were. When she left for Italy and stayed, it was a loss to me, to the world, and to her."

The love between actress and director was evident up to the last year of his life at the American Film Institute Life Achievement Award in 1979, as she brought the audience to tears with her embrace as she handed him a key—just like the one from *Notorious*.

in a tweed suit that matches Devlin's, but with black gloves and a large black bow around her neck. "I learned my restraint lessons very well," said Head. "In what was one of the sexiest love scenes ever on screen, Bergman and Grant were totally dressed, but who remembers what they wore?"

Drink is a big theme throughout *Notorious*. Alicia uses alcohol to cover up feelings of guilt and inadequacy. She wakes up, hungover, to a luminous

Above: Edith Head's simple use of color makes Ingrid stand out in a scene as with the white dinner party dress.

Opposite: Ingrid Bergman's costumes in *Notorious* marked the start of a thirty-year collaboration between Edith Head and Hitchcock.

STAGE FRIGHT (1950)
MARLENE DIETRICH

Aspiring actress, Eve Gill (Jane Wyman) is visited by her friend Jonathan, who declares he is the secret lover of flamboyant stage actress, Charlotte Inwood (Marlene Dietrich). He claims that he helped Charlotte cover up the murder of her husband, but got caught in the act with a blood-stained dress and is now on the run and wanted by police.

Eve is fond of Jonathan and agrees to help, hiding him at her father's house. Her father notices that the blood on the dress has been smeared on deliberately and suggests Jonathan has been framed.

Eve decides to investigate. Posing as a maid called "Doris" she starts working for Charlotte. She discovers that Charlotte is actually having an affair with her manager.

As "Eve" she meets Detective Smith who has been assigned to the case and they become friendly. Eve persuades him to set Charlotte up. During a secretly recorded meeting at the theater, Charlotte admits to "Doris" that she planned her husband's death, but that Jonathan killed him.

Detective Smith then reveals that Jonathan really did kill Charlotte's husband, and that Jonathan has killed before, but got off on a plea of self-defense.

Jonathan is brought to the theater. As he tries to escape, Eve confronts him and he admits that his story was a lie. He threatens to kill her. As she tries to get away, Jonathan is killed by the stage's falling safety curtain.

Hitchcock's daughter, Pat, who bore a striking resemblance to Jane Wyman, made her movie debut in Stage Fright.

After signing a four-picture deal with Warner Bros. in 1949, Hitchcock chose *Stage Fright* as his first project for the studio. The script was based on a story called *Man Running* and was set in the London theater world, with a man accused of murder, a glamorous stage star, and a theme of disguise. It was the first film Hitchcock made in London since leaving for Hollywood, and he hired a cast of esteemed British character actors including Alastair Sim and Sybil Thorndike. Hitchcock told François Truffaut: "What specifically appealed to me was the idea that the girl who dreams of becoming an actress will be led by circumstances to play a real-life role by posing as someone else in order to smoke out a criminal."

Hitchcock's wife, Alma Reville, hammered out the script with Hitchcock and Whitfield Cook. While Hitchcock wanted a twist on the wrongly accused man actually being guilty, Alma believed the audience would feel cheated and advised against using a false flashback. There were discussions back and forth, but ultimately Hitchcock's version won out with this flashback featuring in the opening scene.

Jane Wyman, at the time contracted to Warner Bros. Studio, was hired as the young actress, Eve, studying at the Royal Academy of Dramatic Art. Jane Wyman was a veteran actress who had acted in sixty-three films; she had just won an Oscar for *Johnny Belinda* and was going through a divorce from Ronald Reagan. Wyman also had an "astonishing resemblance" to Hitchcock's daughter, Pat, who was given a small role as Chubby Bannister, a fellow RADA student, and stood in for Wyman during the driving sequences. At the time, Pat was living in London and studying at RADA, and there was a correlation of Hitchcock's loving relationship with Pat and that of Eve and her "unique" father (played

by Alistair Sim), whom she conscripts to help her solve the crime. François Truffaut described *Stage Fright* as "somehow paternal, a family picture."

Hitchcock thought a glamorous diva like Tallulah Bankhead would be ideal for the part of Charlotte, but Jack Warner dismissed the idea because *Lifeboat* had not been so successful.

Hitchcock suggested Marlene Dietrich, who was nearly fifty, a grandmother, still completely glamorous—and a true Hollywood star. "When I first thought about working with Alfred Hitchcock, I was quite thrilled," Dietrich said. "I thought I would learn a lot from a true master. I'd heard he was a technical genius, and I'd always had a great interest in the technical part of making a film. I was familiar with his British work, that wonderful *39 Steps* with the beautiful Madeleine Carroll. I hoped he'd like me the way he obviously liked her."

Hitchcock sent an outline of the script to Dietrich at her apartment at the Hotel George V in Paris, and she was enthusiastic about the project. She met the Hitchcocks and Cook at the St. Regis in New York in April 1949 for further discussion, during which they enjoyed drinks and conversation. But true to her diva reputation, Dietrich and her agent negotiated a tough contract—a salary of $10,000 a week and a wardrobe designed by Christian Dior that Dietrich would keep at the end of filming. Hitchcock refused to relinquish complete control, and he ensured that there was a clause that said he would need to approve designs.

Since her days working with German auteur Josef Von Sternberg, Dietrich had learned exactly how she should be lit so that her hair and her cheekbones were illuminated. She still looked like a star of the 1930s, with her thin penciled eyebrows, thick lashes, and painted lips and a halo of blonde hair, all surrounded by a shimmering cloud of feathers or net.

She also insisted that her astrologer accompany her and have approval for the date when filming would begin in the summer of 1949. Marlene "was a professional star," said Hitchcock. "She was also a

Page 100: Marlene Dietrich as Charlotte in a tailored Dior suit.

Above: Jane Wyman on set with Alfred Hitchcock. Jane bore a striking resemblance to Hitchcock's daughter, Pat, who also appeared in the film.

Opposite: Dior's costumes broke away from wartime austerity, using yards and yards of fabric such as net, chiffon, tulle, and organza.

professional cameraman, art director, editor, costume designer, hairdresser, makeup woman, composer, producer, and director."

Dietrich told English critic and author John Russell Taylor that Hitchcock "frightened the daylights" out of her. Hitchcock "knew exactly what he wanted . . . a fact that I adore, but I was never quite sure if I did it right. After work he would take us to the Caprice restaurant and feed us with steaks he had flown in from New York, because he thought they were better than the British meat, and I always thought he did that to show that he was not really disgusted with our work."

Charlotte was written to take on some of Dietrich's affectations. Since Dietrich was famous for her musical numbers in films, Charlotte was given a song to perform. Dietrich was close with Edith Piaf and asked if she could perform "La Vie en Rose." But Hitchcock wanted a less familiar song and suggested Cole Porter's 1927 ditty "The Laziest Gal in Town." There was a small compromise: Dietrich hummed "La Vie en Rose" several times during the film.

Behind the scenes, Dietrich embarked on a dressing room affair with the married Michael Wilding, which became quite obvious when they were late for a scene. "We became inseparable," said Wilding. "In fact she would not move a step without me. She insisted that I accompany her everywhere, and she took as much interest in my appearance as she did in her own."

The wardrobe Dietrich had demanded as part of her contract was sensational. Breaking away from wartime austerity in favor of yards and yards of excessive material, Christian Dior's creations suited a film about performance and artificiality and featured huge amounts of aigrette feathers, net, chiffon, tulle, and organza. In 1949 *Women's Wear Daily* wrote of the prophetic nature of Dior's designs and anticipated they would set trends: "The film's debut is set six months ahead, so that these silhouettes composed by Dior for this film have fashion significance." But they were also designed to suit the narrative.

The pale, pleated dress with the bloodstain at the beginning of the film is replaced by an identical dress in a darker, navy version, symbolizing a transition to a

"I thought I would learn a lot from a true master. I was familiar with his British work, that wonderful *39 Steps* with the beautiful Madeleine Carroll. I hoped he'd like me the way he obviously liked her." MARLENE DIETRICH

Ever the perfectionist, she rehearsed and rehearsed "The Laziest Gal in Town," and, when it came to filming, she insisted she perform in the theater in front of the extras, who gave her a standing ovation at the end of the number.

Opposite: Hitchcock directs Dietrich in *Stage Fright*. She has said that he frightened the daylights out of her.

darker side of Dietrich's character and hinting at her duplicity. Hitchcock also insisted that Dietrich wear marabou, white fox, black stockings, and diamonds, as this is how he envisioned the character, the glamorous accessories helping to construct a facade. Charlotte accessorizes her tailored Dior suit with white fox on her shoulder—it hangs off her as she talks of the dog she had to put down, and she later dramatically flings it away.

MARLENE DIETRICH

Marlene Dietrich was the cabaret star of German cinema in the 1920s and Hollywood in the 1930s, who seduced with the light of a cigarette or the touch of her top hat.

Born in Berlin in 1901, Dietrich honed her talents in the jazz clubs of Weimar Germany, before gaining international attention as Lola in *The Blue Angel*. She conquered Hollywood with Josef Von Steinberg films *Morocco*, *Shanghai Express*, and *The Scarlett Empress*. During the Second World War she performed around the world for allied troops and returned to the cinema in the late 1940s with Billy Wilder's *A Foreign Affair* (1948). Dietrich worked into her seventies on stage performing songs like "Lile Marlene" and "Falling in Love Again." In later years she hid from the public in her Parisian apartment, ensuring her legend grew around her, and died at the age of ninety in 1992.

JANE WYMAN

Wide-eyed Jane Wyman was born in 1917 in Missouri, and after her father died, she was given up to strict disciplinarian foster parents. Originally a blonde, she was signed to Warner Bros. at the age of sixteen. She became successful throughout the 1930s and 1940s in both comedies and dramas, winning an Oscar in 1948 for her role as a deaf mute rape victim in *Johnny Belinda*. She acted in prestige pictures throughout the 1950s, including *Magnificent Obsession*, for which she was nominated for another Oscar. Her career continued on television, and in 1981 she began a new soap career as a family matriarch in *Falcon Crest*. In 1940 Wyman married actor and future president Ronald Reagan. They had three children, one of whom died during childbirth, and divorced in 1949. She married a further four times.

Supplementing Christian Dior's costumes was Warner Bros. designer Milo Anderson, a "boy wonder" of costume design whose long career at the studio began after being requested by Busby Berkeley for *Footlight Parade*. He designed for *Captain Blood* (1935), *The Adventures of Robin Hood* (1938), and *Mildred Pierce* (1945), and had worked with Jane Wyman on many previous movies. Milo said, "I designed for Jane Wyman when she was a chorus girl, later when she did comedies, and finally when she did *Johnny Belinda*, which won her an Oscar. She is a dear friend, a great actress, and she has a wonderful figure." He added, "Marlene Dietrich was another dear friend, although she was very hard to satisfy." While Dior designed Dietrich's costumes, Milo created initial sketches, took care of the gowns, and carried out extra fittings.

In her book *The Dress Doctor*, Edith Head described Dietrich as "indefatigable," with a large thermos of coffee to keep her going; she talked about herself in the third person when looking at her reflection in the mirror. Milo recalled that "Marlene would fit one costume for a month if you let her, and even after we started shooting, she would go back to Paris every weekend to refit the clothes. This was before the Common Market, so every time those dresses crossed the border, they had to pay more duty. The final costs were staggering."

While Dietrich had Dior, Jane Wyman was upset at what she perceived to be her frumpy wardrobe. Her clothes had to fit that of a RADA student, and she was seen in a belted wool trenchcoat with black leather gloves for many of her scenes. But at the garden party, she was given an ankle-length white-embroidered dress that was as sheer and frilled as Marlene's. Wyman worked with hair and makeup to improve her appearance, and Jack Warner backed her up as she was his star, and he wanted her to look good.

"I had lots of problems with Jane Wyman. In her disguise as a lady's maid, she should have been rather unglamorous," said Hitchcock. "But every time she saw the rushes and how she looked alongside Marlene Dietrich, she would burst into tears. She couldn't accept the idea of her face being in character, while Dietrich looked so glamorous, so she kept improving her appearance every day."

The scene in which Wyman wears a disguise as Charlotte's maid, with thick glasses, a tweed coat, and a cigarette hanging from her mouth,

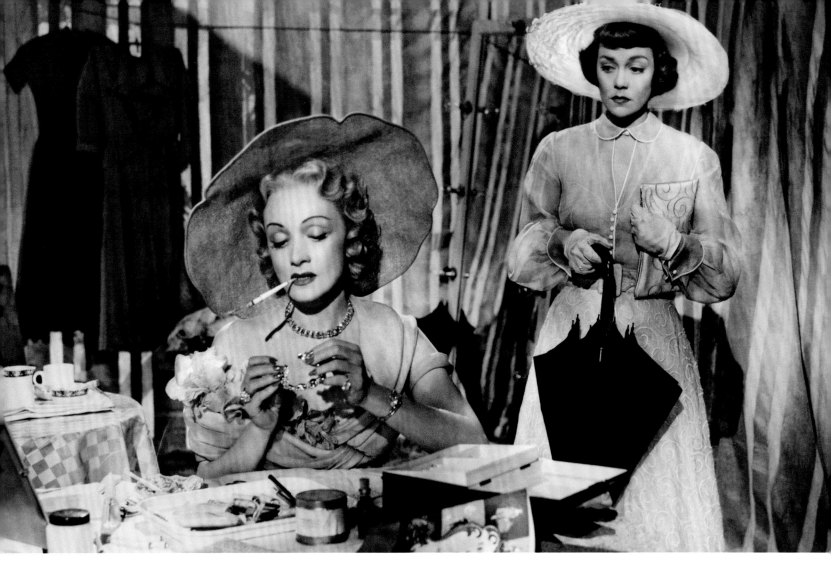

Top: For the garden party scenes, Jane Wyman was given a dress as sheer and frilled as Marlene Dietrich's.

Above: Jane Wyman as Eve. Her costumes were not glamorous like Dietrich's. This caused a fair amount of fashion feuds, and according to Hitchcock cost the film its success.

is played for laughs. For Hitchcock, glasses were a way of deglamorizing people, but this joke look had to be softened, as it would have been unlikely for Charlotte to have accepted a scruffy maid to help her. But Wyman was very funny in the film, bringing humor to her maid disguise and comedic lines and in the final scene, we see the terror in her eyes—huge and wet under a strip of light.

In 1950 *Picturegoer* reported a fashion feud on the set between Dietrich and Wyman but acknowledged that Wyman's Milo Anderson costumes were just as stylish. "When it's a matter of line and originality, Jane's clothes take some beating. I particularly like her pencil-slim, gray flannel suit with saddle-stitching on the collar, pockets and belt. Marlene may provide the glamour, but Jane's clothes will set many of us busy copying simple, striking styles."

Stage Fright did not do well at the cinema, and Hitchcock blamed it on the supposed failings of his leading actresses. The "lack of reality" in Wyman's character hurt the film, he said later. "She should have been a pimply-faced girl. Wyman just refused to be that, and I was stuck with her."

DIAL M FOR MURDER (1954)
GRACE KELLY

Tony (Ray Milland) discovers his wife, Margot (Grace Kelly), is having an affair with American crime writer Mark Halliday (Robert Cummings) so blackmails an old acquaintance, Swann, into murdering her.

He gives Swann a latchkey to their flat with instructions to hide it under the stair carpet once Margot is killed. Swann attacks Margot when she answers a ringing phone in the night, dialed by her husband, Tony. However, the plan goes wrong and Margot kills Swann in self-defense.

Tony then incriminates Margot by planting the key from Swann's pocket (which he thinks is their latchkey, but is actually Swann's flat key) in her handbag. It works and Margot is arrested and sentenced to death. However, the investigating detective (Hubbard) starts to doubt Tony, especially when he discovers the hidden latchkey under the stair carpet, and devises a trap to catch him.

Hubbard switches raincoats with Tony. He summons Margot to the flat and she tries to use the key in her handbag to open the door, but it doesn't fit: it is Swann's key that Tony planted in her handbag. Hubbard waits to see if she knows about the latchkey under the stair carpet. She doesn't, and so is cleared of suspicion.

They wait for Tony. When he arrives he can't open the door either (he has Hubbard's raincoat with Hubbard's key) but goes immediately to the hidden latchkey proving his guilt.

Grace Kelly, like her contemporary, Audrey Hepburn, had something that was quite different from the typical sex bomb look of the time. In 1950s United States, there was a dichotomy between being Marilyn Monroe on screen and chaste in real life, and Grace, with her warm elegance, fell somewhere between the two. Grace Kelly was the benchmark for Hitchcock's ideal blonde and his greatest leading lady since he lost Ingrid Bergman to Rome. She had the beauty and talent that he so admired, and she displayed the right combination of fire and ice. She may have been the virgin snow on which he wished to imprint a bloody footprint, but she also had an assuredness that never made her the victim. Hitchcock said of Kelly, "She's sensitive, disciplined, and very sexy. People think she's cold. Rubbish! She's a volcano covered in snow."

Dial M for Murder was originally written by Frederick Knott for the BBC in 1952 and swiftly adapted for the stage. It seemed perfect for Hitchcock and Warner Bros., so he bought the rights, with Knott adapting his script for the screen. The setting remained in London, despite being filmed on the studio lot, but Hitchcock's attention to detail included ensuring street sounds were of London traffic, which he felt was quite different from Los Angeles traffic.

Like the play, the film adaptation kept the action essentially contained to one room, but Jack Warner insisted it was made in 3-D. Warner Bros.' *House of Wax* was massively popular at the time, and he wanted to explore the technology further. But Hitchcock didn't want to use the typical gimmicks. "No spears or chairs to throw at the audience," he said. As the director predicted, 3-D fell out of popularity soon after production. In addition, the 3-D camera was huge and bulky, testing everyone's patience when it dominated the set. Kelly recalled, "We had

endless rehearsals and were always doing an awkward dance around the enormous machine."

Hitchcock couldn't afford a big star to play Margot, so he turned his attention to finding a newcomer who wouldn't require a large salary. He wanted to cast a cool blonde with a simmering sexuality beneath the surface to make it believable that she would cheat on her husband. In fall 1953, Hitchcock watched Grace Kelly's screen test for the part of an Irish girl in *Taxi*. He hadn't been impressed with her as a Quaker bride in *High Noon*, but he saw something special in the *Taxi* screen test and contacted her agent. At the time, there was buzz around Grace's performance in the unreleased *Mogambo* as a prim wife who was sexually awakened by Clark Gable. Hitchcock arranged to meet the young actress in June 1953.

"I was very nervous and self-conscious at my first meeting with him, but he was very dear and put me at my ease," Kelly remembered. "We talked about travel, food and wine, music, fashions—anything except the character of Margot Wendice in the movie."

He realized that Kelly was perfectly suited to the role of Margot as "she has fire and ice and great passion, but she does not flaunt it," and while "she was rather mousy in *High Noon*," he said "she blossomed out for me." He coached her to lower her voice, which could be nasal, and talked through exactly what she would wear. He planned a color progression with a bright wardrobe at the start, becoming more somber as the story progresses, from "brick, then to gray, then to black." But when Hitchcock described a plush velvet robe during the attempted murder scene, she had to disagree. "It seemed right for Lady Macbeth in her sleepwalking scene, but not for me in this sequence," she said. She knew that her character wouldn't bother putting on a robe over her nightgown to answer a ringing telephone, particularly if she thought she was alone.

Hitchcock was impressed with her suggestion, as the sheer, diaphanous nightgown made her look even more vulnerable to an intruder. Kelly said, "After that, I had his confidence as far as wardrobe was concerned, and he gave me a very great deal of liberty in what I wore in his next two pictures." Kelly was a woman who knew her own mind, particularly when it came to how she would look. She was adamant that

Page 108: Grace Kelly was the benchmark for the Hitchcock blonde; a combination of fire and ice—cool and assured, but also sexy.

Above: A wardrobe test featuring Grace Kelly in the sheer chiffon nightgown.

Opposite: Grace Kelly as Margot Wendice. She was a relative newcomer and didn't require a big salary, but Hitchcock, impressed by her, subsequently gave her more control over her wardrobe.

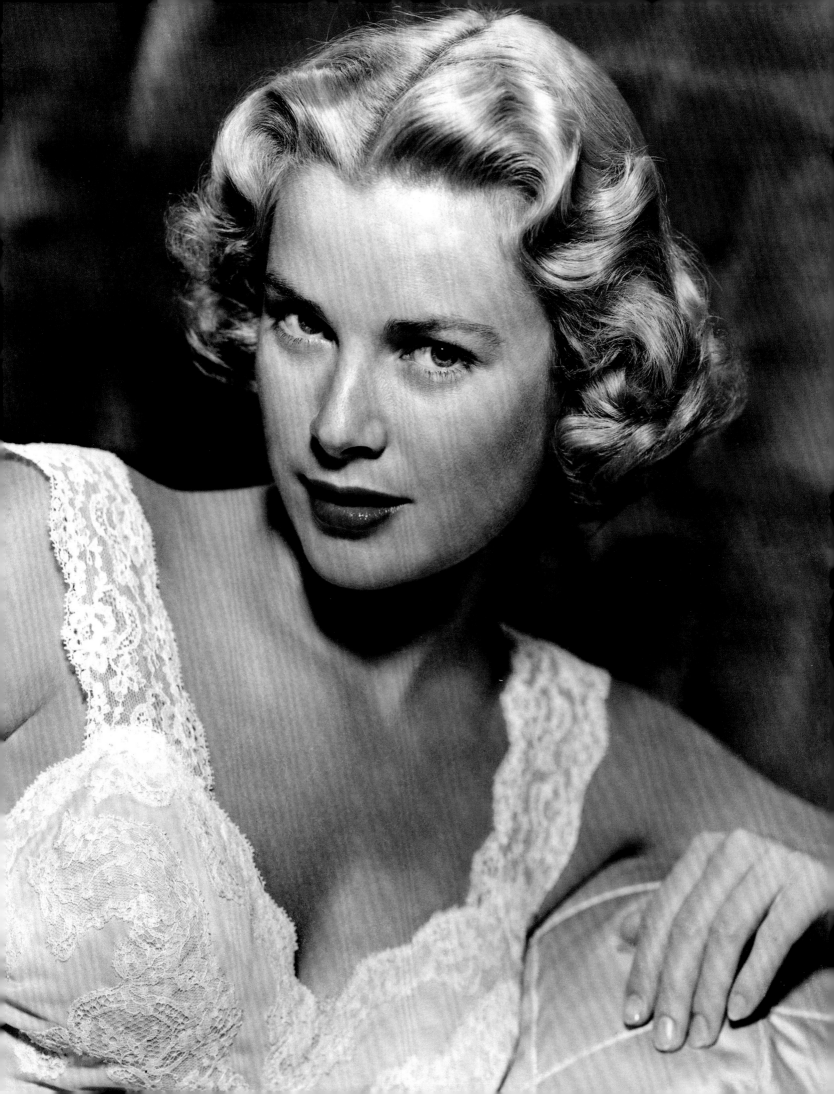

GRACE KELLY

Grace Patricia Kelly was born in 1929 in Philadelphia and from an early age was determined to be an actress, despite her parents' disapproval. After graduating from the American Academy of Dramatic Arts in New York she had some success in the theater and in television before making her film debut in *Fourteen Hours*.

In 1952 she starred with Gary Cooper in *High Noon* and was given a seven-year contract by MGM. She was nominated for an Academy Award in *Mogambo* and won for *The Country Girl* in 1954, as Bing Crosby's dowdy wife. She had a hit single with "True Love" following her role in the musical *High Society*, and is beloved for her roles in three Hitchcock films.

She retired from acting at the age of twenty-six when she married Prince Rainier of Monaco, and as Princess Grace of Monaco she remained a style and fashion icon for the rest of her life. She had a stroke while driving in 1982, and died of injuries sustained in the subsequent crash, aged fifty-two.

she would not look overly made up, and so she fought with the makeup man over the amount of blush he wanted to apply, per Jack Warner's instruction.

Margot's costumes were assigned to Moss Mabry, Warner Bros.' head costume designer. He engineered the red jacket and jeans look in *Rebel Without a Cause* and created two decades' worth of costumes for the epic *Giant*. Mabry designed and tested several different options, especially for the dress in the second scene in which Margot entertains her lover. Mabry said of Grace, "She sold these clothes like I didn't dream possible, and it was actually difficult to decide which ones she should wear in the film. Miss Kelly knows exactly how to stand, how to sit, and how to walk, and you have no idea how these things can 'make' or 'kill' a beautiful dress."

However, the red gown, with its circular skirt, figure-hugging bodice, and bolero, was a very deliberate decision by Hitchcock. Edith Head, who later worked with both Hitchcock and Kelly on *Rear Window* and *To Catch a Thief*, said, "He had strong feelings that color should never be so strong that it overpowered the scene or the actress. If the script called for a girl in a red dress, that was one thing, but to put her in a red dress for no reason was out of the question in a Hitchcock film."

The contrast between Margot as wife and adulterer is made clear as her costume arc changes from muted tones to hot red. The kiss between husband and wife over the breakfast table, with Grace in pale pink cardigan and skirt, is quickly followed by the passionate fireside embrace between Margot and her lover.

In this scene, her red lips, red lace dress with its tight bodice, and red shoes put her in the position of seductress. "In this case," Hitchcock explained, "red doesn't mean stop. It means go."

Opposite: Hitchcock looks on as Robert Cummings and Grace Kelly embrace during a scene from *Dial M for Murder*.

Above: Grace Kelly and Ray Milland chat on the set of *Dial M for Murder*. Grace wears the pale pink cardigan and skirt from the breakfast scene where husband and wife kiss.

Her handbag also stands out as scarlet, and Tony must invade this feminine space in order to set up her murder. In the press, there was a focus on the fashion show aspect of Kelly's costumes, particularly with the red dress, lovingly described as being made from Swiss imported handkerchief lace in fire engine red. The sheer chiffon nightgown was described as "sensation without revelation" and as "a satin, flesh-colored unit, close fitting enough to make the nightdress interesting . . . but not so much to endanger Miss Kelly's modesty."

Margot wears a brick-toned button-down dress with three-quarter-length sleeves on the evening of the attempted murder, but after she is questioned, her costumes become darker. When she is being sentenced for her crimes, she wears a gray dress with a black line leading from around her collar to her beltline, creating the impression of a hangman's noose. A bulky and drab brown coat is worn over the dress to indicate her despair.

It took a week to shoot the attempted murder scene, as it involved many camera setups meant to create the sense of frenzy in quick edits. Hitchcock specified that the scissors had to shine in the light, just as the

knife in *Blackmail* did. "There wasn't enough gleam to the scissors," he was quoted as saying. "And murder without gleaming scissors is like asparagus without hollandaise sauce. Tasteless."

Of the attempted murder scene, Kelly said: "We tried to keep everything cheerful during the breaks, but frankly, it was all awkward and difficult. This was my first leading role in a movie, and I tried to give Hitch what he wanted. But after three or four days of work on this sequence, from seven in the morning to seven at night, I went back to my hotel covered in bruises."

Because of Kelly, Hitchcock was in good spirits throughout the shoot. Like Ingrid Bergman, she was reliable, diligent, and dedicated to her performance. He liked that she wasn't a pushover and that she took his sometimes odd and jarring humour with a pinch of

Above: Grace Kelly with Hitchcock and Robert Cummings. She wears the red lace dress from her adulterous scenes.

Opposite: Wardrobe tests for the drab coat and gray dress with the line from its collar indicating a hangman's noose, and the red cocktail dress worn with fur wrap, designed by Mabry.

salt. As he was fond of doing with his leading ladies, Hitchcock tried to shock her with his dirty jokes, but she swiftly informed him that she had heard much worse at a girls' convent school, which made him roar

confidence after having felt ignored by John Ford during the *Mogambo* shoot. "Hitch was always so decorous and dignified with me. He treated me like a porcelain doll," she said. As Hitchcock biographer

> ## "Hitch was always so decorous and dignified with me. He treated me like a porcelain doll." GRACE KELLY

in appreciative laughter. She enjoyed his puns and word games, particularly one in which they came up with famous names without the first letter, such as Rank Sinatra or Lark Gable.

He worked more closely with her than any other director had in the past, and this helped boost her

Patrick McGilligan wrote: "Kelly was the Hitchcock fantasy woman come to life—a dream blonde as ladylike as Madeleine Carroll but as earthy and wanton as Ingrid Bergman. Kelly didn't mind Hitchcock's abruptness, or his despotism, which amused her."

REAR WINDOW (1954)
GRACE KELLY

Photographer L. B. "Jeff" Jefferies (James Stewart) is confined to a wheelchair in his apartment after breaking his leg. His rear window looks out onto several other apartments, including that of Lars Thorwald (Raymond Burr) and his bedridden wife, and he takes to spying on his neighbors through the lens of his camera.

One night, Jeff hears a woman scream and glass breaking. Next morning he notices that Thorwald's wife is gone.

Convinced that Thorwald has murdered his wife, Jeff asks his friend Tom, a detective, for help; but he finds nothing.

Soon after, a neighbor's dog is found dead. Certain that Thorwald also killed the dog to stop him digging up something in the courtyard, Jeff asks girlfriend, Lisa (Grace Kelly), and Stella (his nurse) to help.

While Jeff distracts Thorwald, Lisa and Stella dig up the courtyard; they find nothing. But Lisa climbs into Thorwald's apartment to investigate further.

Thorwald returns to discover Lisa. Jeff calls the police, who arrive in time to save her by arresting her. From his window, Jeff can see Lisa pointing to her finger with Mrs. Thorwald's wedding ring on it. Thorwald notices, and realizing that she is signaling to someone, spots Jeff.

Thorwald confronts Jeff in his apartment. Jeff fends him off by firing his camera flashbulbs to blind him. However, Thorwald pushes Jeff out of the window.

Police officers arrive just in time to catch Jeff and Thorwald confesses to them soon afterward.

During the making of *Dial M for Murder*, Hitchcock excitedly discussed his next project with Grace Kelly, and she was so keen to work with him again that she turned down the role of Edie Doyle opposite Marlon Brando in *On the Waterfront* to play Lisa in *Rear Window*. By 1954 Hitchcock had slimmed down, and he told Francois Truffaut, "I was feeling very creative at the time; the batteries were well charged." *Rear Window* was the first of his Paramount films, which comprise what is considered to be his golden age. It was here he assembled his ideal team—costume designer Edith Head, production designer Robert Burks, assistant director Herbert Coleman, and editor George Tomasini. A monumental replica of a Greenwich Village brick apartment block was built on the Paramount studio lot, complete with fire escapes, small gardens, and chimneys. *Rear Window* was filmed in Technicolor and in the widescreen format so that the audience could really become involved in its world.

In James Stewart, Hitchcock found his all-American alter ego as the wheel-chair-bound photographer L.B. "Jeff" Jefferies. Hitchcock told Truffaut: "He's a real Peeping Tom . . . sure he's a snooper, but aren't we all?" *Rear Window* is a self-referential work about the act of filmmaking itself and the way cinema allows us to glimpse the private lives of characters on screen. Jeff owes a debt to

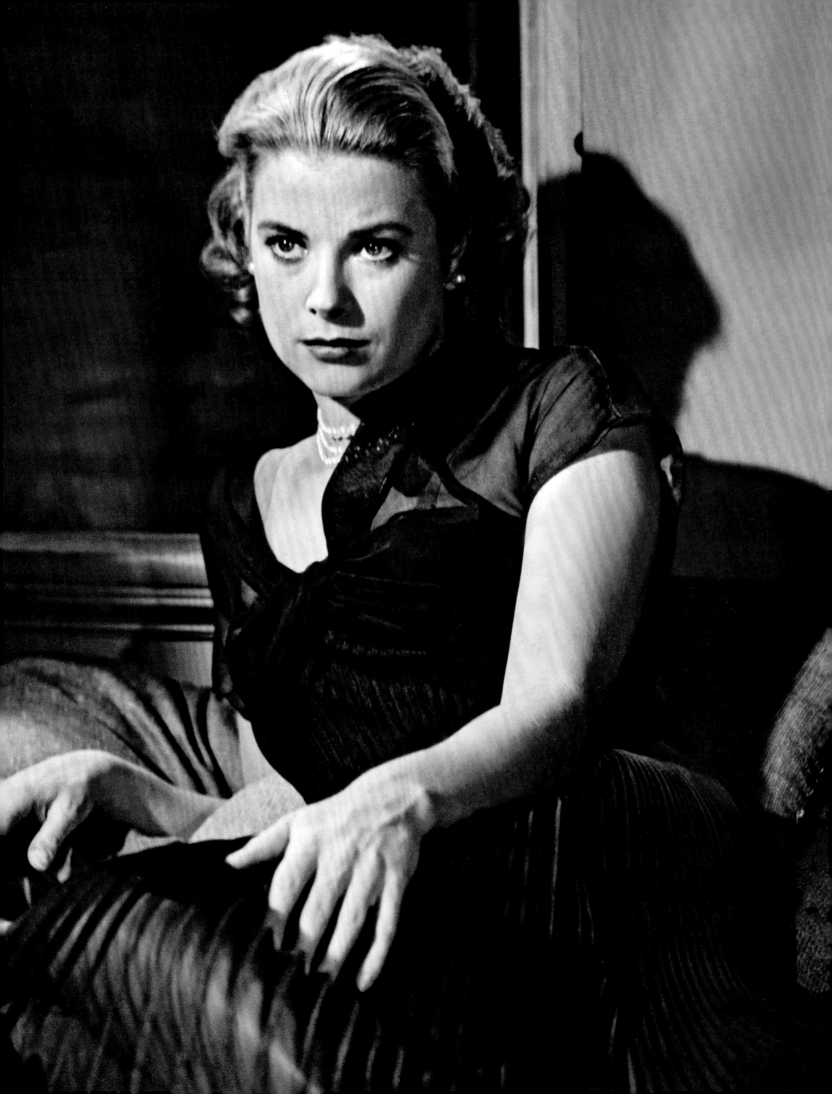

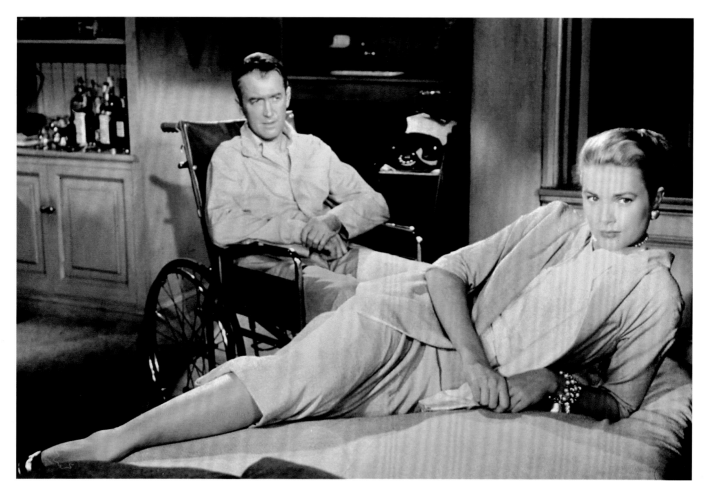

Robert Capa, a photojournalist who had a relationship with Ingrid Bergman at the time of *Notorious*, and who chose work over settling down.

Central to the film is the relationship between Jeff and Lisa. While Jeff is obsessed with the lives of his neighbors, he seems disinterested in looking at his beautiful but "too-perfect" girlfriend Lisa—that is, until she becomes an active participant in solving the murder. Jeff is having doubts about their relationship, and we see different versions of love through the neighbors he spies on: a childless couple who dote on their dog, lustful newlyweds, a bachelor musician, an unhappy spinster, and a blonde dancer with plenty of admirers. These characters were all color-coded so they could be easily identified, with spinster Miss Lonelyhearts in emerald green and dancer Miss Torso often in pink.

Sticking with the film's theme of voyeurism, Grace Kelly's Lisa is a fashion maven who is used to being watched and admired. Lisa likes to display herself through glamorous costume, with an awareness of creating meaning through what she wears. A pale "peach parfait" night-gown is worn by Lisa as "a preview of coming attractions," to tempt Jeff to look at her rather than the neighbors. "How far does a girl have to go before you'll notice her?" she says.

"Hitch wanted her to look like a piece of Dresden china, something slightly untouchable."

EDITH HEAD

Page 116: Edith Head's costume sketch for the black dress worn by Grace Kelly in *Rear Window*.

Page 117: Grace Kelly as Lisa in *Rear Window*. Grace had turned down a role opposite Marlon Brando to play her.

Above: To demonstrate that Lisa was a career girl, Edith Head designed this shantung silk suit in Hitchcock's favorite eau-de-nil color.

Opposite: Edith Head's sketch of the eau-de-nil suit, with white halter-neck blouse.

She has intimate knowledge of the fashion world, saying "if there's one thing I know, it's how to wear the proper clothes." Lisa chooses a fresh-from-Paris gown as it is "what's expected" of her as a Park Avenue socialite, but she also wants to show she is adventurous enough for Jeff.

Grace Kelly's elegance and model-trained poise suited the role, but Hitchcock also wanted to bring out the warmth and spark in her personality, which he felt was sometimes missing on screen. He helped her bring wit, sweetness, and pluckiness to the part.

Lisa was originally an actress in the script, but she was changed to a top fashion model and buyer. She was based on Hitchcock's friend Anita Colby, who had transitioned from model to businesswoman. Hitchcock asked scriptwriter John Michael Hayes to spend time with Kelly to shape the character from her personality. Hayes said: "I spent a week with Grace Kelly, and got to know that she was whimsical and funny and humorous and teasing. She was like the girl next door, but she was very sexy and had all these attributes."

By the time Kelly arrived in Los Angeles in late November for wardrobe fittings, Hitchcock had already instructed Edith Head on what styles and colors she would wear to advance the story. Although Head had also costumed *Notorious* in 1946, *Rear Window* would be the true start of a lengthy collaboration with Hitchcock, in which she would get to know his strong opinion on the color and style of costumes.

Lisa was to be dressed in high fashion, and Head created a complete 1950s wardrobe of a New Look cocktail dress, a smart business suit, and a floral day dress, chosen to suit New York's sweltering summer and reflect the development of the plot. Because the film is set in one room, Head knew that everything

within had to make an impact. She said Hitchcock felt "it was important that Grace's clothes help to establish some of the conflict of the story."

"Hitch wanted her to look like a piece of Dresden china, something slightly untouchable," said Head. Head used luxury fabrics for her costumes, with shantung silk for the green suit, soufflé for the negligee, and plenty of organdie. She explained, "There was a reason for every color, every style, and he was absolutely certain about everything he settled on. For one scene he saw her in pale green, for another in white chiffon, for another in gold. He was really putting a dream together in the studio."

Grace Kelly's dreamlike entrance is at first foreboding, as a shadow stretches over a sleeping Jeff,

but then we see her face come into frame, slowed down as she leans into him for a kiss, and with an effect created by shaking the camera. Hitchcock said, "I wanted to get right to the important point without wasting any time. Here it's the surprise kiss."

As with *Notorious*, Hitchcock succeeded in breaching the time limit for kisses, by breaking up the censors' three-second rule with whispered sweet talk and innuendo. "An actress like Grace, who's also a lady," said Hitchcock, "gives a director certain advantages. He can afford to be more colorful with a love scene played by a lady than with one played by a hussy. With a hussy such a scene can be vulgar, but if you put a lady in the same circumstances, she's exciting and glamorous."

Lisa turns on the lights one by one to reveal a gown with an off-the-shoulder black velvet bodice and full white silk organza skirt with layers of net beneath. This dress was to be high fashion—a gown that would suit Manhattan cocktail parties and dinner at 21, and with a price tag that shocks Jeff. It was based on a New Look silhouette, and Edith Head said the simple neckline "framed [Kelly's] face in close-ups. Then, as the camera pulled back, the beaded chiffon skirt immediately told the audience she was a rich girl."

Lisa's full ballerina-length skirt bobs up and down as she rushes around the crammed apartment, emphasizing how much she dotes on Jeff. But instead of impressing Jeff, it serves to cast further doubt in his mind as to whether she can match his adventurous career. "Those high heels, they'll be great in the jungle. And the nylons and those six ounce lingerie," he says. "They'll make a big hit in Finland, just before you freeze to death." However it turns out that Lisa is resourceful: She packs a frothy, satin negligee into her compact Mark Cross overnight case in order to prove that she can live out of one suitcase.

Above: Edith Head's sketch shows the dress was based on a New Look silhouette with a simple neckline that helped frame Grace's face in close-ups.

Opposite: For Grace Kelly's dreamlike entrance she wears a high fashion gown with an off-the-shoulder black velvet bodice and a ballerina style, white silk organza skirt with layers of net.

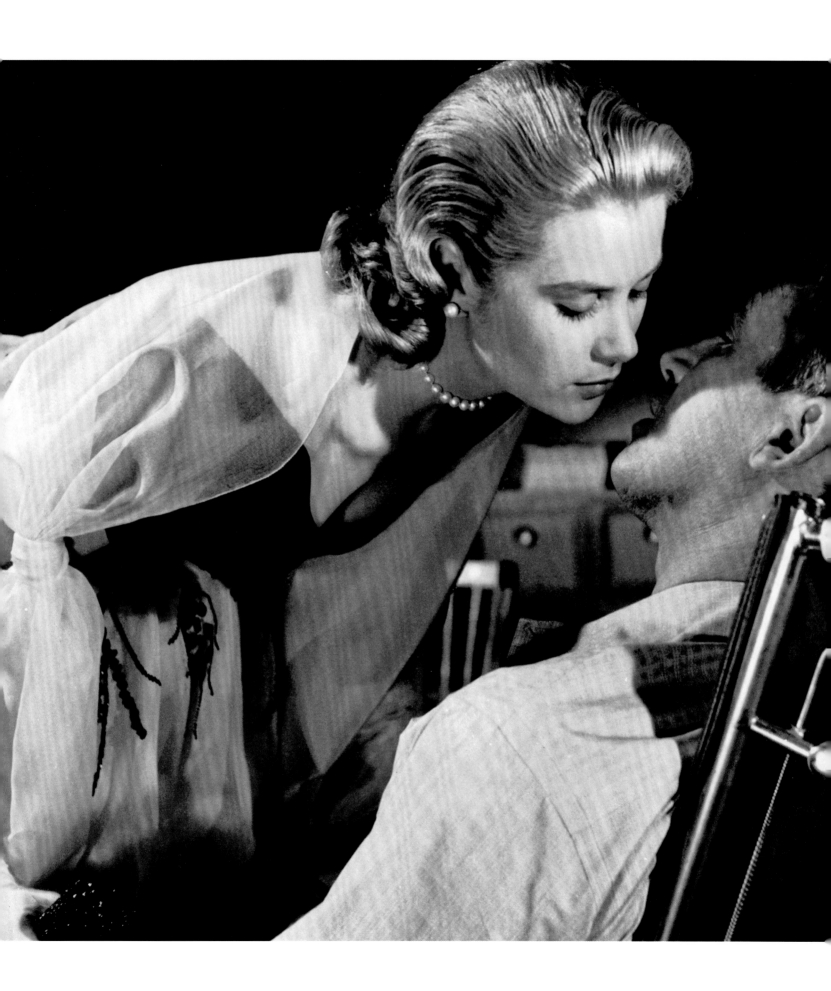

Lisa's black, silk organza cocktail dress with the pleated skirt becomes a somber marker when she starts to believe that a murder has taken place; her Balenciaga-styled raw silk suit in Hitchcock's favorite eau-de-nil, worn with a white halter-neck blouse, demonstrates that she is an independent career woman. "The suit was the one Hitchcock had first seen in his mind's eye, color wise, and it caused a furor fashion-wise," Edith recounted. A white pillbox hat with a veil acts as a screen as she joins in the voyeurism with Jeff and showcases her "feminine intuition" by insisting a woman would never be without her favorite handbag and it would always hang on the bedpost. When she takes off her hat, it's as if he sees who she really is for the first time.

By the time Lisa sneaks into Thorwald's apartment, Jeff has found a new appreciation for his girlfriend, realizing she is not as frivolous as he thought. She wears a floral day dress, designed to add a sense of vulnerability as she climbs up the fire escapes and clambers over railings. The floral dress also connects Lisa to Mrs Thorwald, whose head is buried in the flower beds. In a subversion of conventional gender roles, Jeff is incapacitated, and it's Lisa who throws herself into the action while he watches helplessly. There is also the ironic touch of the wedding ring—she wears Mrs. Thorwald's on her finger, which not only is evidence but also inspires Jeff to marry her.

In the final scene, Lisa is dressed in jeans and a pink shirt, reading a book on the Himalayas, having adapted her clothes to suit Jeff's way of life. But when he falls asleep, she swaps it for *Harper's Bazaar.* Lisa is fully in control of creating this new image, as evident with the name "Lisa" sung in the final moments.

Kelly was well liked on set, as she was always prepared. James Stewart said, "Everybody just sat around and waited for her to come in the morning, so we could just look at her. She was kind to everybody, so considerate, just great, and so beautiful." Assistant director Herbert Coleman agreed. "Every man who ever was lucky enough to work with Grace Kelly fell in love with her, me included. Even Hitchcock— although he only was in love with two people, and that was Alma and Pat."

For one scene, during dialogue rehearsal, Kelly unexpectedly sat on the window seat to talk to James Stewart. Coleman protested to Hitchcock it would cost a fortune to do different lighting on the apartments opposite. Kelly recalled, "I hadn't even thought of the technical problem involved, and I told Hitch, 'Oh, don't bother with that— I'll sit somewhere else!' But Hitch said, 'No, Grace, it's better your way.'"

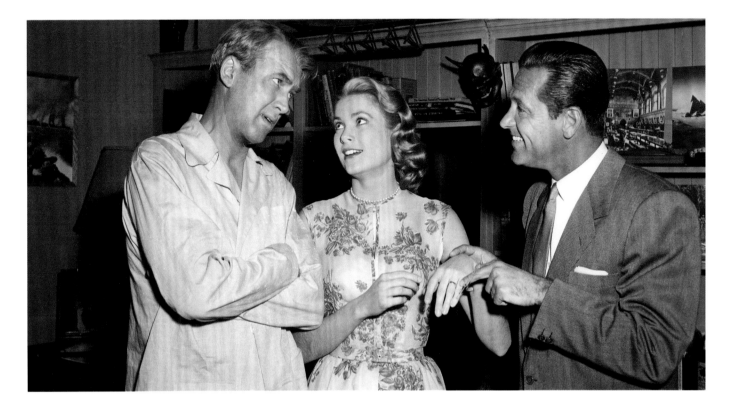

"Everybody just sat around and waited for her to come in the morning, so we could just look at her. She was kind to everybody, so considerate, just great, and so beautiful." JAMES STEWART

Opposite : Edith Head's sketch for the floral day dress that Lisa wears when she climbs up the fire escape to investigate the murder she thinks has taken place. It was designed to make her look more vulnerable.

Above: Grace Kelly in the floral dress with James Stewart (left) and William Holden (right) on the set of *Rear Window* as the two actors pretend to fight over her.

On its release in August 1954, *Rear Window* was a huge hit, turning Grace Kelly into a star. Nineteen fifty-four was declared the year of Grace by *Time* magazine, she was named best actress of the year by New York Film Critics Circle, and she was fast becoming a fashion icon. In 1955 *Vogue* described Kelly as "remote as a Snow Queen . . . too wholesome to be mysterious, she settles instead for fragile, tantalizing perfection, occasionally irritating to women, but pure ego-feeding tonic for men."

Edith Head was nominated for an Oscar for her costume designs, and magazines gushed over Grace's costumes. "Woman picturegoers will find it hard to keep their minds on murder when they see *Rear Window*. Why? Because Grace makes it a tip-top fashion," wrote *Picturegoer*. "That white organdie print dress is so simple you could practically make it yourself by running up a couple of seams—but the flowers look live enough to pick: proof that, if you want to choose a print, you should go after one that is an exclamation mark."

While he often liked to refer to his actresses as "cold," Hitchcock said Kelly was "the warmest actress I have ever directed." From then on, he hoped every one of his films could star her. Perhaps he was in love with her, as many people were. But James Stewart dismissed the theory that he was consumed by unrequited love. "Why anybody would think that, I have no idea. I don't think there was a dark side to Alfred Hitchcock. He was a genius, certainly, in the brightest light that could possibly be."

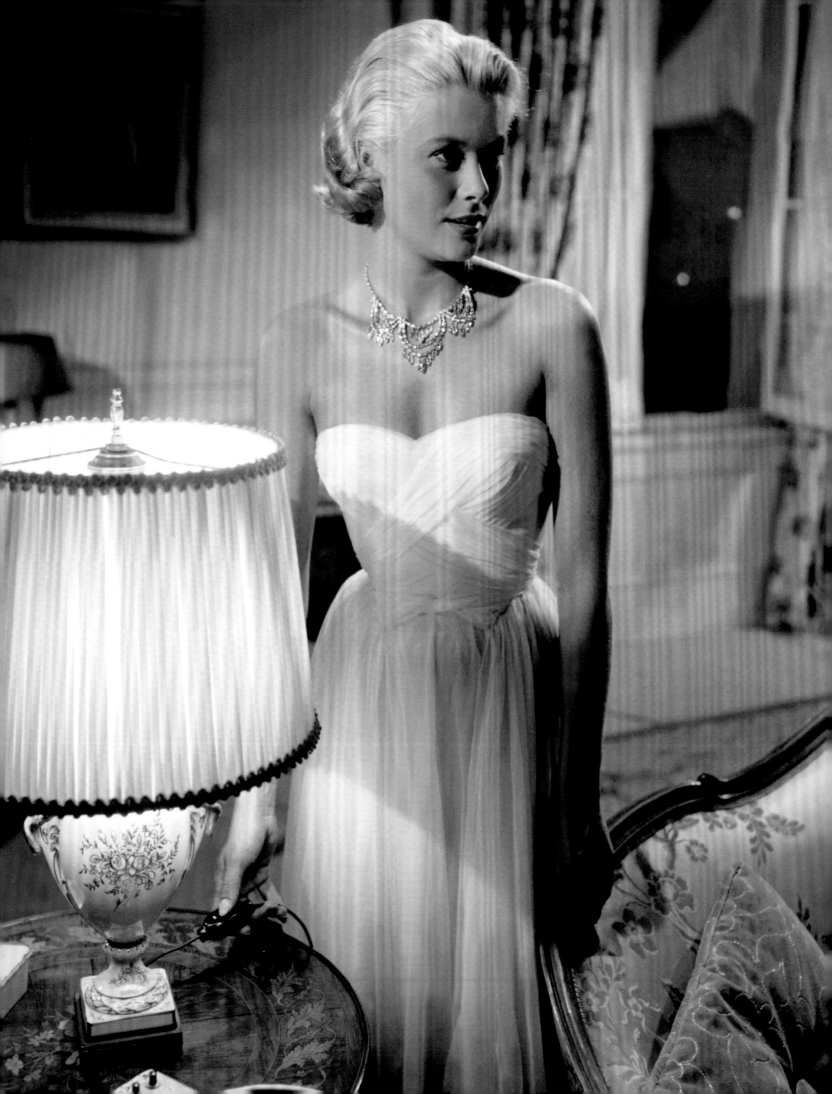

TO CATCH A THIEF (1955)
GRACE KELLY

John Robie (Cary Grant) is a retired jewel thief who lives on the French Riviera. Following a spate of new robberies, the police believe Robie is active again and attempt to arrest him.

He seeks refuge at a restaurant where his old acquaintances Bertani and Foussard work. Foussard's daughter, Danielle, has a crush on Robie and helps him get away. He escapes, believing that if he can catch the thief himself, he can prove his innocence.

He discovers that widow Jessie Stevens (Jessie Royce Landis) and her daughter Frances (Grace Kelly) top the list of most expensive jewelry owners, and becomes friendly with them.

Frances is wary of him, but eager to have some fun she seduces him. Next morning her mother's jewels have vanished and she accuses Robie. Once again he escapes from police.

Staking out an estate where he believes the thief will strike, Robie is attacked on the rooftop. He retaliates and the attacker falls to his death.

It is Foussard. The police think they have their thief but Robie realizes that Foussard could not have climbed onto the rooftop because of his wooden leg.

Frances forgives Robie and they plan to catch the thief at an upcoming masquerade ball. The police are watching them, but having arrived at the ball in costume, Robie switches places with someone in the same costume and sneaks out to the rooftop where he catches the real thief trying to escape. It is Danielle, and she confesses to the police.

To Catch a Thief was Grace Kelly's final film for Hitchcock.

François Truffaut told Hitchcock that *To Catch a Thief* was the film "that aroused the press's interest in your concept of movie heroines." It was his third outing with Grace Kelly, and Hitchcock said that "to build up Grace Kelly, in each picture between *Dial M for Murder* and *To Catch a Thief* we made her role a more interesting one."

Hitchcock ensured there was innuendo and mischief in the character of Francie, to suit Grace's natural sense of humor. "Francie is eager to be a thief," said Kelly. "She's out for kicks and thrills, and she thinks it's exciting to join up with a man she believes to be an outlaw. She was all set to climb out over the rooftops with him!"

The role may have been more interesting, but the content was frivolity. *To Catch a Thief* was a travelogue in VistaVision, taking the audience to the Riviera and all its glitz, with beautiful people and beautiful scenery. Just as *The Man Who Knew Too Much* showed travel posters for Switzerland, the film opens with the posters on display in a travel agent window. Hitchcock called it "a lightweight story," and that it "wasn't meant to be taken seriously."

The film may have been lighthearted, but his casting was perfect, and he knew he wanted Cary Grant and Grace Kelly right from early planning. Cary Grant was fifty (Grace was twenty-four years old), but he was tanned, good-looking, and debonair. They played off each other with their flirtatious double entendres, many of which were improvised.

Grant had originally planned to retire in 1953, but he was drawn back to the cinema by Hitchcock. "It was the period of the blue jeans, the dope addicts, the 'Method,' and nobody cared about elegance or comedy at all," he explained later. As for Kelly, Hitchcock said: "I'm not sure what I would have done if I hadn't been able to get Grace.

I saw her in this role ever since I bought the rights to the novel."

The film's Côte d'Azur location was as big an attraction to all involved, especially Grace, who was dreaming of France and the Edith Head costumes that she would be wearing. The film would be perfect after "the intensity of *The Country Girl* and the discomforts of *Green Fire* . . . and how could I turn down the chance for another Hitchcock picture? I was flattered he wanted me."

However, MGM didn't want to loan her out again, as they were now aware of her value and wanted her to make films for them. Hitchcock campaigned for her, and Kelly threatened to quit the studio unless she got what she wanted. She refused films that she thought were stupid, boring, or silly, and if there was little more required for her other than to be the damsel in distress. She was steadfast and confident MGM would back down and let her do *To Catch a Thief*, telling Edith Head, "No matter what anyone says, dear, keep right on making my clothes. I'm doing the picture."

She eventually got her way but had to ensure she finished *Green Fire* in time to begin location shooting on the French Riviera. By the time she arrived in France, she had worked on four films in six months, and she was exhausted. "I finished *Green Fire* at eleven o'clock on the morning of May 24. I went into the dubbing room, at one in the afternoon—and at six o'clock that evening I was on my way to France."

Paramount considered *To Catch a Thief* to be of great value, and so, in a rare act, Edith Head was sent on location to France with the production. Grace Kelly's costumes had already been made in Hollywood, but Hitchcock wanted Edith there in case there were any issues. For Edith Head, *To Catch a Thief* was "a costume designer's dream. I had a big budget, perfect people to dress, and a perfect director, as well as a great story."

Head designed "attention-getting clothes" for Francie that dripped in elegance and wealth—bathing suits, sunglasses, tailored sundresses, and gowns with a Delphic silhouette. Kelly was given pale shades—azure

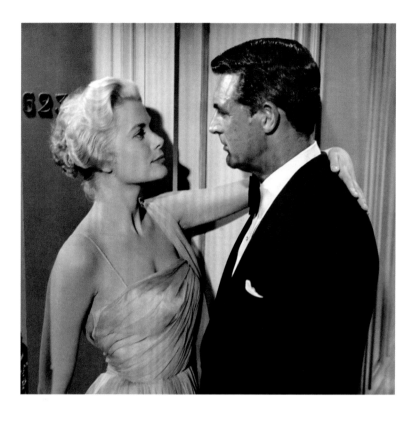

Page 124: Grace Kelly as Francie. The dress design was kept deliberately simple to showcase the diamond necklace without distraction and to suit the narrative of Cary Grant as jewel thief.

Above: Grace Kelly and Cary Grant. Many of their flirtatious double entendres were improvised.

Opposite: Edith Head's sketch of the Greek goddess-inspired gown. Its unusual ice-blue color creates a glacial first impression.

126

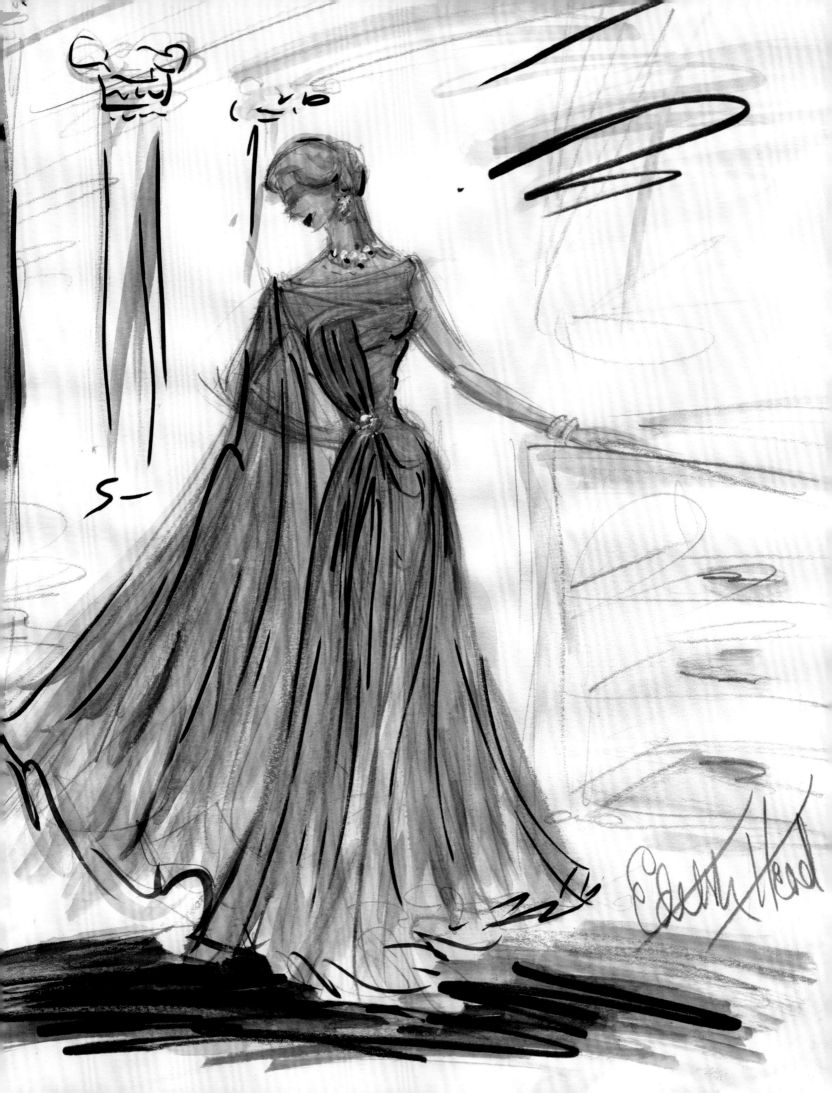

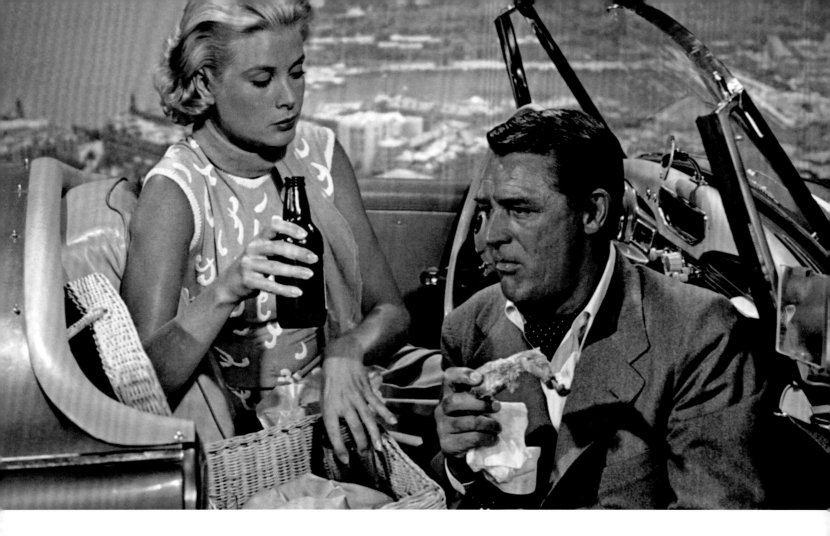

blue, lemon yellow, pale coral—to work with the bright, Mediterranean location and progressively "warm up" with the character. But as a woman of good taste, Francie wears little jewelry, in contrast to her mother who would choose to sleep in her jewelry.

Francie is first seen sunbathing on the beach in a yellow bathing suit, swimming cap, and cat-eye sunglasses as Cary Grant's John Robie walks past. The bikini was the height of fashion on the Côte d'Azur in the 1950s, and it would have been more attention-grabbing for Kelly to wear one. But both Hitchcock and the United States Motion Picture Production office wouldn't allow Grace to reveal so much.

Francie is next seen in an ice-blue chiffon dress with spaghetti straps, pleated with a sheer drape over one shoulder, and no jewelry. The gown's unusual color creates a glacial first impression, while the Greek goddess style adds to the sense of aloofness, so her natural warmth and thrill-seeking nature must be gradually highlighted through the rest of the film.

"I deliberately photographed Grace Kelly ice-cold and I kept cutting to her profile, looking classically beautiful, and very distant," Hitchcock said. "And then, when Cary Grant accompanies her to the door of her hotel room, what does she do? She thrusts her lips right up to his mouth."

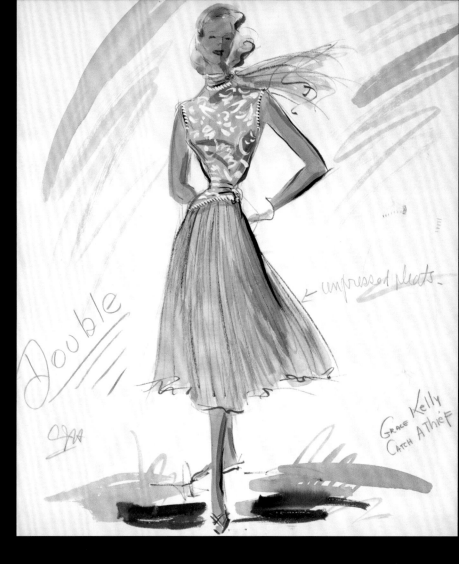

Within the sketch: Double · compressed pleats. · Grace Kelly Catch A Thief

Opposite top: In the picnic scene, the pink crêpe outfit was made to look very feminine, and lent itself well to the flirtatious nature of the dialogue.

Opposite bottom: Edith Head with Grace Kelly on the set of *To Catch a Thief*.

Right: The coral pink crêpe skirt and top as designed by Edith Head.

He claimed this scene was inspired by an evening in New York when Grace Kelly suddenly kissed him outside her room, before closing the door. This was more likely to have been pure fantasy and wishful thinking, rather than reality.

The next day Robie is taken aback when he sees Francie in the hotel lobby, and so her costume was designed to be striking in its use of monochrome—a white skirt over a black halter-neck top and capri pants, topped off with a huge sunhat. It was originally meant to be worn in the preceding hotel room scene with Francie, Robie, and her mother, but because the lobby outfit was to be startling, Francie was given an Chinese-inspired yellow and white dressing gown for the earlier scene.

While the pale blue chiffon gown had tiny straps, the white evening gown was strapless so as to act as a blank canvas for showcasing the diamond necklace. There also had to be enough fabric visible to show that she was wearing clothes in close-ups. The dress contrasts with her tan, the neckline highlights her necklace, and the fabric swishes as she walks with determination. The gown was also simple enough to allow for the fireworks to make an impact as they kiss. Head explained, "The strapless gown had to have simple lines, so that it did not detract from the necklace, yet it had to emanate an haute couture quality that matched the luxury of the jewels. Hitch was very explicit about such things."

The coral pink crêpe skirt and top, which Francie wears during the picnic scene in which she drives at high speed along the winding coastal road, was designed to be very feminine. In the preceding swimming scene, she had been humiliated by a younger woman, and so now she wants to "make a play" for Robie and look as ladylike as possible, with white gloves and a pink, silk scarf. The flirting in

at danger to come. "Hitch told me to dress Grace 'like a princess,' and I did," recalled Head. "Of course, I had no idea I was dressing a real princess-to-be!" Edith Head was inspired by a Louis XVI–themed ball held in Biarritz in 1953 by the Marquis de Cuevas, and the scene was complete artifice—perhaps Hitchcock's comment on emptiness beneath a glittering surface.

"Hitch told me to dress Grace 'like a princess,' and I did. Of course, I had no idea I was dressing a real princess-to-be!" EDITH HEAD

this scene was improvised: "Do you want a leg or a breast?" "You make the choice." The obvious innuendo gave the Motion Picture Production Code cause for concern.

The color intensified with the drama, culminating in Francie's outfit at the masked ball. She wears a Marie Antoinette–style golden wig, mask, and an eighteenth-century gown of gold lamé and mesh. The skirt was covered in golden birds, a motif common throughout Hitchcock's work, and which would hint

Hitchcock guided her through the sequence with every movement and tilt of the head, but Kelly commented later that she felt stiff in that scene. "When I see the costume ball sequence at the end, I feel very embarrassed. It seems overdone—but most of all, I did my bit in those scenes badly, and Hitch should have made me do them over."

Location shooting took place throughout June 1954, and Kelly was joined in France by fashion designer Oleg Cassini, who she had fallen in love

with and hoped to marry. They frequently went out to dinner at small restaurants in the hillside around Cannes or spent evenings in the casinos and night-clubs of Monte Carlo whenever she found some free time between shooting. Sometimes they joined the Hitchcocks and Cary Grant and his wife Betsy, and the director always supervised the restaurant and menu choices.

Everyone got on very well while filming, particularly Hitchcock and his two stars, who sparked off each other as they improvised some of the dialogue. One of the word games they played between setups was coming up with funny names for the crew, such as Otto Focus for the cameraman and Ward Robe for the costume man.

"[Kelly] had a marvelous sense of humor," Grant said. "Otherwise I don't think Hitch would have been attracted to her, because he too had a wonderful sense of humor." He claimed she "acted the way Johnny Weissmuller swam or Fred Astaire danced—she made it look easy." She never complained, even when her wrists were bruised during take after take for a scene where Robie grabs Francie's arms. Grant recalled, "Just by chance I happened to catch a glimpse of her massaging her wrists and grimacing in pain. But a moment later she came out and did the scene again—she never complained to me or to Hitch about how much her arms were hurting." Cary Grant, like Jimmy Stewart, dismissed the theory of Hitchcock's unrequited love for Grace. "Hitch may have been

sexually attracted to Grace, but so were a lot of other people. So what's the big deal?"

To Catch a Thief was released in August 1955, and it turned out to be nearly as big a hit as *Rear Window*. "If sometimes you have to make corn, try at least to do it well," Hitchcock said at the premiere. Robert Burks won the film's only Oscar for his color cinematography. Edith Head was nominated for costume design, and she said failing to win "was the single greatest disappointment of my costume design career." The costumes for the winner, *Love Is a Many-Splendored Thing*, "were blah compared to my gowns for *To Catch a Thief*."

Hitchcock's further plans for Grace Kelly included *The Trouble with Harry* and an adaptation of the stage play *Mary Rose* by J. M. Barrie. However, these roles never came to be for Kelly. It's often thought that Grace Kelly was introduced to Prince Rainier of Monaco during the filming of *To Catch a Thief*, but they actually met the following year, in 1955, when she was invited to attend the Cannes Film Festival. *Paris Match* magazine organized a photo feature with Kelly meeting the prince, and this would change the course of her life.

Opposite: Edith Head's sketch for the gold ball gown. Failing to win the Oscar for costume design was the greatest disappointment of Head's career.

Right: The gold ball gown was covered in golden birds—a common Hitchcock motif that hints at impending danger.

THE MAN WHO KNEW TOO MUCH (1956)
DORIS DAY

Dr. Ben McKenna (James Stewart), his wife, singer Jo McKenna (Doris Day), and their son Hank (Christopher Olsen) are on holiday in Morocco when they meet Frenchman, Louis. Louis offers to take them to dinner, but cancels on seeing a sinister-looking man at the McKenna's hotel.

Later, the McKennas meet English couple Lucy and Edward Drayton at dinner.

The next day they see a man being chased by police through a market. Ben realizes it is actually Louis, who whispers that a foreign statesman will be assassinated in London, and mentions "Ambrose Chappell."

Lucy returns Hank to the hotel while the police question Ben and Jo. Hank is then kidnapped but won't be hurt if the McKennas keep quiet about Louis's warning.

They travel to London and find "Ambrose Chapel," where Edward Drayton is posing as a minister and reveals that he and Lucy are terrorists planning the assassination during a concert at the Royal Albert Hall.

At the concert Jo sees the sinister-looking man from Morocco and realizes he is the assassin. As he shoots she screams, and he misses his target. He flees, but falls to his death from a balcony.

Hank is being held by the Draytons at the embassy. Ben finds him by following the sound of him whistling along to his mother singing, "Que Sera, Sera."

The film won an Academy Award for Best Song for "Que Sera, Sera (Whatever Will Be, Will Be)," sung by Doris Day.

Both Hitchcock and Doris Day had been keen to work with one another for some time, and when they met at a Hollywood party, Hitchcock promised the actress that he would find the right part for her. He had been particularly impressed with her performance in *Storm Warning* (1951), a melodrama about the Ku Klux Klan that showed her in darker, dramatic form compared to her usual light musical performances.

Hitchcock had been considering a remake of his 1934 film *The Man Who Knew Too Much* since the early 1940s, but by 1955 he was in a position to make it with the expensive gloss that marked his Paramount films of the 1950s. He had found his everyman actor James Stewart, who agreed to do the film before the script was written, while VistaVision and Technicolor allowed for the global locations to really be brought to life.

Creatively charged from the success of his Grace Kelly films, Hitchcock held out hope that he could reunite Kelly with Jimmy Stewart once more. But Kelly was unavailable due to an MGM contract dispute, and so Hitchcock turned to Doris Day. The thirty-one-year-old was a similarly trim blonde who would look good in Edith Head's costumes, but she was wholesome rather than glacial—more girl-next-door than aloof. With her popularity as a singer and musical star, the character of Jo McKenna was changed to a famous vocalist who gave up her career to be a doctor's wife and a mother. Paramount insisted that a song be created for Day to perform, and they settled on "Que Sera, Sera," by Jay Livingston and Ray Evans. Hitchcock thought it worked, yet Day was unconvinced of its merits. To her surprise, the song won the Academy Award for best song and would become the number most closely associated with her.

The 1934 version of *The Man Who Knew Too Much* opened in St. Moritz, Switzerland, as this was where the Hitchcocks had spent their honeymoon. But for the remake, the location was transplanted to the bustling souks and desert landscapes of Morocco, offering a contrast to the gloomy streets of London in the second half of the film. While the first film played to fears of Hitler and Nazi Germany, in the 1950s the paranoid threat was the Soviet Union and the Cold War. Whatever the location, the terror of the plot came from ordinary people plunged into chaos.

There were few actors considered more apple-pie American than James Stewart and Doris Day, so the English couple of the original film became tourists from the Midwest with a son rather than a daughter. The characters seem at times ignorant of the customs of the country they are visiting, but Jo McKenna is strong and self-reliant, and despite giving up her career for the Midwest, she retains contact with her friends from the stage in London. She and husband Ben hint at their monthly arguments, and she wishes they could talk about having another child. She may have some regrets about the career she left behind, but, by the end of the film, it is her music that saves her son.

Associate producer Herbert Coleman was concerned that Doris Day didn't possess the acting range for some of the more dramatic scenes, but

Page 132: Doris Day in a tailored gray suit by Edith Head. It was designed to blend into the gloomy London scenes and not distract from the plot.

Above: Hitchcock watches as Doris Day and James Stewart shoot a scene on location in Morocco.

Opposite: Doris Day and Alfred Hitchcock on location during the London scenes of *The Man Who Knew Too Much*.

DORIS DAY

Born Doris Mary Ann Kappelhoff in Cincinnati, Ohio, in 1922, Doris Day changed her name when she became a singer with big bands in the 1940s. Her first hit single was "Sentimental Journey," the anthem of troops heading home during the war. Day crossed over to cinema for hit musicals including *Calamity Jane* (1953), winning the Oscar for best song.

Throughout the 1950s she tested her skills with dramatic roles, but it was her romantic comedies that cemented her as the biggest box-office star in the world. She was paired with Rock Hudson in *Pillow Talk, Lover Come Back,* and *Send Me No Flowers,* and Cary Grant in *A Touch of Mink,* earning her the nickname "the World's oldest virgin." Day turned down the part of Mrs. Robinson in *The Graduate* because she found it "vulgar and offensive." When third husband Marty Melcher died in 1968, she was shocked to discover he had misappropriated all her money, forcing her to do *The Doris Day Show.* She continued on television throughout the 1970s, but retreated from the public eye to become an animal activist, living in Carmel-by-the Sea.

Opposite: Hitchcock liked to harmonize costumes with scenes, and the blue linen shirtwaist dress worn here by Doris complements the blue palettes and sand tones of Morocco.

he was convinced after he saw the way she handled the sedative scene. Jo's husband, Ben, decides to drug her before breaking the news that their son Hank has been kidnapped, and Day made this scene traumatic, emotional, and somewhat disturbing as she tearfully tries to fight the drowsiness. During another poignant scene, Day broke down in sobs, which had not been specified in the script. When Hitchcock questioned why she was crying, she pointed out that her child had just been kidnapped and she may never see him again, so "of course I'm crying." It was possibly the most emotional performance of one of his leading ladies, brought by Day's experience rather than Hitchcock's direction.

During a first meeting at Paramount Studios, Hitchcock and Day discussed the clothes she would be wearing, and she found the director was "very precise about exactly what he wanted for my wardrobe." Hitchcock asked Edith Head to design a tailored gray suit for the scenes set in London, which shares strong similarities to the structured gray suit Kim Novak wears in *Vertigo*. This suit was a practical costume for a woman who was traveling, while the color, blending into the gloomy brick buildings and quiet streets of London, would not distract from the plot.

As the McKennas arrive in Morocco in the opening scenes, Jo's costume is more relaxed, with a white shirt, black tie, and beige jacket. For evening drinks and dinner at a Marrakesh restaurant, Jo wears an organdy dress with green sprig design, layers of petticoats, and a matching wrap. Not only did it reflect Hitchcock's preference for green, but it heightened the sense of the character as a wife and mother. The blue linen shirtwaist dress with a white belt and white basket was designed for daytime sightseeing, but it carries through to the drama in the police station. Hitchcock often visualized a harmony in both costume and set design, and so the color of this dress complements the palette of blues and sand tones in the Moroccan scenes, standing out against the orange of the Marrakesh bazaar while blending with the pale blue of the hotel room.

"I always looked forward to my fittings with Edith," Doris Day recalled. "She was witty, quick, and very exciting. She dresses actors for the part, not for themselves alone. They weren't right for me.

> "I always looked forward to my fittings with Edith. She was witty, quick and very exciting. She dresses actors for the part, not for themselves alone." DORIS DAY

But they were just what a doctor's wife would wear. And that's what I was playing."

However, she must have liked the wardrobe more than she admitted, as Paramount offered to sell Day the costumes she wore in the film for half the cost.

Day was terrified of flying and had never even been out of the United States, which made it difficult for the location filming in Marrakesh and London. The actress was managed by her husband Marty Melcher, and he negotiated with Paramount for expenses and travel for the couple and their son. To avoid flying, the Melchers took the Super Chief train from Los Angeles to New York, and the RMS Queen Elizabeth ocean liner to Southampton. They then traveled to Paris and on to Cannes, where she would make an appearance at the Cannes Film Festival. From Cannes, they took the boat to Casablanca and a bus to Marrakesh, and this whole trip took a month. She brought with her the three pieces of luggage that contained her costumes for the film, as it would save on import duty if she carried it as her personal wardrobe.

As leading lady, Day's appearance on screen was of great importance, and so hairdresser Virginia Darcy accompanied the production on location to ensure her hairstyle was well attended to. There were also concerns from producers that the Moroccan sun had given Day a deep tan and enhanced her freckles. These showed up in the close-up shots, but they preferred her to look less natural and more "made-up."

While it was James Stewart's character who struggled to come to grips with local customs, particularly with some humorous moments in the dining scene, Doris Day grappled with culture shock in real life. She found that Marrakesh was "ungodly hot," and was particularly disturbed by the poverty on display.

Art director Henry Bumstead remembered "going out to a restaurant with Doris Day and eating couscous. You know, you use so many fingers. But Hitch never did that. Doris Day wouldn't do that, either. She wouldn't eat anything people had their hands in."

Hitchcock also found Marrakesh uncomfortably hot and busy, and he even changed out of his customary suit and tie for a short-sleeved shirt, although he still kept it buttoned up to the neck. Production manager Doc Erickson reported that Hitchcock "was ready to go home as soon as he arrived. He's not even keen about going to London, but he's committed himself to those damned interiors up there now . . . well off to the square and to the howling mob again—it's been plenty hot here, too." Filming took place during Ramadan, during which the extras appeared to be low on energy due to fasting, and a degree of tension resulted in armed guards being rushed in to control the crowds. But as Bumstead added, "It's a great experience—heat, rush, dirt and all."

Above: Doris Day in an organdy dress with a green sprig design. On set, she grappled with the heat and cultural customs such as eating food with fingers, as did Hitchcock.

Opposite: Doris Day and Alfred Hitchcock in London during filming of *The Man Who Knew Too Much*.

Despite the difficulties in adjusting, Day was still a complete professional who required little guidance from her director. But a lack of input from Hitchcock left her feeling insecure. "Not once did Hitchcock say a word to me that might have indicated he was a director and I was an actress," she said. "I loved him personally," Day said. "We would go to dinner and laugh, and he was warm and loving, just really sweet. But I didn't understand him on the set." Like other actors who worked with Hitchcock, Day didn't understand why he observed a scene but rarely stepped in to guide it. In exasperation, she asked for a meeting with the director to find out what she had been doing wrong. "He was

astonished," she recalled. "He told me it was quite the reverse, that he thought I was doing everything right—and that if I hadn't been doing everything right, he would have told me." Hitchcock also explained his own insecurities to Day—often he was afraid of walking across the Paramount lot as he felt nervous when meeting other people.

The Albert Hall grand finale was a ten-minute, dialogue-free scene, with the dramatic music of the live orchestra covering up all other sound as anticipation builds for that fateful clash of the cymbals. As with the first film, we see the gun slowly push out from behind the curtain and then hear the mother's scream, which ultimately distracts the killer. But it is Doris Day's emotional rendition of "Que Sera, Sera," singing passionately in the hope that her son will hear her and reveal where he is being held, that holds the key to the drama of these sequences.

As Philip Hensher wrote in the *Guardian*: "The ripple of hope, despair, and passionate attachment across Day's face is mesmerizing, as is the simultaneous surface glitter and smile she puts on to entertain the audience." Hensher describes it as the most emotional, warm performance in a Hitchcock film, and this refusal to be icy was perhaps the reason why he never used Doris Day again.

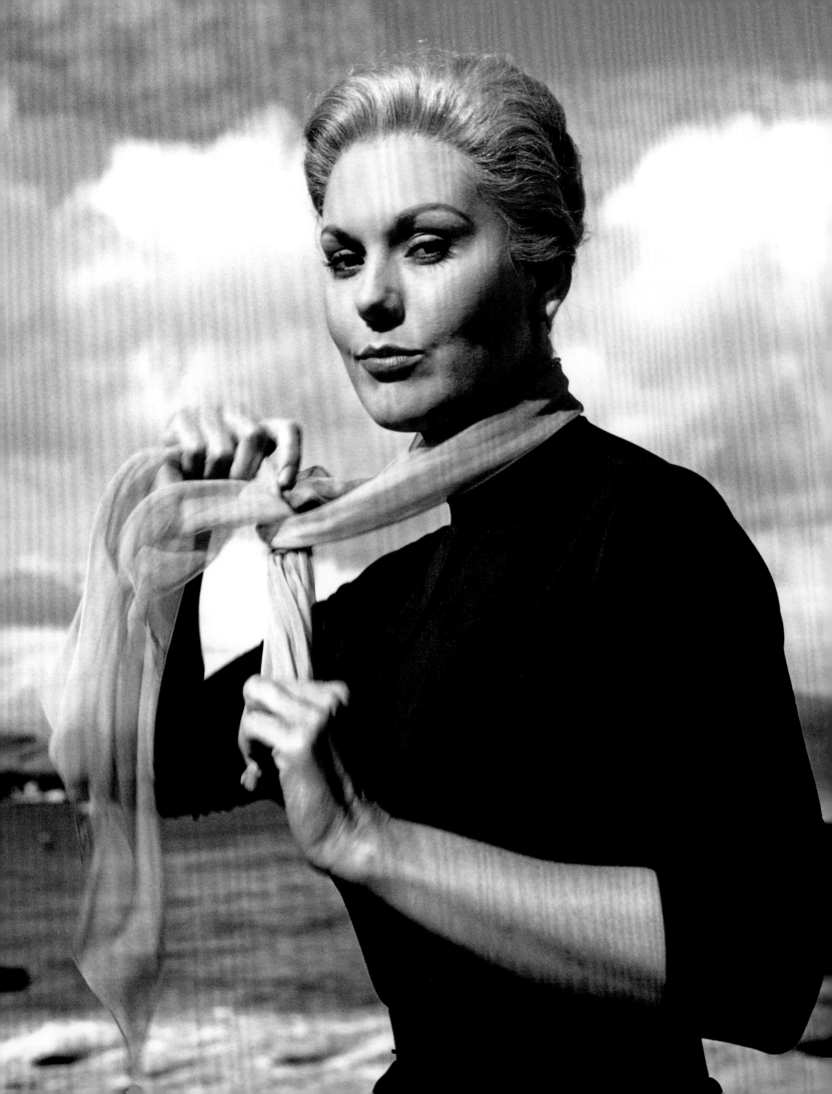

VERTIGO (1958)
KIM NOVAK

Scottie (James Stewart) is a retired police detective with a fear of heights. An old friend, Gavin, asks him to follow his wife, Madeleine (Kim Novak), claiming she has been possessed.

Scottie tails Madeleine and sees her looking at a painting of Carlotta Valdes, who Gavin says is haunting Madeleine. She attempts to drown herself in the San Fransisco Bay, but Scottie rescues her.

They spend the next day together and Madeleine recounts a nightmare to Scottie. He identifies its setting as Mission San Juan Bautista and drives her there. Suddenly Madeleine runs up to the church's bell tower. Scottie, halted by his vertigo, sees Madeleine plunge to her death. Scottie has a breakdown. Once recovered, he notices a woman who reminds him of Madeleine, but is called Judy.

A flashback reveals that Judy was the person Scottie knew as "Madeleine." Judy writes a letter to Scottie explaining that Gavin had paid her to impersonate his wife, deliberately taking advantage of Scottie's vertigo, so that he could fake his wife's suicide, throwing her body from the bell tower. But she destroys the letter.

Scottie becomes obsessed with "Madeleine," asking Judy to change her clothes and hair. When he notices her wearing the necklace in the painting of Carlotta, he realizes the truth and drives her to the Mission.

He forces her up the bell tower. Scottie reaches the top, finally conquering his acrophobia. Judy confesses her deceit and begs Scottie's forgiveness. He embraces her, but a shadowy figure appears, startling Judy, who falls to her death.

Vertigo, a film about obsession and identity, is often considered to be Hitchcock's most autobiographical. It is a hypnotic film that mirrors his control over the image of his actresses. For Hitchcock, he said he "made the film in order to present a man's dreamlike nature."

Partly inspired by French arthouse cinema and *Les Diaboliques*, *Vertigo* was more aligned with the beatniks in the North Beach and Greenwich Village coffee houses than a mainstream audience. Saul Bass, who created the iconic movie poster, looked to European film posters, suggesting a man and woman trapped in a vortex, and playing to the themes of fate and eternity, as well as the spiral motifs featured throughout the film.

Kim Novak plays both the mysterious Madeleine and the earthy Judy, whose identities are bound by what they wear. Madeleine floats, ghostlike, through her scenes, in a gray suit like the San Francisco fog, as we are led to believe she is haunted by a suicidal eighteenth-century Spanish aristocrat. Judy, in her bolder, gypsy-like clothing, wants to be liked for who she is, but instead she is made over into the exact image of the ghostly Madeleine.

In *D'entre Les Morts*, the book on which the film was based, the wife's name was also Madeleine, and she wore her hair in a tight bun, with her figure wrapped in a "smart gray suit" cinched tight at the waist. For Hitchcock, the San Francisco location was so important that he sent the first scriptwriter, Maxwell Anderson, on an all-expenses-paid trip to research sites such as the harbor, bridge, San Juan Bautista, and Mission Dolores, where Madeleine creates the illusion she is possessed by a woman of the past.

Filming was delayed while James Stewart insisted on some time off. In the meantime, Hitchcock's new protégée, Vera Miles, was being shaped into the dual character with extensive wardrobe planning and testing with Paramount's head designer Edith Head.

The film was further delayed for Hitchcock to undergo an operation, but by that time Miles was expecting her third child. After losing yet another actress (Ingrid Bergman and Grace Kelly had both gotten married), he "lost interest" in Miles and "couldn't get the rhythm going with her again." He said, "I was offering her a big part, the chance to become a beautiful sophisticated blonde, a real actress. We'd have spent a heap of dollars on it, and she has the bad taste to get pregnant."

Kim Novak was loaned to Paramount from Columbia Pictures for a substantial fee, of which she only received a fraction. But because she was another studio's property, Hitchcock would not control her in the way he did Miles, who was contracted to Hitchcock directly.

Novak could understand the feeling of being made into someone else, having been groomed by Columbia boss Harry Cohn to take over from Rita Hayworth in 1953 as the studio's biggest star. Columbia marketed her as the "Lavender Blonde" with the voluptuous figure and cool-as-ice looks. By 1957 Novak was one of the top stars in Hollywood. She was admired for her ethereal blonde looks and figure but not so much for her acting skills, which were often made fun of in the press. Hitchcock told *Picturegoer* in 1958: "She's the world's sexiest star and I've actually got her to act. I used the psychological approach. I bolstered her ego." The writer of the article agreed, saying dismissively of Novak that "the screen's sleeping beauty actually shows signs of life . . . when a waxwork doll acts human it's a shattering experience."

"Of course, in a way, that was how Hollywood treated its women in those days," Novak said. "I could really identify with Judy, being pushed and pulled this way and that, being told what dresses to wear, how to walk, how to behave. I think there was a little edge in my performance that I was trying to suggest that I would not allow myself to be pushed beyond a certain point."

Novak requested her wardrobe, makeup, hairdresser, and body makeup personnel from Columbia, but as the wardrobe had already been planned by Edith Head for Vera Miles, there wasn't much room

Page 140: Kim Novak in character as "Madeleine" in *Vertigo*.

Above: Edith Head's costume sketch for the gray suit.

Opposite: Kim Novak in the gray suit from *Vertigo*. She hated it but came to appreciate its role in making her feel uncomfortable as Judy dressed in Madeleine's clothes.

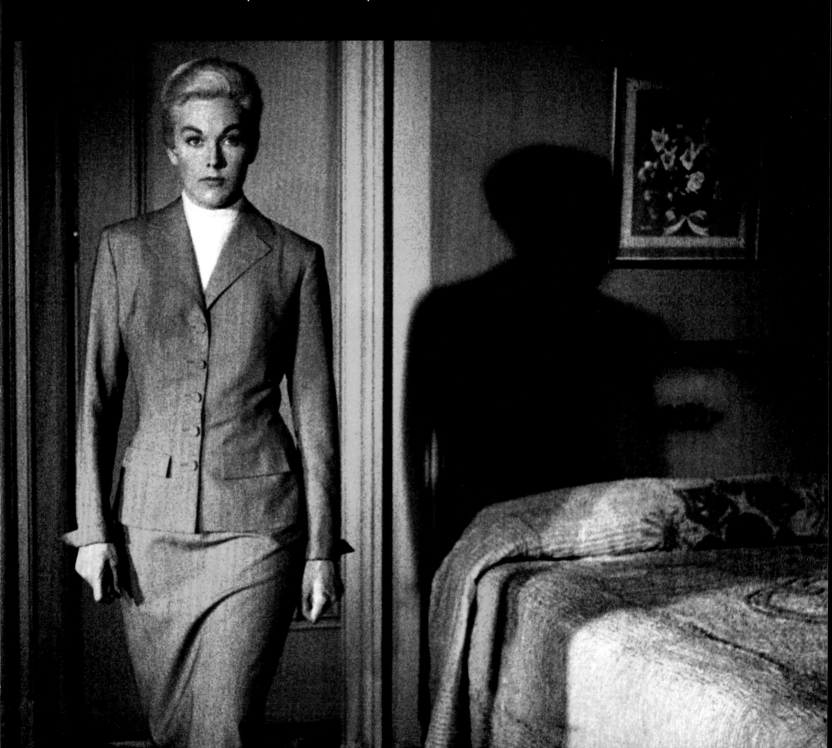

"I could really identify with Judy, being pushed and pulled this way and that, being told what dresses to wear, how to walk, how to behave." KIM NOVAK

Run N.

None must be text-
 pe 39-43.
skirt pg 54
full. or
full top

top on
left
 or
 right

keep cuffs
to make sure
of dots -

check
appro
on
spe
ba

—text skirt

okay to fix

Edith Head

for negotiation. For the mysterious character of Madeleine, Hitchcock was very specific that she should wear a gray suit with black heels.

He told Head "the girl must look as if she's just drifted out of the San Francisco fog." For Scottie (the character played by James Stewart), the gray suit is key to Madeleine. He can't be with Judy until she puts it on. Head explained that Madeleine "walks and drives a car in San Francisco, where everyone wears suits—and the script specifically calls for a gray tailored suit."

Novak met with Head to look over the sketches and discuss her costumes, but she was insistent that she didn't want to wear gray or the black shoes, because, according to Head, "they would exaggerate what she thought were her rather fleshy calves." The designer told Novak she should speak with Hitchcock if she had issues with the costume. Head said: "I don't usually get into battles, but dressing Kim Novak for her role in *Vertigo* put to the test all my training in psychology."

Head explained to Novak that color was vital, because Hitchcock painted his films like an artist. "The character would go through a psychological change in the second half of the film and would then wear more colorful clothes to reflect the change," she said. "Even in a brief conversation, Hitch could communicate complex ideas. He was telling me that women have more than one tendency, a multiplicity of tastes, which can be clouded by the way they view themselves at any particular moment. He wasn't about to lose that subtle but important concept."

Over lunch with Hitchcock, Novak explained the gray suit was too restrictive, while the black shoes made her feel disconnected and "pulled down." "Look, Miss Novak," he said, "you do your hair whatever color you like, and you wear whatever you like, so long as it conforms to the story requirements." Hitchcock later told François Truffaut: "I used to say, 'Listen. You do whatever you like; there's always the cutting-room floor.' That stumps them. That's the end of that."

Opposite: An Edith Head costume sketch for the character of Judy. Head found Novak difficult to please and said she had to "put to the test all my training in psychology."

Above: Kim Novak as Judy who is voluptuous in tight sweaters and cheap jewelry.

KIM NOVAK

Marilyn Pauline Novak, born in 1933 in Chicago, won two scholarships to the School of the Art Institute of Chicago, but after modeling work for a refrigerator company and a small chorus part in the Jane Russell film *The French Line* (1954), she was discovered and signed to Columbia Pictures. With a name that was too similar to Marilyn Monroe, she was changed to Kim, and billed as the Lavender Blonde and the new Rita Hayworth.

Novak became a huge star with roles in *Picnic* (1955), *The Man with the Golden Arm* (1955), *Pal Joey* (1957), and *Bell, Book and Candle* (1957). She felt great pressure from having her image, and her relationships, controlled by Columbia Pictures, and by the late 1960s she left acting to concentrate on visual arts, taking on occasional TV roles such as *Just a Gigolo* (1979) opposite David Bowie and *The Mirror Crack'd* (1980).

She moved to a ranch in Oregon with husband Robert Malloy, retreating from public life to work as an artist.

After Hitchcock explained it, she accepted that the director wanted her to feel the discomfort of Judy, who is embodying the image of someone else. "I hated that silly suit," Novak later said. "But it helped me to be uncomfortable as Madeleine."

Head showed Novak a new set of suit sketches demonstrating the different possibilities for gray, with "swatches of the most beautiful sheer wool fabrics you've ever seen; cold grays, warm grays, pink grays, blue grays, slate grays," which helped her like that stiff suit just a little more. Completing the outfit was a gold bird pin to suit the name Madeleine Elster, which is German for magpie. The beautiful black satin gown and coat lined with emerald green worn in the restaurant scene also helped appease Novak and take away the sting of the gray suit.

Novak's fashionable blonde crop was a trendsetter at the time, but she was given wigs to wear as both Madeleine and Judy—the severe, blonde pulled back chignon for Madeleine that represents a vortex and the long, brasher chestnut hair for Judy.

Novak specified that she preferred to go without a bra, and this was acceptable for earthy Judy, who is brassier and voluptuous in tight sweaters, heavier make-up, and cheap jewelry. It's also interesting that Midge, who has an unrequited love for Scottie, is a brassiere designer. Judy has obvious sexuality and an appetite, whereas Madeleine is cold, untouchable, and as blonde as can be, in that it is artificial peroxide.

"It killed me having to wear a bra as Madeleine, but you had to, because they had built the suit so that you had to stand very erect or you suddenly were 'not in position,'" Novak explained. "It was wonderful for Judy because then I got to be without a bra and felt so good again. I just felt natural. I had on my own beige shoes and that felt good."

Hitchcock used color in *Vertigo* to paint meaning into every scene. Red is the color of Scottie's fears, while green represents Madeleine (she even drives a green car). The first time we see Madeleine is in a vivid red restaurant, wearing an emerald cape. Judy is first introduced in a green outfit to link her with Madeleine—a moss green pencil skirt, green sweater with polka dot collar and cuffs (to hint at the red polka dressing gown worn by Madeleine), and a little rabbit brooch at the neckline. When Judy tries to assert her own identity, she chooses a lavender dress or a yellow shirt, but with a hint of green in a scarf and in a skirt to reference Madeleine.

Judy, whose hotel room has a green neon light outside, emerges from the bathroom as an ethereal ghost bathed in light, having been made over by Scottie in Madeleine's image. The camera circles them as they kiss, as Scottie is hypnotized by this vision.

Hitchcock thought Novak had grandiose ideas about herself and arrived "with all sorts of preconceived notions that I couldn't possibly go along with." But he was cordial, and the cast felt that they got on well. Novak has maintained that she has nothing but good things to say about Hitchcock. She said to the *Telegraph* in 2014, "I didn't find him controlling whatsoever. I found him a joy. I did not find him to be weird at all. I never saw him make a pass at anybody or act strange to anybody. And wouldn't you think if he was that way, I would've seen it or at least seen him with somebody? I think it's unfortunate when someone's no longer around and can't defend themselves."

After instructing her to wear the gray suit, she respected his reasons for the character. She thought, "He knows my point of view, he must see a reason why that would work. He wants me to feel that discomfort as Madeleine. And, of course, she should feel that way because she's actually Judy, playing the part of somebody, so that edge of discomfort will help me."

The ending of the film was a departure from anything Hitchcock had done before, as it showed the failure of the hero and the death of the leading lady. Unlike Cary Grant's character in *North by Northwest*, Scottie is unable to save her from falling. This, as well as the film having a more "arthouse" feel, led it to flop on its release. It wasn't until later that it gained the recognition it deserved: It is now considered one of the best films ever made.

Opposite: Edith Head's sketch of the white coat Kim Novak wears in *Vertigo*. The coat's color reflects the coldness and unavailability of Madeleine, while the black dress and scarf offers a morbid foreshadowing of her death.

Above: Kim Novak wears a spectacular white coat designed by Edith Head in *Vertigo*.

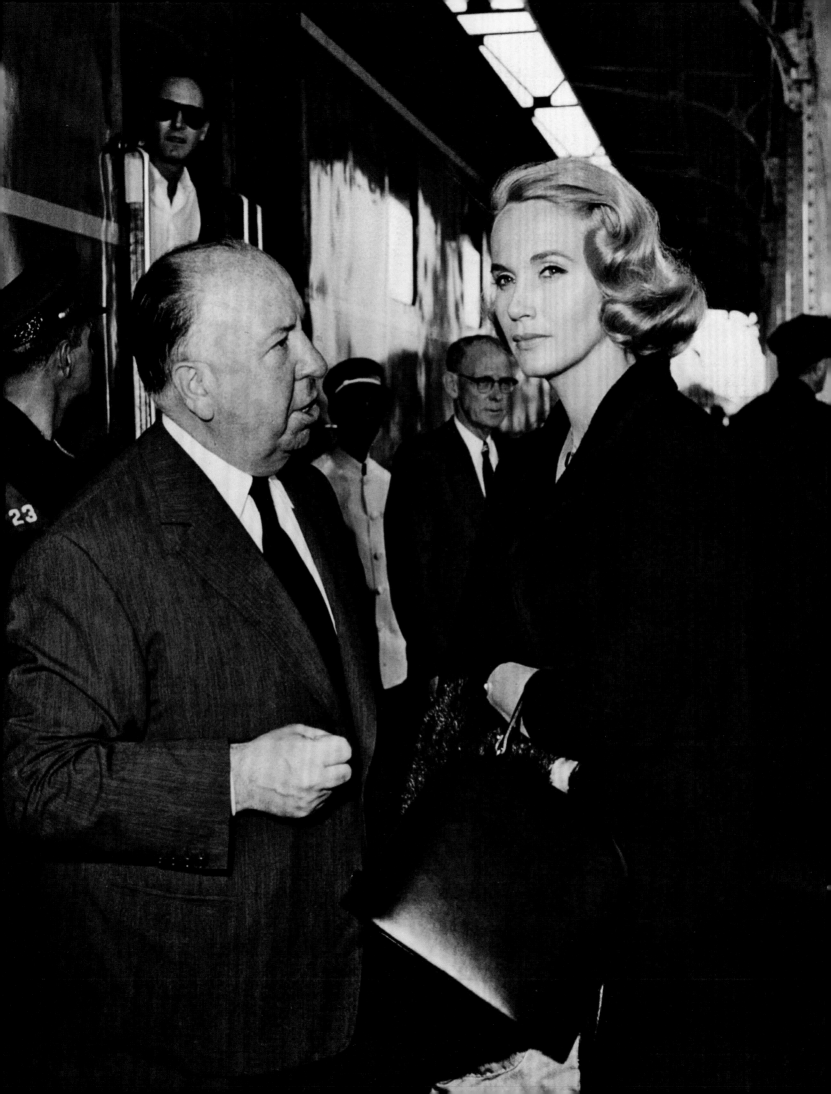

NORTH BY NORTHWEST (1959)
EVA MARIE SAINT

Roger Thornhill (Cary Grant) is mistaken for "George Kaplan." Kidnapped, he is taken to Lester Townsend's house and interrogated by spy Phillip Vandamm (who Thornhill assumes is Townsend).

Vandamm tries to kill Thornhill, but Thornhill escapes. He then learns that Townsend is a United Nations diplomat but on meeting him, discovers that he is not the man he met before. When Townsend is then killed, Thornhill flees and attempts to find the real "Kaplan."

On the train to Chicago Thornhill meets Eve Kendall (Eva Marie Saint). Unknown to Thornhill, Kendall is working with Vandamm. She arranges a meeting between Thornhill and "Kaplan"; although it is really a set up to kill Thornhill by crop duster.

Thornhill then tracks Kendall to an art auction, where he also finds Vandamm.

Thornhill gets away by forcing police to arrest him. They take him to the government agency's intelligence chief, a man called "The Professor," who reveals that Kaplan does not exist and was invented to distract Vandamm from the real government agent: Kendall. Thornhill agrees to help maintain her cover.

Meeting on Mount Rushmore, Thornhill (as Kaplan) negotiates Vandamm's turnover of Kendall in exchange for freedom to leave the country. Kendall shoots Thornhill "fatally" with a handgun (loaded with blanks), and flees.

Later, Kendall escapes from Vandamm and with Thornhill climbs down Mount Rushmore. She almost falls to her death, but Thornhill grabs her and proposes while hauling her up.

When ninety-year-old Eva Marie Saint recounted her experiences working with Hitchcock during a retrospective at the Hollywood Bowl in 2014, she anticipated "people are going to be disappointed because my stories are so nice." Eva spoke many times over the years about her warm memories working with Hitchcock, commenting in 1958: "He's wonderful, has no pretences, and doesn't take himself too seriously. That's what makes him such a wonderful director."

Eva Marie Saint was happily married with two young children when she was cast as Hitchcock's latest blonde, the Mata-Hari secret agent Eve Kendall in *North by Northwest*, opposite Cary Grant. She was highly regarded in Hollywood as a method-trained actress, but her career had been on pause while she devoted time to her children and set up home in Mandeville Canyon. She generally played downtrodden characters such as Edie Doyle in Elia Kazan's *On the Waterfront*. When she won the Oscar for Best Actress for that role, the heavily pregnant Eva joked that she might give birth on the stage because of her excitement.

Following the box-office disappointments of *The Wrong Man* (1956) and *Vertigo* (1958), *North by Northwest* was a return to the classic Hitchcock film, with its hybrid of adventure, romance, and suspense, plus a story involving a wrongly accused man pursued by both criminals and the police. It was a huge hit and major talking point of 1959, as lines outside cinemas snaked around the corner and tourism to Mount Rushmore, the setting of one of its major scenes, was given a boost.

The film oozes 1950s aesthetics, from Saul Bass's modernist opening credits that represent both the lines of a Manhattan skyscraper and map gridlines, to the Frank Lloyd Wright–style home in North Dakota. It was filmed in VistaVision Technicolor, to capture, as *Variety* praised, "the

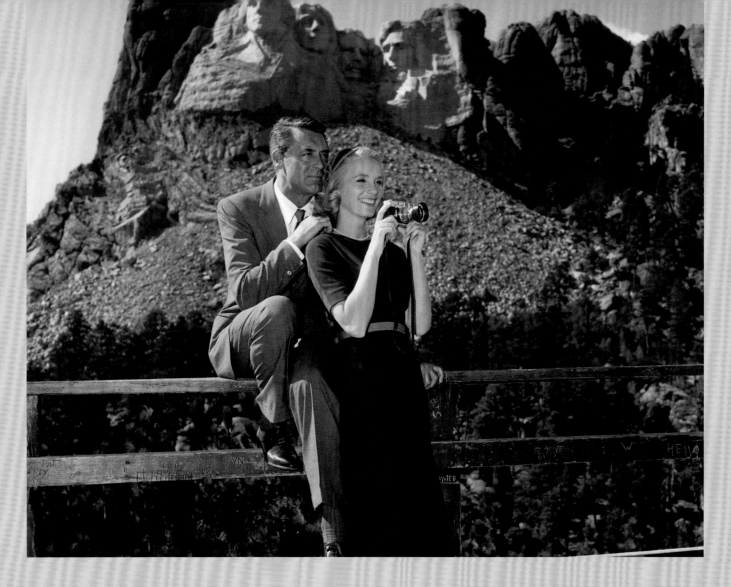

hot yellows of the prairie, or the soft green of South Dakota forests."
It reflects the stark change in setting as advertising executive Roger
Thornhill is taken from a business meeting at the Oak Bar in the Plaza
Hotel to a drunken escape through Long Island, and from the United
Nations to an encounter with a crop duster in Indiana and a final show-
down on Mount Rushmore. And all this time he wears one suit—a
Glen Plaid flannel suit with no vents, which was the fashion at the time
for advertizing men on Madison Avenue. Filmed from mid-summer to
late autumn in 1958 at locations across the United States, followed by
interiors on the studio back lot, *North by Northwest* captures the fashions
of late 1950s America, a place and time of new wealth and consumerism,
with New York buzzing as the advertizing and financial capital.

When it came to casting the lead actress, MGM suggested Cyd
Charisse or Sophia Loren, two indisputably sexy brunettes who were
both on contract to the studio. Sophia Loren was also a favorite choice
for Cary Grant, who was unofficially engaged to her for a brief time, but
Hitchcock had hoped that he could lure Grace Kelly back to Hollywood.
When that ambition was unsuccessful, focus turned to Eva Marie Saint.

Also a Nordic blonde, Eva was very intelligent and well-regarded but not considered a sex symbol, having up until then played drab and downtrodden characters in "kitchen-sink dramas." "You don't cry in this one," Hitchcock told her. "There's no sink."

Saint was invited to an initial lunch meeting with Hitchcock and his wife, Alma, at their home in Bel Air, California, arriving in a beige dress and little white gloves because her mother had read that Hitchcock liked women in beige and wearing gloves. Hitchcock was impressed with the actress, feeling that he could transform her into the "alluring woman" in the script. She found his guidance helpful while she shaped the character. He supervised hair, wardrobe, and makeup and provided instructions for how she could become the confident character he envisioned. For Saint, Hitchcock was just as serious as Elia Kazan, who, as a method-director, would whisper in the ears of each actor before emotional scenes. Hitchcock was more focused on outward appearance, starting with externals and working inwards, and offering three key pieces of advice: lower her voice to stop it rising when excited, keep her hands still, and always look Cary Grant in the eye when talking to him, as her confident character would do. Hitchcock "believes in close-ups," Saint said. "This is the first film I've ever made with so many of them. He helped me control my facial expressions. You know Eve Kendall has a lot going on in her life. She's been around, but she's cool and calculated."

Saint created a nuanced portrayal of the conflicted double agent, a woman who is definitely not a passive blonde. She saves, seduces, and then betrays Thornhill, but she must fight her emotions as she makes the choice between following her heart and protecting her country. From dowdy and shy characters to a seductress spy who could "tease a man to death without half trying," Saint's role was considered quite a transformation. Sheilah Graham wrote in her column on the film's release: "You must have been as surprised as I was at the magical change in the actress I'd always thought of as pale, wan and a trifle on the mousy side. In this movie she literally, figuratively and physically sparkled with sex appeal."

Eva Marie Saint glowed under Technicolor, and it was her new look that was one of the main attractions. Louella Parsons reported that "for

Page 148: Hitchcock directing Eva Marie Saint as Eve Kendall on the set of *North by Northwest*.

Opposite: Cary Grant and Eva Marie Saint. *North by Northwest* was a box-office success and boosted tourism to Mount Rushmore.

Above: The costumes in *North by Northwest* capture the fashions of late 1950s America; a time of new wealth and consumerism. This MGM costume sketch was rejected by Hitchcock, who selected Eve's wardrobe off-the-rack.

EVA MARIE SAINT

Eva Marie Saint was born in Newark, New Jersey, in 1924, and studied teaching at Bowling Green State University, before switching to acting after trying out on stage. She moved to New York where she worked as an NBC page, while also doing countless rounds of auditions for live radio and TV shows and commercials. It was while auditioning that she met producer Jeffrey Hayden, also job hunting in New York, and they were married in 1951 until his death on Christmas Eve 2016.

Eva Marie studied at the Actors Studio, helping train her for the role of Edie Doyle in *On the Waterfront*, winning the Academy Award for Best Supporting Actress. The film launched her film career, and she and Hayden moved to Los Angeles with their two small children. She starred in *A Hatful of Rain* (1957) and *Raintree County*, before Hitchcock made the surprise decision to cast her in *North by Northwest*. She balanced acting with family life, choosing only the occasional film, but continued acting into her eighties and nineties, including as Martha Kent in *Superman Returns* (2006).

the first time in a movie Eva Marie wears a gorgeous modern wardrobe that shows off her streamlined figure." She wears two popular styles of the late 1950s: narrow Chanel-style pencil skirts with suit jackets, and a full skirt that owed its style to Christian Dior's New Look, worn with a matching bag and gloves, as was the fashion of the time. Hitchcock had definite ideas of how Eve Kendall would look. She was to be dressed like a kept woman, and to match the part, Hitchcock told Hedda Hopper, "I've extracted every bit of sex she has and put it on the screen. Also gave her beautiful clothes. I dislike drab females on or off screen."

Saint was to wear more makeup around the eyes, as Hitchcock didn't want "the wide-eyed all-American look," as the actress told Sheilah Graham in 1959. Hitchcock also insisted that MGM's star hairdresser, Sydney Guilaroff, cut her hair into a chic bob, as he thought it looked more exotic. It took Guilaroff "hours and hours and hours to get the natural look." Eva also added during publicity interviews that playing the character was difficult to shake off at the end of each day. "Driving home, I'd find I'm still this woman, Eve Kendall—my eyes half closed, speaking in low tones. I could only get back to being me when I took off all the makeup and put on my own clothes, and knew I was home."

Edith Head was too busy with Paramount Pictures to be loaned out to MGM, so Helen Rose, MGM's celebrated designer, was assigned to the film. But she had a full schedule, so she supervised while Harry Kress created sketches. But after Saint was photographed in each outfit for wardrobe tests, Hitchcock was not satisfied, feeling she looked as if she was still the waifish character in *On the Waterfront*. It may not have helped that, at the time of these photographs, she hadn't yet adopted the heavy-lidded gaze of Eve, or her confident stance and body language.

The plan was to ship the wardrobe out to Chicago on September 8, 1958, to begin principal photography, which left no time to make up a new set of sketches. So Hitchcock and Saint went shopping at expensive department store Bergdorf Goodman in New York, where they viewed a parade of models in various suits and gowns, and Hitchcock felt like a rich man overseeing her wardrobe, "just as Stewart did with Novak in *Vertigo*."

They chose a black suit, a charcoal brown full-skirted jersey dress, and a burnt orange dress and jacket. One of Eve's most striking costumes is a black, long-sleeved cocktail dress printed with red roses, which she

On the clapperboard:

8-27-58
PROD NO. 1743 TITLE
ACTOR Eva Marie Saint ROLE EVE
CHANGE NO. SCENE
SET
SYNOPSIS
CHG # 3
ART
GALLERY
REMARKS
DESIGNER COSTUMER
COLOR B & W DATE

wore to the art auction. Saint had loved this gown when she saw it in the department store. Hitchcock chose red for moments of danger, and these wine-red roses are a forewarning that her cover could be revealed. "He'd done his homework, I'm sure, and he didn't have the models come out in anything but what he would choose, too," she said.

The only survivor of the original MGM-designed costumes was the chestnut stole, which was used for Eve's first scene on the train and worn with a navy tailored suit, a sleek white blouse, black gloves, and a black handbag. As a kept woman of wealthy means, Eve's accessories were expensive but restrained. She wears a simple emerald pendant and an unobtrusive watch with thin leather strap. "Because of all these external

Opposite: One of Eve's most striking outfits is this long-sleeved black cocktail dress with red rose print.

Above: Hitchcock found MGM's wardrobe test shots underwhelming and instead took Eva shopping at Bergdorf Goodman to choose her outfits.

things he gave me, I was able to figure out what kind of lady she was," she said.

Hitchcock was protective over his actresses, as Saint describes in her recollection of the filming of the auction scene, when, on a break, she was dressed in the black dress with red roses, drinking coffee from a Styrofoam cup. "He was so upset. Here, his leading lady, in the dress that costs thousands of

depend upon it not being in any way suggestive of an imminent illicit sex affair," wrote the censors. But in the final scene, Hitchcock took his revenge by including a shot of a train going through a tunnel, the sexual connotations of which appear to have gone over their heads.

Once again Hitchcock was praised for the transformation of his leading lady. In the lead up

"He (Hitchcock) has transformed her into a Dietrich-style seductress, replete to the boudoir-whisper voice. She brings it off sharply and the result is that the Grant-Saint combo sizzles like sparkling burgundy." *MIRROR NEWS* 1959

dollars, is going, first of all, to get her own coffee. And second of all, that she's sipping from a Styrofoam cup. So he made me put it down. He had someone go and get me a cup of coffee, in a china cup, on a china dish, and there I sat."

The sexy flirting between Saint and Grant in the dining cart of the train is one of the highlights of the film—a "meet cute" with danger that referenced *The 39 Steps*. But instead of being rejected by the woman on the train as Hannay was by Pamela, Roger Thornhill is protected by Eve, although this turns out to be duplicitous.

Hitchcock liked to push boundaries when it came to the production code, and these flirtatious train scenes, and the line "I never make love on an empty stomach," in particular, were considered unacceptably sexually suggestive by the censor's office, which said, "It cheapens the girl and the picture." Similarly, the love scene in the cramped cabin would also have caused problems, especially if the actors were seen in nightwear, so they remained fully clothed. "The acceptability of this scene will

to the film's release, publicity from the MGM press office focused on the way Hitchcock coaxed out Eve's character. This theme was picked up by dozens of newspapers, with the *Mirror News* commenting that the director "has wrought an astounding change in Eva, too long identified with starkly drab or overly sweet screen characters. He has transformed her into a Dietrich-style seductress, replete to the boudoir-whisper voice. She brings it off sharply and the result is that the Grant-Saint combo sizzles like sparkling burgundy."

While Eva Marie Saint was a smart and talented enough actress to be able to make these changes with minimal guidance, Hitchcock was disappointed to find that her acting talents and ambition outweighed his Svengali influence. He said: "I took a lot of trouble with Eva Marie Saint, grooming her and making her appear sleek and sophisticated. Next thing you know she's in a film called *Exodus*, looking dissipated!"

Opposite: Under Hitchcock's guidance, Eva Marie Saint transformed from being "a trifle on the mousy side," to "sparkling with sex appeal."

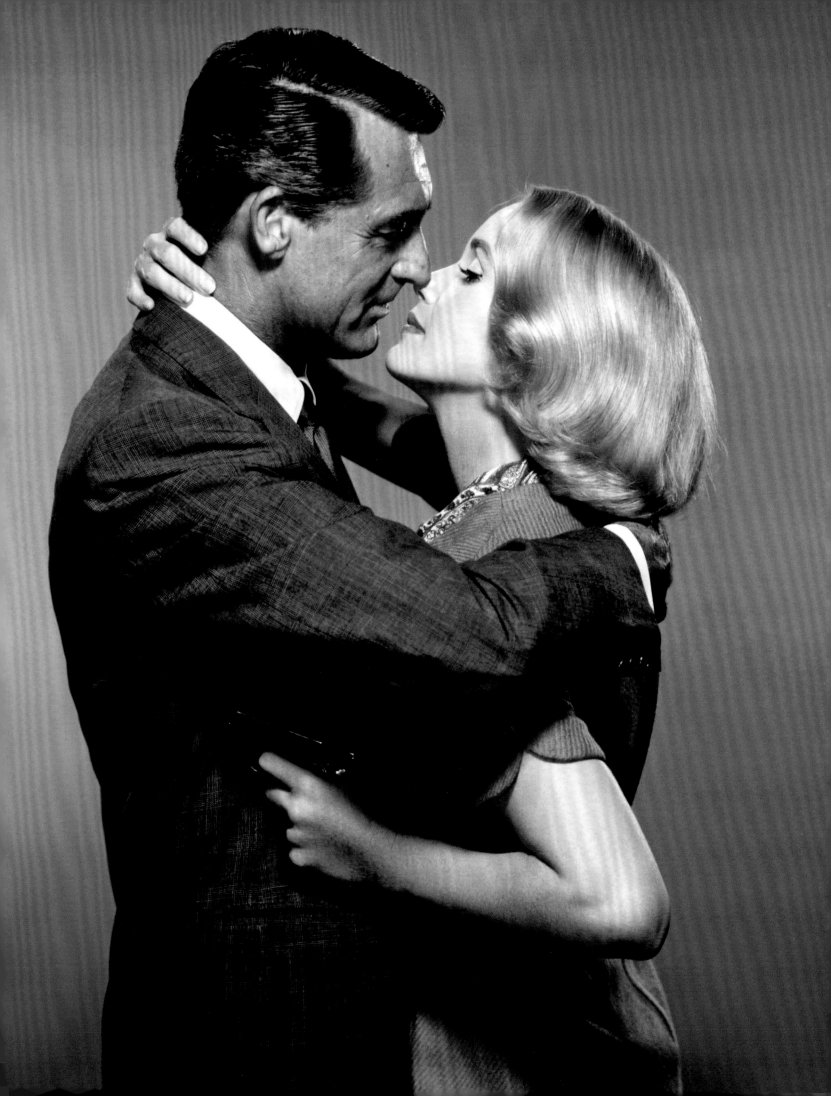

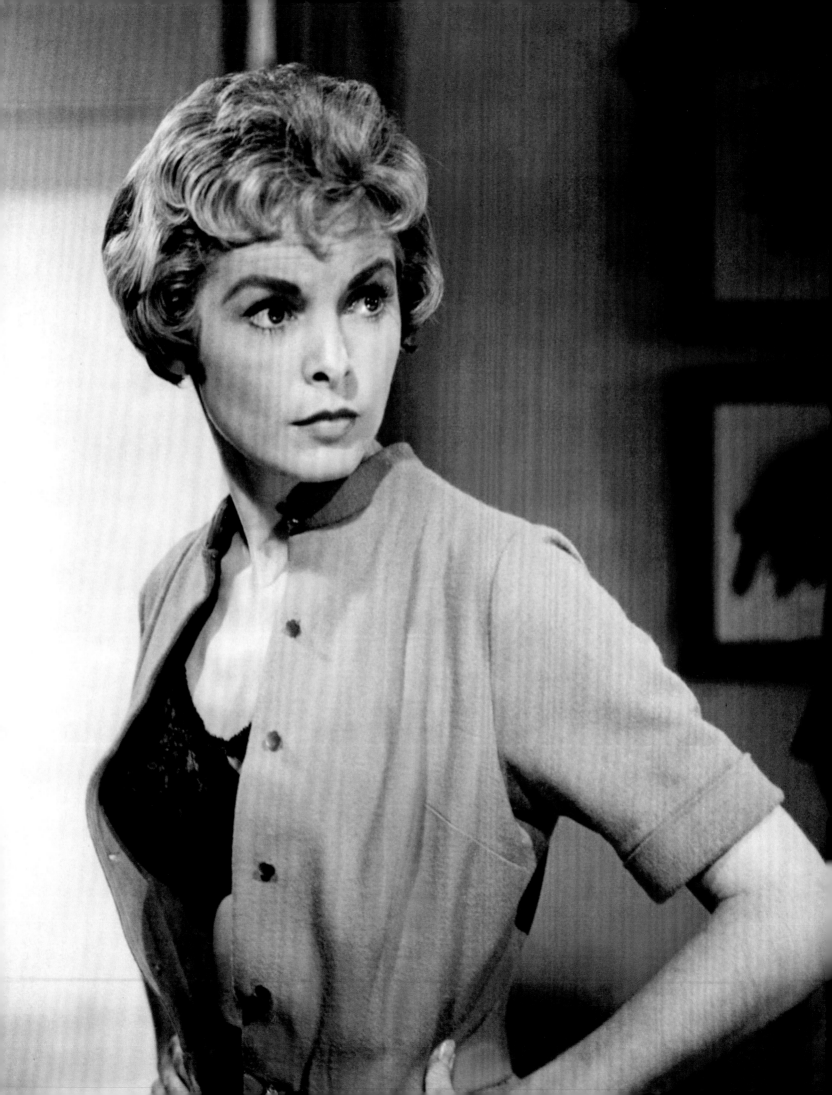

PSYCHO (1960)
JANET LEIGH

Having stolen money from her boss, Marion Crane (Janet Leigh) ends up at the Bates Motel run by Norman (Anthony Perkins).

Feeling guilty about the money, Marion decides to return it, but first she takes a shower. A female figure suddenly enters and stabs her to death.

Discovering the murder, Norman cleans it up, putting both body and money into the trunk of Marion's car and sinking it in swamps.

Marion's sister, Lila, and Marion's boyfriend, Sam, become concerned about Marion's whereabouts. A private investigator, Arbogast, traces Marion to the Bates Hotel. Arbogast is suspicious of Norman and goes in search of Norman's mother, but is killed.

When Lila and Sam don't hear from Arbogast, they visit the local sheriff who tells them that Mrs. Bates has been dead for ten years.

At the motel, Sam distracts Norman while Lila sneaks into the house. Realizing what they want, Norman knocks Sam out and pursues Lila.

Lila hides in the cellar where she discovers the mummified corpse of Mrs. Bates. Lila screams as Norman, holding a knife and wearing his mother's clothes and a wig, rushes in. Before Norman can attack, Sam, having regained consciousness, stops him. At the courthouse, Norman's behavior is explained; he had murdered Mrs. Bates but unable to bear the guilt, he exhumed her corpse, recreating his mother as an alternate personality.

Psycho was Hitchcock's most profitable film, earning over $12 million.

After a film called *No Bail for the Judge* with Audrey Hepburn fell through in 1959, Hitchcock followed up on a horror story he had read about in the *New York Times* book review: *Psycho* by Robert Bloch. Hitchcock was always on the lookout for something new to stay at the top of his game, and he had noted the success of cheap B-movie horrors such as *The Blob* and *The Fly*, which particularly appealed to a teenage audience for its cheap thrills.

Psycho's story of a serial killer who dresses up as his own murdered mother was considered so distasteful that Hitchcock funded it himself for a 60 percent ownership of the negative—so it would be a feature film on a television budget. He envisioned the film as being about ordinary Americans in an everyday setting, making it even more horrific. It captured Americana—highways, neon signs, car dealerships, motels—and was framed by the California gothic home, the type of place that could appear in an Edward Hopper painting.

A major influence on Hitchcock was the French gothic horror *Les Diaboliques*, which was a huge hit when it was released in 1955 and noted for its shocking twist. It was *Les Diaboliques* that inspired Hitchcock—along with budgetary constraints—as to why he decided to film *Psycho* in black and white. He also told the press that the amount of blood would be too horrific if it was vivid red.

Hitchcock hit upon the idea of not only the twist of Norman being the killer but also of having a big-name actress play the victim, since audiences would not expect a likeable heroine to be killed off so early in the story. When casting Marion Crane, Eva Marie Saint was brought up. However, although Hitchcock admired her, he felt he had completely transformed her as an actress and didn't want to see her regress.

JANET LEIGH

Janet Leigh's career was made by hotels—with her first discovery in a mountain resort, as a young bride trapped in a hotel in *A Touch of Evil*, and then as a victim in the Bates Motel.

For the rest of her career she would be known for the famous shower scene.

Born Jeanette Helen Morrison in 1927 in Merced, California, her parents worked in a ski lodge in the Sierra Nevada Mountains. In 1946 actress Norma Shearer saw Leigh's photo on the reception desk and recommended she be signed to MGM. She worked on dozens of films from 1947, including *Little Women* (1949) and *Scaramouche* (1952). She gained considerable attention when she married Tony Curtis in 1951, and they starred together in several films including *The Vikings* (1958). Leigh was heartbroken when he left her for another actress while she was filming *The Manchurian Candidate* (1962).

She continued with roles in *Bye Bye Birdie* (1963) and later starred alongside daughter Jamie Lee Curtis in *The Fog* (1980) and *Halloween H20* (1998). She was married to Robert Brandt from 1962 until her death in 2004 at the age of seventy-seven.

Page 156: Janet Leigh as Marion Crane in *Psycho*; the film that made Hitchcock the most famous director in the world.

Opposite: In the film's opening, before Marion has stolen the money, she wears a white bra and half-slip to demonstrate her "good" side.

Other names included Piper Laurie, Hope Lange, and Lana Turner, but Janet Leigh had the warm personality that would make her demise on screen even more shocking. She also looked like she could come from Phoenix. Leigh had been in the business for some years, and she and her husband, Tony Curtis, had also been to the Hitchcocks' for dinner parties. "The four of us were not bosom buddies, but we always enjoyed their company, and particularly Mr. Hitchcock's famous wit," she recalled. To Leigh, Hitchcock was a "loveable rascal" who delighted in telling naughty stories, and both she and her husband were "serious fans and had profound respect for his talent."

Leigh immediately warmed to the character of Marion, originally Mary Crane in Joseph Stefano's script, and who he described as "an attractive girl nearing the end of her rope." Marion is around thirty, in a dull job, and has fallen for a man who won't marry her before he has paid off his debts. Tired of meeting in hotel rooms, and aware that time is not on her side, she does something completely out of character; she steals money from her employer to pay off her boyfriend's debts so that they can get married. Her surname, Crane, was one of many references to birds throughout the film. She lives in Phoenix, Bates tells her she eats like a bird, and Bates has caught a menagerie of birds for his taxidermy, which foreshadows Marion's fate.

For costumers, Hitchcock hired Rita Riggs and Helen Colvig, who had worked on the television series *Alfred Hitchcock Presents*. Hitchcock was fastidious in creating a sense of realism for the characters and sent a photographer to Phoenix to capture images of real people. They even found a girl like Marion, visited her home, and photographed her bureau drawers, her suitcases, and the contents of her wardrobe.

It was common practice for costumes to be custom-made by a studio designer, but Hitchcock insisted Marion's were store-bought, not just to save money but also to adhere to the clothing budget of a secretary. Leigh and Riggs visited Beverley Hills store Jax and found two shirtwaist dresses, one in cream cotton and another in blue wool jersey, because, according to Riggs, "Hitchcock likes good wool jersey; it reads well in black and white."

There were ongoing discussions as to whether Marion would wear a black or white bra and half-slip, but it was finally decided that she would

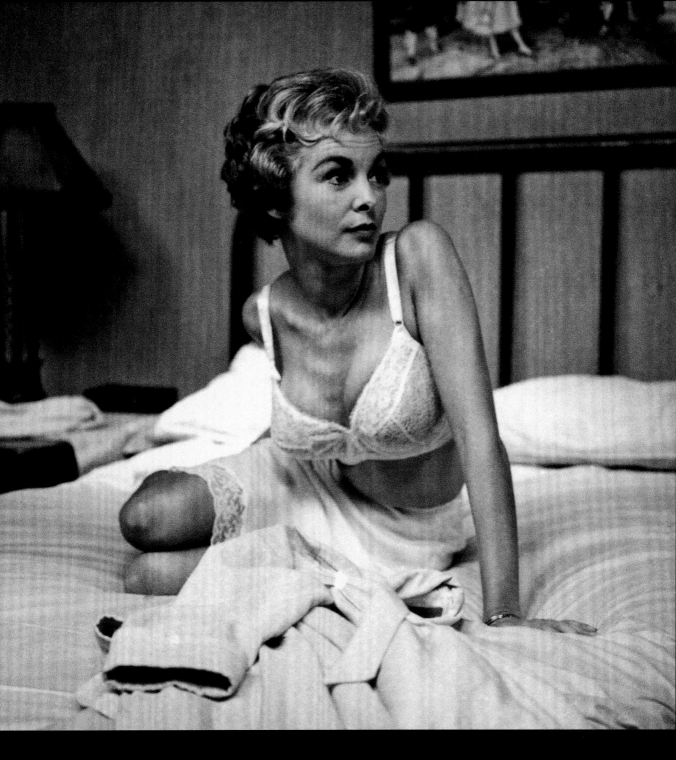

wear white for the opening scene and black after she steals the money, to make a character statement about her good and bad sides. This duality was also represented with her white handbag in the opening scenes, and the black handbag used to carry the stolen money.

It was very risqué to show a bra on screen, but there were two scenes of the film in which Janet would be shown in her bra, both framed from a voyeuristic point of view. In the opening scene, the audience is a fly on

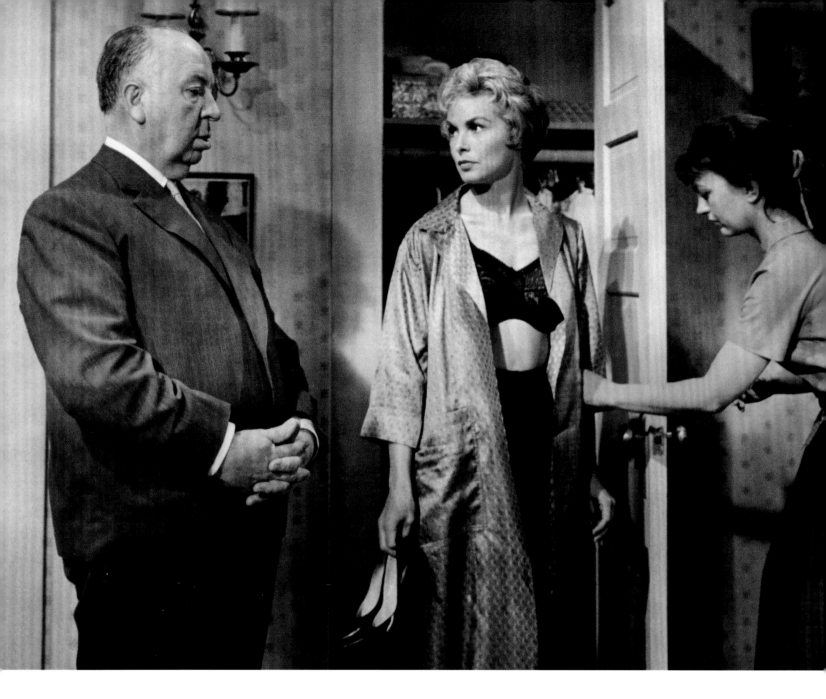

the wall observing the illicit hotel room tryst between Sam and Marion, a scene that was designed to mark the more liberated 1960s. The second underwear scene was the glimpse of Marion in black underwear through the peephole as she gets changed.

Behind the scenes, Janet Leigh was beloved by Hitchcock, as she would laugh at his jokes and risqué stories, enthusiastically taking part in the word games and puns he enjoyed so much. Hitchcock coached Janet at private meetings in his Bel-Air home, helping her create as strong a performance as possible. When Janet mentioned the pre-shoot meetings on the *Dick Cavett Show* in 1969, Tony Perkins raised his eyebrows

in surprise and said, "Oh, really? I never had any private discussions. But then I'm not a girl, or a blonde."

Hitchcock liked to scare Leigh by placing different versions of the shriveled-up Mrs. Bates in her dressing room chair for when she came back from lunch. Leigh wondered whether his jokes were to keep her as tense and nervous as Marion. But she

Above: Hitchcock with Leigh on set. Marion, having now stolen the money, is in a black bra and half-slip.

Opposite: Vera Miles plays Marion's sister, Lila. Although her costumes were designed by Edith Head, Vera didn't like them.

pulled her own stunt—having her photo taken while sitting elegantly on the toilet reading the script in her changing room, as a reference to the flush of the toilet being shown for the first time on screen.

Undoubtedly the most important costume in the film was Mrs. Bates's dress. While Mrs. Bates was supposed to be around the age of forty, the image was created of an older lady, in order to fool the public. The print had to be recognizable from different angles and movements, and it had to stand out in silhouette.

Leigh wasn't the only blonde in the film. Vera Miles was assigned to play Marion's sister, Lila, as her last role under her Hitchcock contract. She was angry throughout filming, as she believed she was still being punished for getting pregnant and dropping out of *Vertigo*. She wasn't given the attention that Janet Leigh was, and she didn't like the taupe shirtwaist dress and overcoat she was assigned, despite the costumes being exclusively designed by Edith Head, as had been stipulated in her contract with Hitchcock. Having shaved off her hair for a previous role, she was also given an unflattering wig. Rita Riggs said, "I have great respect for Miss Head, but I remember thinking 'Gosh, that's a rather dowdy fabric and color.' But it was Mr. Hitchcock's choice. That was some of his perversity coming through."

"It wasn't a nasty situation," said Miles. "I would get my barbs and walk away. I didn't do battle. I just said, 'Take it or leave it.' That's how my relationship with Hitchcock ended. There were a few bitter comments from him, but I never retorted in kind. I look back on him very fondly."

In contrast, Leigh had only warm memories of her time filming. "I cannot think of a single complaint I could legitimately raise," she said. "Now, there may

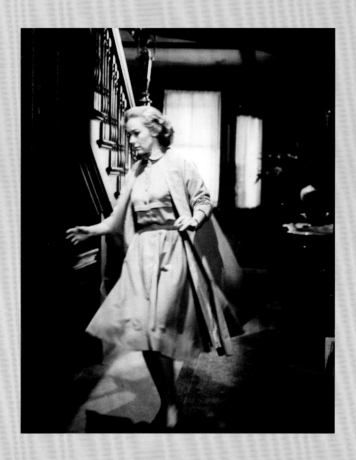

be some reasons why I had the experience I did. I was already established in my profession when I worked with him. I was not under contract to Mr. Hitchcock, so he was not in control of my career. I was married, and we had socialized together with our spouses."

She believed he was a visionary rather than totalitarian, planning every scene in advance with a scale model so that he knew exactly what was needed when it came to filming. "I feel that this control isn't a Svengali type of control we're talking about. This is a vision. He had a vision of each film, and that's what he made."

The shower scene was shot from December 17 to December 23, 1959, taking seven days to cover the seventy-eight camera setups for a staccato that mimics the cut of a knife along with the shrieking violins. Leigh saw the shower as Marion's way of purging

VERA MILES

Born Vera June Ralston in Boise City, Oklahoma, in 1929, and raised in Kansas, she was named Miss Kansas in 1948 and came third in that year's Miss America. She took her stage name from her first husband, Bob Miles, with whom she had two daughters.

As the love interest in *Tarzan's Hidden Jungle* (1955) she fell in love with Tarzan actor Gordon Scott off screen, and they married soon after. She had already starred opposite Joan Crawford in *Autumn Leaves* and was directed by John Ford in *The Searchers*, when Hitchcock "discovered" her after seeing Miles on *Pepsi-Cola Playhouse*. He signed her to an exclusive contract and cast her in "Revenge," the first episode of his TV series. Hitchcock wanted to turn her into a new Grace Kelly, instructing her only to wear black, white, or gray as he felt she was "swamped by color."

Hitchcock cast her as the traumatized Rose in *The Wrong Man*. But after disappointing Hitchcock by becoming pregnant with her third child, he cast her once more in *Psycho* and she was released from her contract. She worked with him again for two episodes of *The Alfred Hitchcock Hour* and reprised the role of Lila in *Psycho II*. She retired from the screen in the nineties.

Above: Hitchcock observes Janet Leigh in a scene from *Psycho*. Showing a bra on screen was very risque, but Hitchcock felt it was what young audiences expected.

Opposite: Hitchcock and Leigh on set. She was fond of him, laughing at his jokes and joining in with the word games and puns he enjoyed.

her soul when she decides to return to Phoenix: "The spray beating down on her was purifying the corruption from her mind, purging the evil from her soul. She was like a virgin again, tranquil, at peace."

Leigh and Riggs poured over stripper costume magazines in order to work out how to protect her modesty. Eventually Riggs came up with the idea to use nude-colored moleskin, which could be adhesively applied. While Janet insisted Hitchcock never asked her to do the film nude, a Las Vegas dancer, Marli Renfro, was brought in as a body double to stand in during the long setup process to ensure the correct lighting and effect of nakedness through the shower curtain. Riggs recalled, "I watched Mr. Hitchcock, the model, and the crew one

"I feel that this control isn't a Svengali type of control we're talking about. This is a vision. He had a vision of each film, and that's what he made."

JANET LEIGH

morning standing around having coffee and doughnuts and thought, 'This is surreal.'"

The color brown was most effective in creating the impression of red in black and white, and Shasta chocolate syrup was liberally used for blood, having just come out with a revolutionary squeeze bottle. Hitchcock and Leigh visited an optometrist for contact lenses for the dead eyes of Marion, but they were told they would need at least six weeks to adjust, or it would permanently damage her eyes. She had to slump over the bath while holding her eyes open, and he snapped his fingers to indicate that the camera had moved past her face.

Hitchcock was worried that once audiences saw the film they would reveal the shock ending. It is strange to think that, at the time, viewers could wander into the cinema at any time, joining the film halfway through, and then start again from the beginning. But, inspired by the message at the end of *Les Diaboliques*—"Don't be diabolical yourself. Don't spoil the ending for your friends by telling them what you've just seen,"—Hitchcock tested out a policy where no one would be admitted after the start of the film. He also used his famous silhouette and droll personality to deliver the message of this campaign.

On its first day of release, lines formed in the early morning and the demand kept increasing. The campaign was so successful that *Psycho* made Hitchcock not only a very rich man but also the most famous film director in the world.

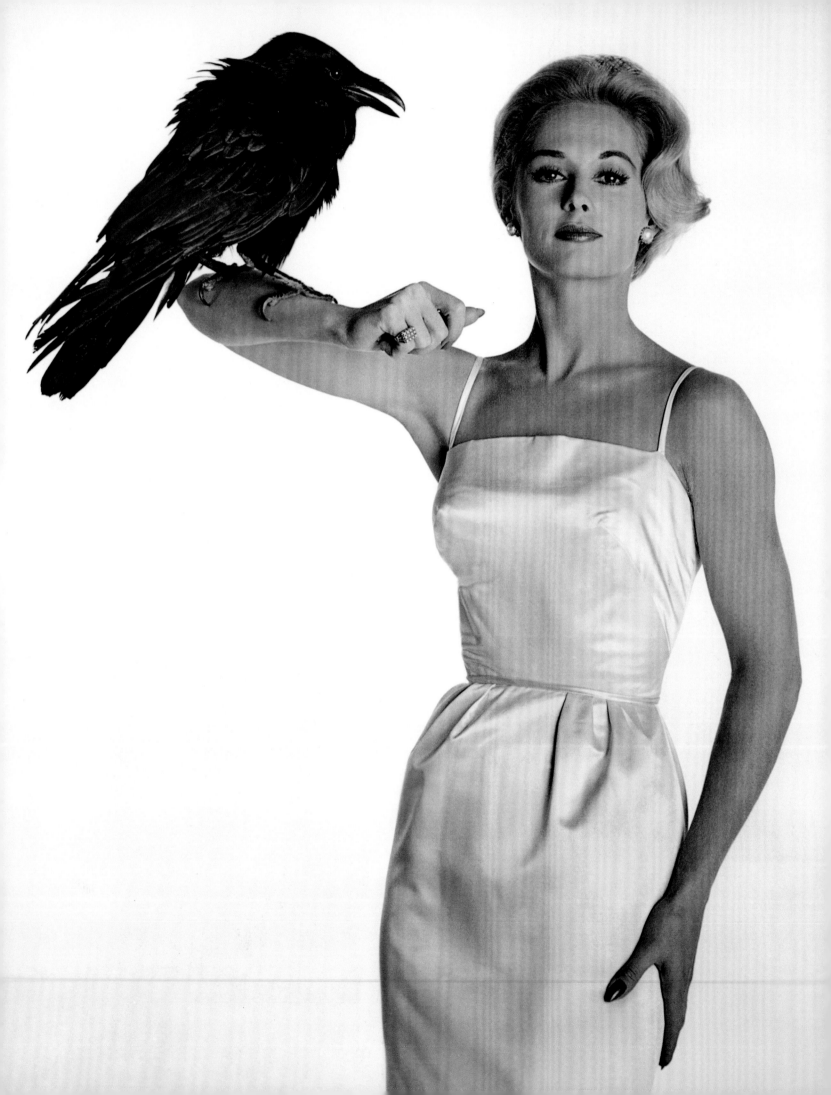

THE BIRDS (1963)
TIPPI HEDREN

Melanie Daniels (Tippi Hedren) meets lawyer Mitch Brenner (Rod Taylor) in a bird shop. He wants to buy a pair of lovebirds for his sister, Cathy's, birthday, but there are none available.

Mitch plays a prank, pretending to think Melanie is the salesperson even though he knows Melanie is a rich playgirl. She is infuriated at this, but attracted to him she finds out his address, buys a pair of lovebirds, and goes to see him. Needing help locating his house, Melanie meets Annie—the local schoolteacher and Mitch's ex-lover. Melanie hires a boat to reach Mitch's home, and after delivering the love birds, he observes her being attacked by a gull and comes to her assistance.

It gets late so Melanie rents a room for the night at Annie's house. While there, they hear a loud thud and discover a gull has flown into the front door.

This is the second in a series of unusual bird behavior that then plagues the town. Birds attack the school house and petrol station and Melanie is forced to take refuge in a phone booth. Mitch eventually rescues her.

When they collect Cathy from Annie's house, they find Annie dead, killed by the crows.

They hide inside the Brenner family home. During the night Melanie hears the sound of fluttering wings from above. She climbs the stairs to the attic. The birds have broken through the roof. They violently attack her, trapping her in the room until Mitch comes to her rescue. He then drives Melanie and his family out of town as they are surrounded by thousands of birds.

Tippi Hedren's experience working with Hitchcock is often considered the pinnacle of his obsession for blondes. In her memoirs, she remembers Hitchcock "with admiration, gratitude, and utter disgust." For Hitchcock, his ego drove his desire to create a star and mold her into the girl of his imagination. "I seem to have a reputation for preferring blonde leading ladies in my films," Hitchcock said, playing up to his own press. "And now in *The Birds*, I am introducing another young lady who happens to be blonde—Miss Tippi Hedren."

With the huge success of *Psycho*, he was pressured to find a suitable follow-up project. He finally chose the eerie Daphne Du Maurier horror fantasy *The Birds*, which first appeared in *Good Housekeeping* in 1952. Birds often appeared within his films as primeval harbingers of danger and death: the bird imagery in *Psycho*, the bird in a cage in *Blackmail*, and the bird pins appearing frequently on his heroines' blouses, which could all be read as symbols of some dark force that is about to strike them.

By the end of September 1961 Hitchcock had considered a procession of blondes, including Pamela Tiffin, Yvette Mimieux, Carol Lynley, and Sandra Dee for the lead part. But none of these women were quite right.

As the tale of discovery goes, Hitchcock and Alma were drinking coffee one morning when an advert for a diet drink came on television with a blonde model. Hitchcock was immediately struck by her "jaunty assuredness, pertness, an attractive throw of the head" and asked his agent to find out who she was.

After ten years as a successful model in New York, Tippi Hedren was being passed over for younger girls, and so she made the decision to move to Los Angeles. She rented an expensive home in Westwood, taking on advertising work when it was offered, but she never expected

TIPPI HEDREN

Born Nathalie Kay Hedren in 1930 in Lafayette, Minnesota, to Swedish Lutheran parents, she was given the nickname "Tippi"—Swedish for little girl. The family moved to Minneapolis after the Depression, and she was scouted as a model when stepping off a streetcar at the age of thirteen.

Tippi moved to New York to begin a successful modeling career under the tutelage of Eileen Ford, appearing on covers for *Life* magazine and *Glamour*, before moving to Los Angeles to find work. After her contract with Hitchcock was dissolved, she won a part in Charlie Chaplin's *A Countess from Hong Kong* (1967).

At the age of twenty-two she married actor Peter Griffith. They had a daughter, Melanie Griffith, but divorced in 1961, and she married agent Noel Marshall in 1964. She and Marshall embarked on an eleven-year project to film *Roar*, raising rescued lions and tigers to star in what would be one of the most ambitious and dangerous of wildlife films. She continued with the occasional film and television work while also raising funds for her eighty-acre wildlife refuge the Shambala Preserve.

Page 164: Tippi Hedren in a publicity shot for *The Birds*.

Above: Edith Head's costume sketch for the green suit. Hitchcock restricted her to two colors—blue and green.

Opposite: A pale green wool shift dress and jacket with a Chanel cut demonstrate Melanie's cool, elegant persona. Six copies were made to allow for the appearance of damage caused by the bird attacks.

the opportunity that was about to come her way. She was informed that a producer was interested in her, and when she eventually found out it was Hitchcock, she agreed to sign on for a seven-year contract, earning $500 a week. "I was that sure she had what it takes; I didn't even bother to interview her," he said.

After they met in mid-October 1961 at his Paramount office, Hedren recalled: "He was shorter and even rounder than I was expecting, and he was remarkably unattractive." She added that: "He had a dry British wit and a fondness for spontaneously reciting very funny, slightly off-color limericks." He recounted that when he first met her, "she walked in with her hair in a beehive, making her face look tiny, and wearing a dress of some awful color, probably turquoise blue . . ." This, he pointed out, was why she needed his guidance to overhaul her image.

It was all very thrilling for Hedren—the wardrobe test, her own bungalow dressing room, her name on the door, and her own chair. She had previously worked with an acting coach, Claudia Frank, while modeling. She wrote in a letter to Claudia: "It's been nothing but fun and work. Edith Head is doing my clothes, Helen Hunt is doing my hair. My test was apparently so successful that Mr. H is tickled ice-cream pink."

Hedren was invited to dinner with the Hitchcocks and agent Lew Wasserman, where she was presented with a beautifully wrapped gift box in which was a gold bird pin. "You're starring in *The Birds*," Hitchcock said, and for Tippi, it was a real-life Cinderella story.

Universal was reluctant to cast such an inexperienced, unknown actress, but Hitchcock had complete confidence in her and believed he could create a new Grace Kelly. "Grace is an easygoing, elegant woman who moves with a benign dignity. Tippi has a faster tempo, city glibness, more humor," he told a journalist.

For Hitchcock, the character began with the visual image. Melanie Daniels was a "wealthy, shallow playgirl," and her wardrobe had to convey this as well as not detract from the ensuing terror. Edith Head created a wardrobe plan, Virginia Darcy worked on the hair, and Howard Smit planned the makeup. According to Head, "The fashion was not too important. He virtually restricted me to two colors, blue and green. We had worked together for so many years that I was well aware of his feeling about garish colors. He didn't like anything bright unless it made a story point. He preferred 'nature colors' as he called them: beige, soft greens, and delicate turquoises. He had strong feelings that color should never be so strong that it overpowered the scene or the actress."

Because of Melanie's cool, elegant persona, she was given a pale green wool shift dress and jacket with a similar cut to a Chanel suit, and repeating the eau de nil color of the suit worn by Grace Kelly in *Rear Window*. Six copies were made to allow for adjustments and tears when she is attacked by the birds.

Hitchcock carefully selected jewelry that would suit a wealthy San Francisco socialite—a bracelet, a ring, and a single strand of pearls. To complete the look, Melanie was given a beige crocodile purse, which she never seems to be without, and a mink coat which he felt was vital to the character and made her look out of place on the outboard motorboat. At the end of filming, he gifted the mink coat to Tippi, which she later sold to fund her wildlife sanctuary.

Above: Tippi and Hitchcock share a joke on the set of *The Birds*.

Opposite: Tippi films the drive to Bodega Bay in the studio with a background projection behind her.

For critic Camille Paglia, Melanie is "the ultimate Hitchcock Heroine," as she is "mistress of chic, a beautiful woman haughtily used to exercising her power over men in public and private." Everything she does, such as dialing the phone with a pencil to save her long, manicured nails, is designed to show us the personality of Melanie, who can easily convince men to offer her assistance. Her pranks demonstrate she is careless with her time and money—smashing windows or jumping into a Rome fountain naked like Anita Ekberg in *La Dolce Vita*.

Hedren's entrance in *The Birds* re-created her television commercial, as she turns at a wolf-whistle only to smile when she sees it's a schoolboy. Robert Boyle said of Hitchcock: "He was quite taken by the way she walked." Her champagne blonde hair is swept into a French twist, as when the birds attack her hair has to come undone. Of her marled black suit with narrow skirt, Paglia says, "The symbolic transition from the titles is subtle but clear: woman is the crow, her stiletto high heels the claws of rapacious nature. Melanie's black leather clutch bag is unusually long and lean, like a phallic rifle case."

she speeds along the country road. This recklessness also demonstrates how independent she is.

There was only one other costume—the nightgown that Melanie buys from a Bodega Bay store,

"It's been nothing but fun and work. Edith Head is doing my clothes, Helen Hunt is doing my hair. My test was apparently so successful that Mr. H is tickled ice-cream pink." TIPPI HEDREN

Melanie's following costume change is quite dramatic, from the dark suit to an outfit that matches the spring colors of the love birds she hopes to surprise Mitch with. She hadn't expected to be leaving the city for Bodega Bay, and her clothes are not really appropriate, with the mink coat embodying a rich woman and the high heels on the car pedals as

and which Edith Head bought off the rack. Melanie still manages to make it look appealing by applying coral lipstick, her hair casually waved. She wears her fur coat over the nightgown in the garden as she embraces Mitch.

In addition to her appearance, Hitchcock was meticulous when it came to shaping the character of

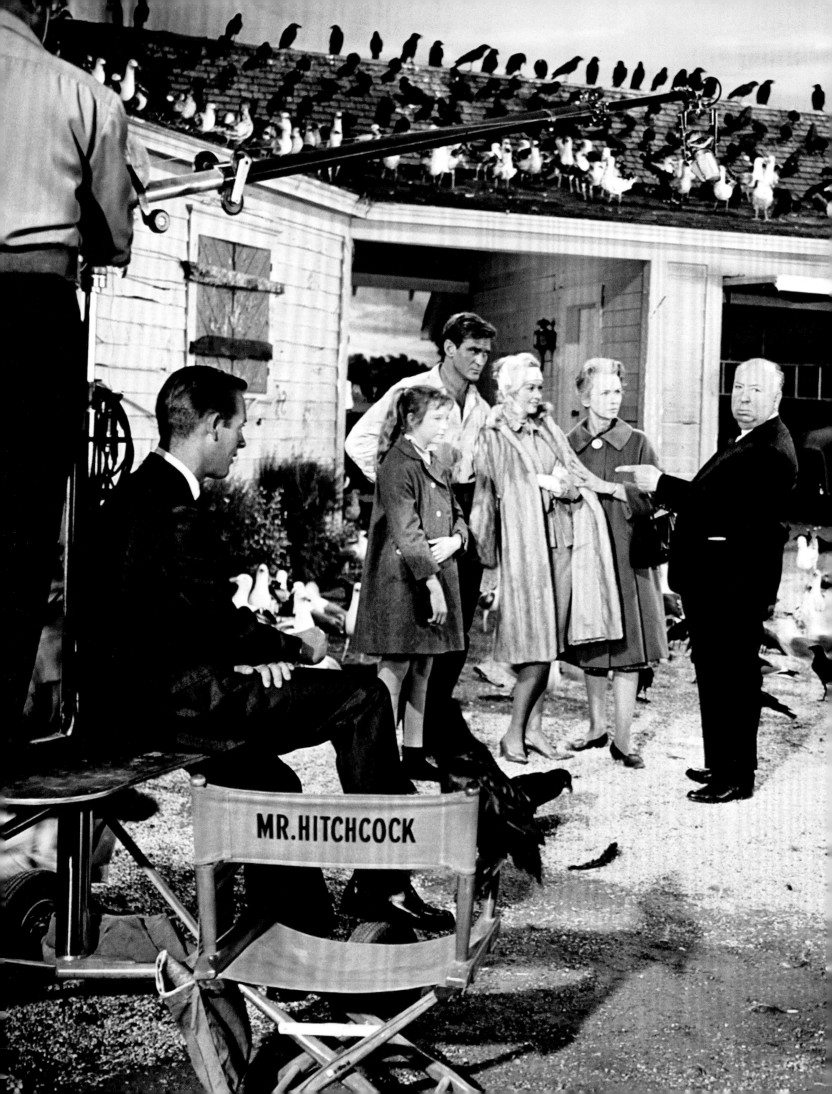

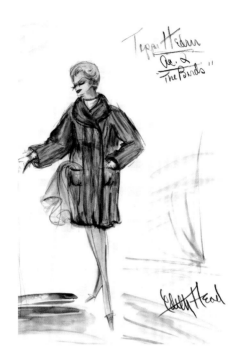

Tippi Hedren
as "
The Birds"

Edith Head

Melanie, as the film rested on Hedren's performance. He held meetings with Hedren in which he talked through the script, discussing how she should play every scene and expression. Hitchcock spoke of "her general poise, her authority, her self-possession," that she notices Mitch's "physical attraction," and that she has "mischievous determination" when she travels all the way to Bodega Bay.

The contrast between earthy brunette Annie and blonde Melanie was played out competitively as Melanie invades her home and flirts with her former partner. "Annie sees a girl in a mink coat asking for the Brenner house, and she's very kind of awkward," Hitchcock told Hedren. "Annie knows what Mitch is. She's had him. And the mere fact that woman mentions Mitch tells Melanie right away there must be something . . . so there's plenty in it, Tippi. Plenty in this scene to play."

Annie is styled as a bohemian from San Francisco who smokes cigarettes from a crumpled packet, as opposed to Melanie's expensive case, highlighted when she elegantly smokes outside the schoolyard, oblivious to the crows that are gathering behind her on the climbing frame.

Filming began in Bodega Bay in March 1962, with studio interiors at Universal completed in early July. It was during the location shoot that Hedren felt Hitchcock was becoming more possessive, as he watched, observed, and controlled. She was not the type of actress who enjoyed his dirty jokes and "filthy limericks," which she felt were designed to keep her off-guard. While other, more experienced actresses could laugh it off, perhaps her fear of being out of her depth made her more vulnerable. He constantly asked her for drinks or dinner after work, maybe trying to replicate those days of Ingrid Bergman as the "human sink." But she felt isolated from the other cast and crew, and believed Hitchcock had ordered that no one else "touch that girl."

It is believed Hitchcock was also unhappy during the shoot, which perhaps put strain on his treatment of the actors. While he normally had a film entirely conceptualized, this time he felt he needed to change the script and increase the conflict. "I was quite tense, and this is unusual for me because as a rule I have a lot of fun during the shooting," he said. "When I went home to my wife at night, I was still tense and upset."

Hedren recounted to Donald Spoto that in a limousine returning to Santa Rosa from Bodega Bay one day, Hitchcock tried to embrace her in

Opposite: Hitchcock on set with the cast from *The Birds* surrounded by real and fake birds.

Above: Head's sketch for Tippi's mink coat. Hitchcock thought the coat was vital to her character. Tippi later sold it to help fund her wildlife sanctuary.

the backseat, making sure it was in full view of coworkers, but she rejected him. In the 2012 TV film *The Girl*—which depicts Hitchcock's alleged obsession with Hedren and takes its title from the name Hitchcock gave to her—it was claimed that as punishment for this rejection, he deliberately sabotaged the phone box scene so that she was covered in glass when a mechanical bird hurtled towards her. But it is unlikely that he would want to disfigure his actress when there were more scenes to film.

Over five days, trainers in long protective gloves hurled birds at her as she fought them off, while jets of air guided the birds away from the lens. Her costume was artfully torn for different shots to indicate rips, while the makeup team painted on bloody gashes to her face. Invisible elastic wires were threaded under her clothes and attached to the legs of the birds, to keep them in place. Cary Grant paid a visit to the set one day, and after watching her suffer, said, "You're one brave lady." As an inexperienced

"I became somber and in such a state of shock that I honestly don't know if the birds drew blood or not. When it was all over, I went to bed for days and had nightmares filled with flapping wings." TIPPI HEDREN

The Birds was the most technically difficult film Hitchcock had ever done. All sorts of tricks were used to control the birds, such as luring them with anchovy paste and placing meat on the camera so they would fly towards it. But the most dangerous scene was saved for last: when Melanie climbs the stairs to the attic, only to be trapped with squawking, scratching birds. Hedren questioned why Melanie would go into the attic when she had known the whole town was under attack. Hitchcock replied, "Because I tell you to."

Tippi was led to believe mechanical birds would be used for this scene, and it wasn't until she arrived on set for filming that the crew plucked up the courage to tell her about the live birds. Bird trainer Ray Berwick said, "I don't think (Hitchcock) knew what he was getting in for. He quickly had to give up any idea of using a lot of mechanical birds if he wanted realism . . . that nice girl took a lot of abuse. It's a miracle she got through it with her face intact."

actress, she hadn't known how to say no, how to negotiate, or to demand a stand-in.

This was traumatic for Hedren, but while it has been claimed that Hitchcock used this scene as a perverse punishment, it seems unlikely he would waste resources filming unnecessary shots, and as we have seen with *Psycho*, these complicated scenes took many days to put together. Hitchcock told Truffaut: "I'm very conscientious about not wasting production money." Hedren told Camille Paglia that Hitchcock "felt very badly about it. In fact he couldn't come out of his office until it was really time to roll the cameras."

After five days of filming, and after one bird scratched Hedren's lower eyelid, she collapsed hysterically in tears. She was taken to her dressing room, dazed and shocked, and a doctor eventually ordered a break from filming. She told *Look* magazine at the time: "I became somber and in such a state of shock that I honestly don't know if the birds drew blood or not.

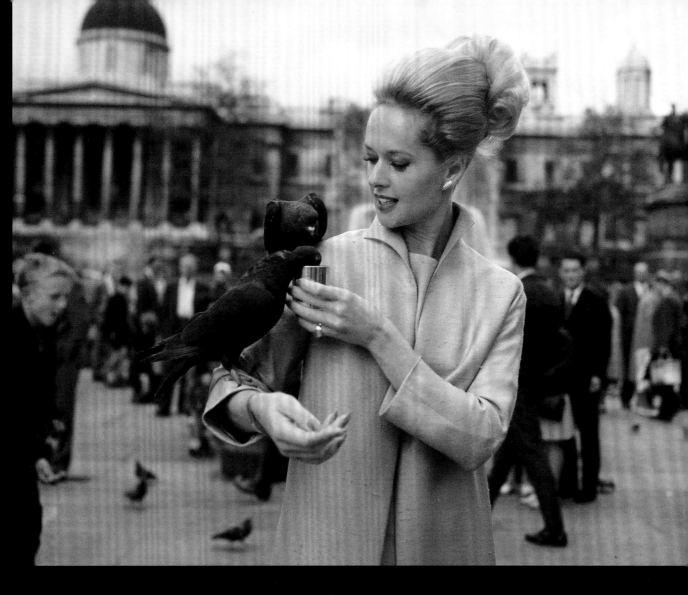

When it was all over, I went to bed for days and had nightmares filled with flapping wings." In order to keep the shoot going in her absence, a body double was used for the scene in which a delirious, injured Melanie is carried down the stairs by Mitch.

Once shooting was finished, Hedren was contracted to go on a world publicity tour in spring 1963 in an $18,000 personal wardrobe designed by Edith Head. Tippi and her new "ladylike" wardrobe in "pale tones" was presented at the film premiere in March 1963, and she was featured on magazine covers, often posing elegantly with a raven on her arm. Hitchcock said, "I took on two almost impossibl difficult tasks at once—a picture in which I had to train birds and a new girl," he said.

Despite the press attention and the screening at Cannes, the film was not as big a success as Hitchcock had hoped. One of the flaws cited was the unsatisfactory ending and lack of an explanation for the bird attack. Was it punishment for a guilty secret, or did Melanie bring them with her? Hitchcock offered one explanation: "This girl symbolizes the complacent people who ignore potential catastrophes whether it be the bomb or birds."

Above: Tippi in London as part of *The Birds* world publicity tour

MARNIE (1964)
TIPPI HEDREN

Marnie (Tippi Hedren) is a kleptomaniac who steals $10,000 from her employer, Strutt.

Mark Rutland (Sean Connery) is a friend of Strutt's and hears about Marnie stealing the money. So when she then applies for a job at his company, he hires her, intrigued.

When Marnie steals money from Mark too, he tracks her down and blackmails her into marrying him.

On their honeymoon, Marnie reveals she can't bear to be touched by a man, and that she has a phobia of the color red. At first he respects her but then he rapes her. She tries to drown herself but Mark rescues her.

Mark's former sister-in-law, Lil (Diane Baker), is upset by the marriage as she wanted Mark herself. She invites Strutt to a party at Mark's house hoping to cause trouble. However, Strutt does not expose Marnie, after Mark threatens to take his business elsewhere.

On a fox hunt Marnie's horse is injured and she must shoot him. The grief drives her mad and she goes to Mark's office to steal money. But she can't do it.

Mark then takes Marnie to see her mother, Bernice. He discovers that Bernice was a prostitute. Marnie recalls that when she was a child one of Bernice's clients comforted her during a thunderstorm. Bernice, fearing he was molesting Marnie, attacked him. A fight ensued and Marnie killed the man with a fire poker, the red blood from his wound causing her phobia of red.

Marnie appeals to Mark for help and he assures her he is on her side and will defend her.

Marnie is a divisive film, with some considering it an unrecognized masterpiece and others seeing it as a misogynist tale of a man blackmailing a woman into marrying him and then raping her. In either case, the film was masterfully composed, using color to convey meaning in a beautifully visual way. Its back projections, painted scenery, and red suffusions gave it the artificial look of a Hollywood film from two decades prior, which critic Robin Wood said is indicative of German Expressionism.

When Hitchcock received a copy of Winston Graham's *Marnie* just before publication in January 1961, he saw the character of Marnie as "one of the most unusual heroines I've ever encountered." He thought this could be the project that would lure Grace Kelly back to Hollywood, and she was excited about the possibility of playing this intriguing character.

Kelly was surprised when her husband, Prince Rainier III, agreed she could return to acting for *Marnie*, and it was officially announced on March 28, 1962, to much press interest. But with pressure from Monaco's citizens, a political situation with France, and a possible legal battle with MGM over her contract, Kelly was unable to make the film.

On June 18, 1962, Kelly wrote to Hitchcock: "It was heartbreaking for me to have to leave the picture. I was so excited about doing it and particularly about working with you again. It is unfortunate that it had to happen this way and I am deeply sorry—thank you dear Hitch for being so understanding and helpful—I hate disappointing you—I also hate the fact that there are probably many other 'cattle' who could play the part equally as well—despite that I hope to remain one of your 'sacred cows.'"

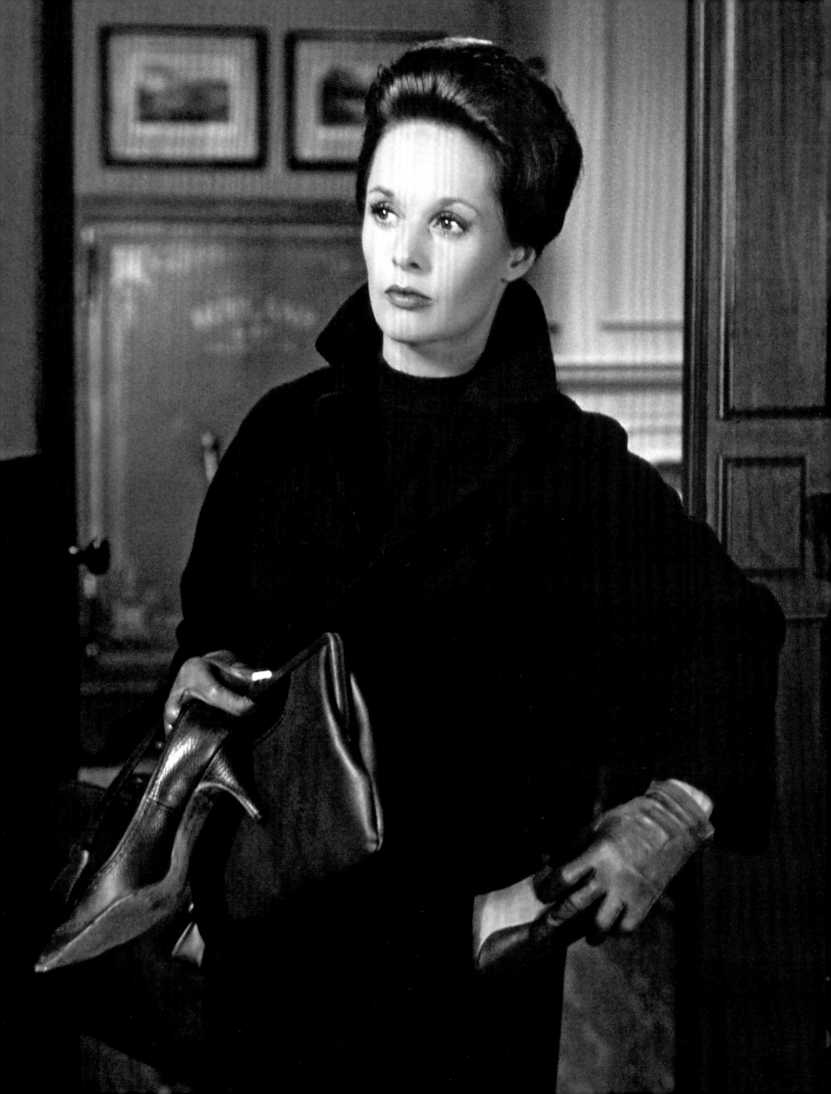

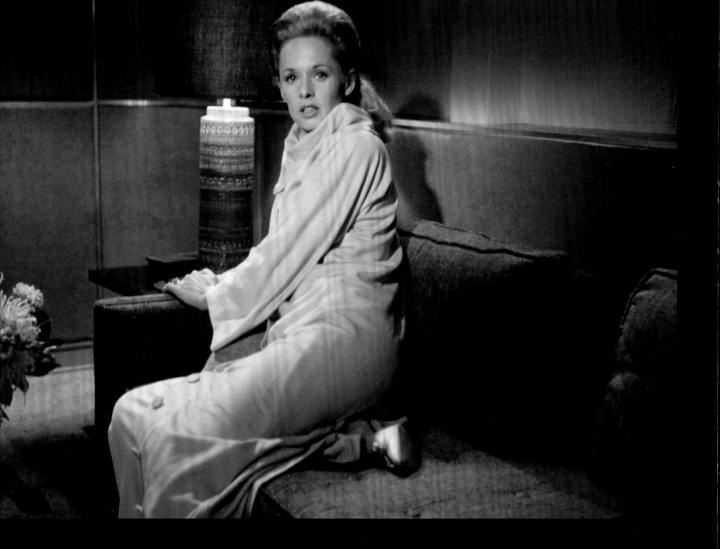

Hitchcock replied to Grace on June 26: "Yes it was sad, wasn't it. I was looking forward so much to the fun and pleasure of our doing a picture again. Without a doubt, I think you made, not only the best decision, but the only decision, to put the project aside at this time. After all, it was only a movie."

Secretly, Hitchcock was devastated that Grace was lost to him, and the role of Marnie was now given to Tippi Hedren. The actress was brimming with confidence from her world tour for *The Birds*, with magazine covers and articles praising her Grace Kelly–like elegance. But Hedren didn't want to be the next Grace Kelly. As Charlotte Chandler wrote, "She wanted to be the first Tippi Hedren."

While Hedren only had three costume changes in *The Birds*, huge effort was placed on her image for *Marnie*. To research hairstyles, Hitchcock's assistant, Peggy Robertson, organized photos to be taken of secretaries, script supervisors, and cashiers on the studio lot. "None of the styles should be wildly exaggerated—such as the beehive," she said. Hitchcock wanted the look of real officer workers.

For a kleptomaniac who changes her hair with every theft, Helen Hunt designed wigs for scenes in which Marnie has black, dark brown,

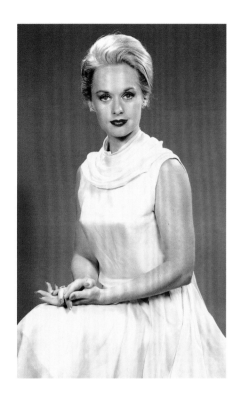

or red hair so that Hedren wouldn't have to dye her own. The makeup department was informed that the key to Marnie's look was not to "over powder," as she was to be "clean, with shine," particularly when horseback riding, as this is how she purifies herself.

To make the most of Hedren's blonde hair, Hitchcock commissioned Parisian hairstylist Alexandre (also known for styling the hair of Grace Kelly after she became princess of Monaco). His assistant, Gwendolyn, flew to Los Angeles at the beginning of November 1963 to create the styles from Alexandre's sketches. Hitchcock told Alexandre that he was "extremely pleased with them and know they will be a great asset to my picture."

Along with hair and makeup, Marnie uses clothes to disguise her identity. Hedren said, "She didn't want anyone to notice her. We did discuss color and the importance of color, and how, after Marnie is married, the clothes change completely." Edith Head and art director Robert Boyle discussed the wardrobe and the sets to make sure the colors complimented each other with a dominant palette of muted browns. The walls of the Rutland office and the Rutland home were designed to match Marnie's outfits, so she can fade into the background.

Bright colors were used to draw attention and represent emotion, as exemplified in the vivid yellow bag in the opening and the bright yellow full-skirted dress Marnie wears when Mark brings back her horse, Forio. This yellow dress was Marnie's brightest costume, used to show she was happy and warm. Because Marnie is disturbed when she sees flashes of red, the color was kept out of costumes, apart from the red polka-dotted outfit worn by the jockey and the red fox-hunting jackets.

Blue represented cool and passive emotions, as with the ice-blue button-up dressing gown worn by Marnie on her honeymoon. Her nightgowns were also designed to look as covered up as possible, conveying her fear of sex and need to keep people out. In this bedroom scene she retreats to an olive green sofa—the same color as the dress she wore when she robbed the safe, which resulted in her forced marriage and the trap she is now in.

In a script meeting with Hedren, Hitchcock mapped out exactly how Marnie would look in the opening scenes with her black hair, brown herringbone suit, and yellow bag tucked under her arm. He told Hedren,

Page 175: Tippi Hedren wears a muted brown suit to blend into the background in *Marnie*.

Opposite: Tippi in the ice-blue, buttoned-up dressing gown worn during the honeymoon scenes.

Above: Tippi Hedren as Marnie. Color played an integral part to the film's narrative, with yellow signifying Marnie's happiness.

"There are many members of the audience who have read the advertising and the publicity, and they say, 'Marnie, she's a thief.' So the smarter ones will say: 'Ah there she is, there's money in that bag, I'll bet'—and we're not showing her face, which adds to the mystery. I have deliberately shown no other people around. I want the audience not to be confused by any other matters except this one figure of the girl with the yellow bag."

When Marnie emerges from the bus station, instead of carrying the emerald bag Hitchcock had initially envisioned, she holds a brown purse that matches her camel coat and helps her blend in with the background set design. At the same time, the yellow taxis pop out from the shot to remind us of the yellow bag filled with money.

Added to the script was a beautiful sister-in-law, Lil, played by Diane Baker, who is suspicious of Marnie and wants Mark for herself. Baker recalls, "Hitchcock had particular colors in mind and how each character should be dressed. My clothes were somber, subdued, and then the bright orange dress, which was a surprise to me."

Baker first met Hitchcock and Alma Reville at their home. "Alma picked up a magazine with Grace Kelly on the front, holding it up to my face and saying I looked like Grace. It was something I had never thought of before, but they were trying to associate a look, someone they could groom." Baker, whose jawline and small nose did bear a resemblance to Kelly, had just come out of a five-year contract with Fox and she had no intention of signing to another.

Lil wears an ox-blood velvet coat and belted sleeveless dress at Marnie and Mark's wedding, which contrasts with Marnie's latte-colored, fur-trimmed coat and hat. The color was perfect for this scheming scene, in which Lil plants a long kiss on Mark's lips and gives Marnie an evil look. The tangerine gown in the party scene makes her visible and contrasts with Marnie's white, "untouchable" Grecian gown.

During development, Jay Presson Allen, the female writer of the play *The Prime of Miss Jean Brodie*, took over scriptwriting from Evan Hunter, who believed he had been fired for objecting to the rape scene. It was not unusual for Hitchcock to bring in different writers for a script, and a woman could add her own dynamic in the shaping of Marnie's complex character. However, Allen was quite heavy-handed with the

Above: Hitchcock commissioned Parisian hairstylist Alexandre to design Tippi's hairstyles in *Marnie*.

Opposite: Sean Connery looks on as Tippi's hair is styled by Virginia Darcy for a scene.

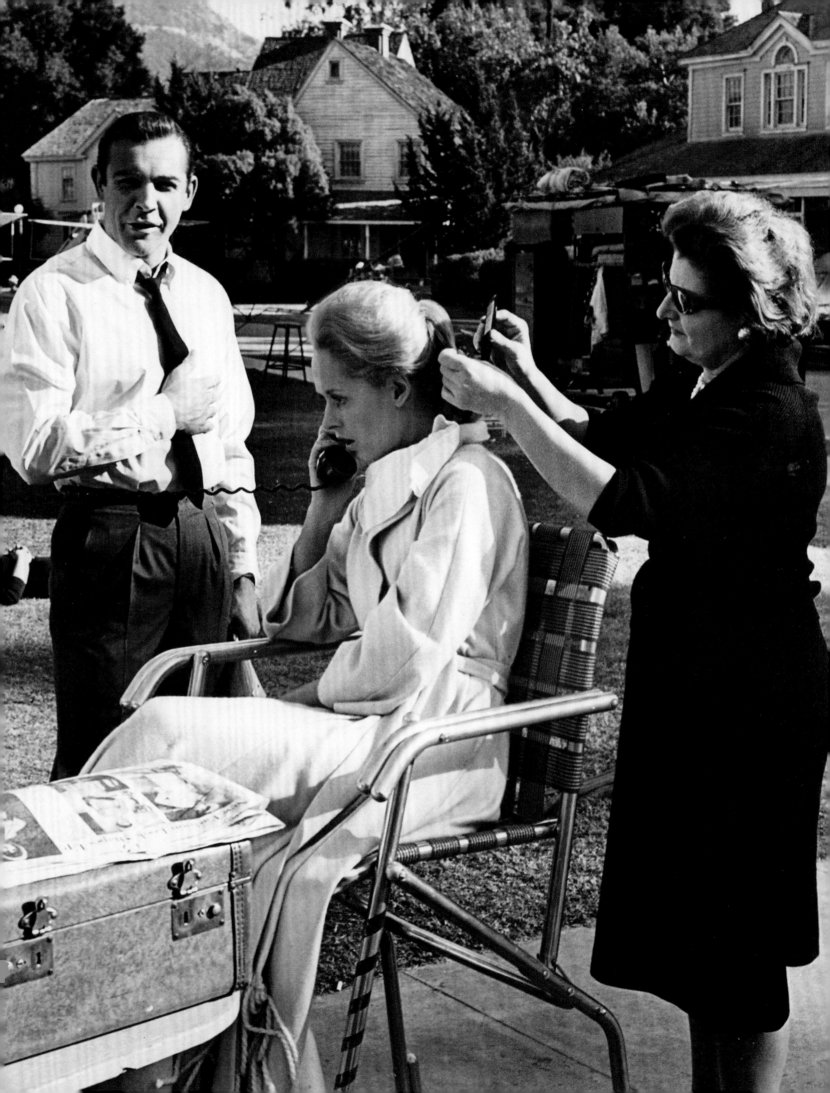

DIANE BAKER

Born in 1938 in Hollywood, Diane Carol Baker moved to New York when she was eighteen in order to study acting and ballet. She was signed to a contract with 20th Century Fox and made her debut in *The Diary of Anne Frank* (1959), directed by George Stevens. *Journey to the Center of the Earth* and *The Best of Everything*, about a group of young career girls in New York, followed. Happy to break free from her studio contract, she worked freelance in films including *The Prize*, *Straight Jacket*, and as the love interest in the final episode of the TV series *The Fugitive* in 1967. She continued acting in film and television, with a notable role in *The Silence of the Lambs* (1991) as Senator Ruth Martin, and from 2004 has been the director of the School of Acting at the Academy of Art University in San Francisco.

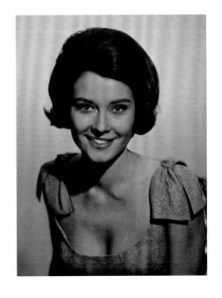

psychoanalysis and the wild animal analogy referenced throughout. The writer became close to the Hitchcocks and was invited to stay at their home. They would regularly go for dinner and cocktails together while discussing the script.

When filming began on *Marnie*, Hedren said the obsession she felt from Hitchcock on *The Birds* was becoming even more suffocating and unhealthy. Hitchcock wooed her with champagne and flowers, revealing his dreams about her and separating her from other members of the crew. Was this a tactic to create conflict and a sense of unease needed for the character, as he had done with Joan Fontaine in *Rebecca*?

Hedren found that she was always referred to as "the girl," an expression quite common in 1920s cinema and which Hitchcock was accustomed to using. But for a modern woman of the 1960s, this must have felt quite objectionable. It was not just a clash of personalities but of eras: the Edwardian Hitchcock and modern Tippi Hedren, living through the emancipation of women.

Eventually, she recalled, he declared his love for her, hoping she would reciprocate. "He was almost obsessed with me, and it's very difficult to be the object of someone's obsession. It's a very painful thing," she said. Hedren gradually revealed the discomfort of her relationship with Hitchcock over the years. She recalled during a round table discussion with other Hitchcock actresses in 1999 that "we used to have tea at four, every afternoon, with china cups and saucers. And it was brought to us. Just the two of us. On the set, which was really a little embarrassing."

When Baker arrived on set to do her scenes, she found that Hitchcock played her off against Hedren, which felt disturbing for her.

She recalled an incredibly painful time on set, when she observed that Hitchcock and Hedren could not even speak to each other. "I was in the middle and felt kind of used," she says of the situation. "He was telling me nice things, complimenting me, but he was also a little envious. He didn't like when young men visited the set, and said, 'Are these your boyfriends?' I was sort of on the edge.

"I suddenly felt and saw the struggle of a disturbed man. It was very hard on people around us and we felt the strain and stress," Baker said. The uncomfortable situation affected her physically, as she came

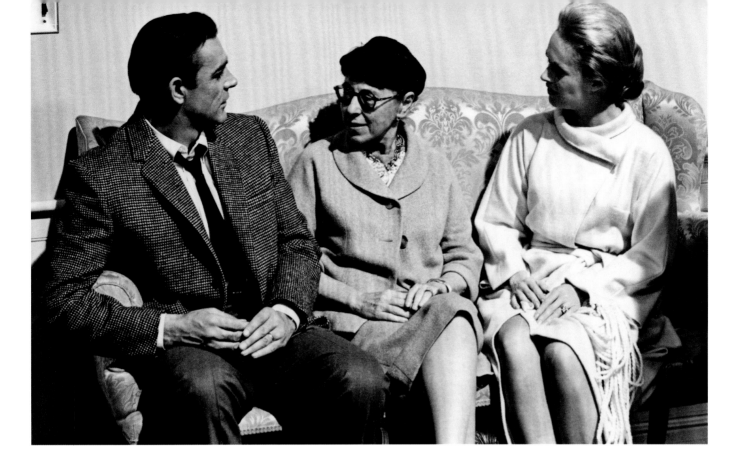

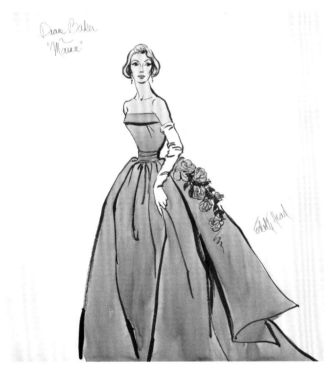

Opposite: Diane Baker as Lil. The tangerine color of her dress makes her stand out against Marnie in the party scene.

Top: Edith Head seated between Sean Connery and Tippi Hedren on the set of *Marnie*.

Above: Head's sketch for Diane Baker's orange dress.

down with an illness during filming, though she had never previously missed a day of work.

"I was a tough cookie, so he couldn't maneuver me," Baker said. "He did very personal things, such as giving strange looks to me before a scene. There was an edge to my character as every time she saw Sean Connery's character with Marnie, she gave this evil look. Hitch wanted to push the buttons, so he wouldn't look at me, he avoided me before these scenes. I'd think, 'Why is he not looking at me, why is he making me feel bad?' Later on, I began to think; maybe he did it on purpose to bring out something.

"I respect Tippi tremendously," Baker said. "The TV show [*The Girl*] was tough, but this was Tippi's experience and what she shared. I never saw Hitchcock again. I found it very difficult to go to his memorial as it [*Marnie*] was a complex, unhappy experience, but I can separate it and appreciate his work."

Hitchcock and Hedren's relationship broke down irreparably when Hedren was refused permission to go to an awards ceremony in New York.

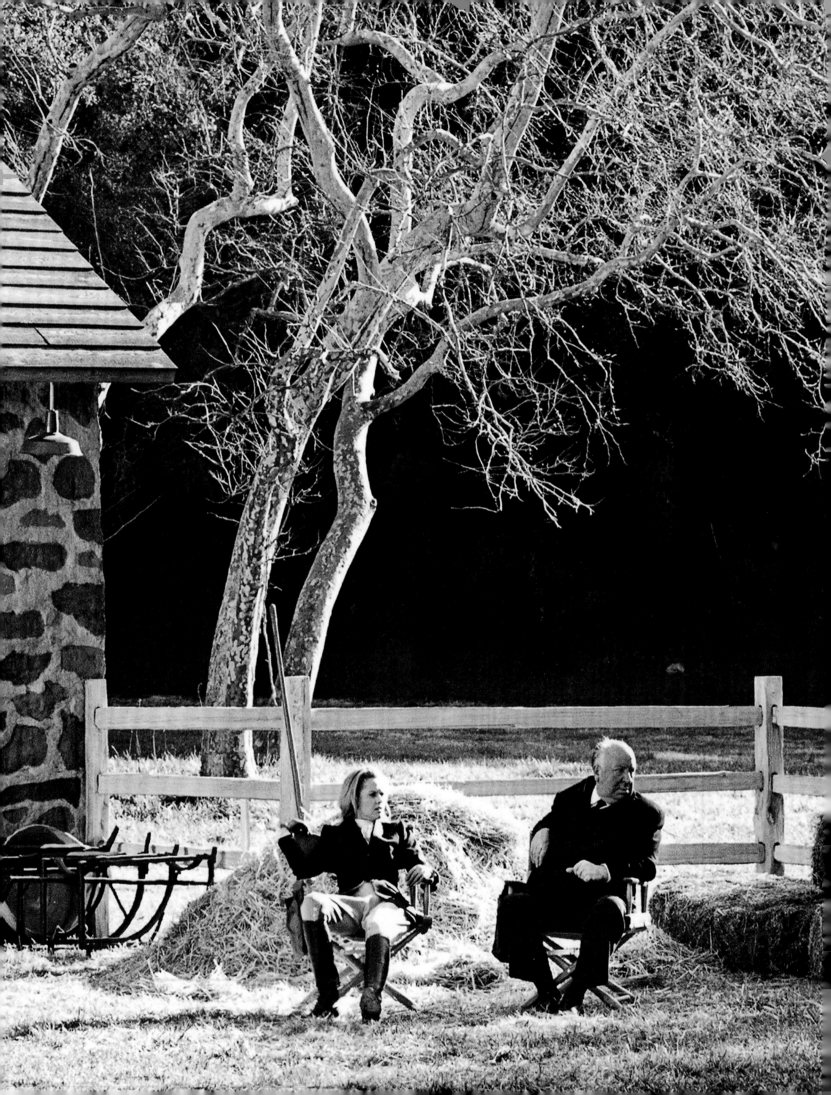

Accounts differ, but records at the Margaret Herrick Library note that Hedren was nominated as a "Star of Tomorrow" by the Foreign Press Association and was invited to appear at the Ambassador Hotel on Wednesday, February 5. Universal's publicity department believed it was a "rat race" and that Hedren wouldn't get enough attention to justify taking time off from shooting. Peggy Robertson told Hitchcock: "Tippi's appearance may have some bearing on the finals for the Golden Globe Awards in March, but it is doubtful. As she is working on a picture, this would be a legitimate excuse for her absence."

hands on me," and that he tried to sexually assault her. Again accounts differ, but it was certainly a frightening experience for her. Allen, having been told that Hitchcock was impotent, doubted Hedren's claims of sexual assault and called it a "cri de coeur." She said, "He was a very Edwardian fellow. Hitch loved his family. I would say that he was possibly a little carried away by Tippi, how attractive she was, but that was all there was to it."

Even after their relationship collapsed, Hitchcock still hoped that Hedren would star in his version of J. M. Barrie's *Mary Rose*, a Scottish ghost story to be adapted by Allen. Universal, dissuaded

"He was almost obsessed with me, and it's very difficult to be the object of someone's obsession. It's a very painful thing." TIPPI HEDREN

For Hedren "there was no reason other than meanness and control for Hitchcock to refuse to let me take that trip," and her excitement about the awards turned to great disappointment. She erupted in anger at him, calling him a fat pig. "She did what no one is permitted to do. She referred to my weight," he told his biographer, John Russell Taylor. She demanded he break their contract, while Hitchcock fired back that he could ruin her career.

A few weeks later, she claimed that in her dressing room "he suddenly grabbed me and put his

by their perceived disappointments of *Marnie* and *The Birds*, refused to allow him to make the film, the first time in possibly two decades that he had been told no.

Marnie was released in July 1964 to lukewarm reviews. Hedren blamed Hitchcock for ruining her career, convinced he had turned down all offers she received, while he blamed her for the film's lack of success. Hitchcock said, "It had wonderful possibilities, or so I thought. I thought I could mold Miss Hedren into the heroine of my imagination. I was wrong." After *Marnie*, according to François Truffaut, Hitchcock "was never the same . . . its failure cost him a considerable amount of self-confidence."

Opposite: Tippi Hedren and Alfred Hitchcock on the set of *Marnie*.

FRENZY (1972)
ANNA MASSEY &
BARBARA LEIGH-HUNT

Richard Blaney's ex-wife, Brenda (Barbara Leigh-Hunt), runs a matchmaking service. His friend, Robert Rusk, is one of her clients, but has been blacklisted for strange kinks.

Rusk visits her office and tries to seduce her. When she rejects him, he rapes and strangles her. Suspicion falls on Blaney as he has been seen threatening his ex-wife in public. Rusk then murders Blaney's girlfriend, Barbara "Babs" Milligan (Anna Massey).

He hides her body on the back of a lorry with sacks of potatoes. However, he discovers that his tie pin (with the initial R) is missing, and realizes that Babs must have torn it off during her murder.

He finds Babs's body but rigor mortis has set in and he has to break her fingers to get the pin.

Meanwhile, Blaney is imprisoned. But Oxford, the investigating detective, starts to think he may have arrested the wrong man.

Blaney escapes from prison and goes straight to Rusk's flat. Oxford follows him there. Blaney arrives and finds Rusk asleep in bed. He attacks him. However, it is the body of another of Rusk's female victims, strangled by a necktie.

Oxford arrives and sees Blaney by the corpse. Blaney begins to protest his innocence when they both hear a loud banging noise coming up the stairs.

In comes Rusk dragging a large trunk. Oxford comments: "Mr. Rusk, you're not wearing your tie" as Rusk drops the trunk in defeat.

Frenzy is the only Hitchcock film to feature nudity and be given an X rating.

Before he made the critically maligned Cold War thriller *Topaz*, Hitchcock planned a serial-killer thriller called *Kaleidoscope Frenzy*, set in New York. Sample film stills and footage indicate it would have been a new experimental style, maybe similar to Wes Craven's early exploitation films with their violence and nudity. But Universal told Hitchcock flatly that he could not make it.

Hitchcock returned to the serial killer idea at the beginning of the 1970s, using the novel *Goodbye Piccadilly, Farewell Leicester Square* by Arthur La Bern as source material. It would be filmed cheaply and quickly in London, and Anthony Shaffer—whose stage play, *Sleuth*, was receiving good reviews at the time—was hired to do the screenplay. When Hitchcock couldn't secure Michael Caine to play antihero Dick Blaney, he settled on a cast of relatively unknown British actors.

For *Frenzy*, Hitchcock chose to capture the London he knew as a boy: the Covent Garden fruit and vegetable market where his greengrocer father worked; the dark, polluted Thames; Wormwood Scrubs Prison; and traditional English pubs. He complained about the "psychedelic nature" of modern pubs, saying, "They look wrong . . . there's nothing like dark wood in a good pub."

Frenzy was far from the Swinging London of King's Road, with the psychedelic visuals of the Rolling Stones or modish Twiggy. "The London that he remembered didn't exist anymore," said Barbara Leigh-Hunt, who played Brenda Blaney. "He tried to re-create a London that wasn't there."

The Hitchcocks were pleased to be back in London again, where they enjoyed the restaurants and plays, and saw Ingrid Bergman on stage in *Captain Brassbound's Conversion*. The couple stayed in a suite at

ANNA MASSEY

Anna Massey, born in Sussex, England, in 1937, was the daughter of two actors, Adrianne Allen and Raymond Massey, and was the goddaughter of director John Ford. She first appeared on stage at the age of seventeen in *The Reluctant Debutante*, and without formal training, won roles in Samuel Beckett and Harold Pinter plays. Throughout the 1960s she starred in London West End productions, winning rave reviews in David Hare's *Slag* in 1971.

Massey's British film work included Michael Powell's *Peeping Tom* (1960), and she moved into television, notably as Mrs. Danvers in *Rebecca* (1979), Margaret Thatcher in *Pinochet in Suburbia* (2006), and winning a Bafta for *Hotel du Lac* (1986). She also crossed into British crime series with parts in *Inspector Morse*, *Midsomer Murders*, and *Poirot*. Noted for her rich, Thespian voice, she was awarded Commander of the British Empire in 2005, and was married twice—to actor Jeremy Brett in 1965 and Russian metallurgist Uri Andres. Massey died in 2011, from cancer.

Page 184: Barbara Leigh-Hunt as Brenda.

Opposite: Anna Massey as Babs. Costumes were designed by Julie Harris, who was credited with shaping the London look of the swinging 60s and 70s.

Claridges, and the director traveled by Rolls Royce to Covent Garden every morning for location shooting. He signed autographs with his famous caricature for the crowds of people who gathered to watch filming.

Hitchcock was in great pain after a bad fall and he was suffering from arthritis, so vodka at lunch dulled the pain, but it also made him sleepy. Despite ill health, Hitchcock still employed his offbeat humor to relax the actors on set. "He would always, before a take, tell you some dirty schoolboy joke," said Anna Massey, who played Babs. "He did that to relax you because it relaxed him."

While the London settings and dialogue appeared dated, costumes were designed by Julie Harris, credited with shaping the London look of the Swinging Sixties and Seventies. She won an Oscar for *Darling*, starring Julie Christie, and she dressed the Beatles in *A Hard Day's Night*.

Dick Blaney, played by Jon Finch, is a down-on-his-luck, ex-squadron leader who is out of step with fashion, conveyed through a tweed jacket with leather patches on the shoulders and elbows. This jacket serves as an important plot point, and therefore had to look distinctive. Finch, who delivered his lines in an almost Shakespearean manner, made it clear he thought Shaffer's script was dated. He told a journalist from the *Times* who was visiting the set that "some of the lines are frankly unbelievable, but he has told us to change anything we like, so all the actors are getting together to work out something reasonable."

Massey shared the same opinion. "Frankly, it was a rather dated script," she said. "And as Hitch hadn't been in London for a long time, I don't think he was aware of how old-fashioned the dialogue really was." But she added that from early on, Hitchcock was "concerned about every detail—clothes and colors and set dressings." She went on to explain, "He taught me how to make a good batter—and later I realized that this was apt at a time when we were making a film so crowded with food."

The themes of food, sex, and violence feature throughout Hitchcock's career, but the food metaphors are even more obvious in *Frenzy*. Bob Rusk munches on an apple after he murders, Dick Blaney takes out his frustration by stamping on grapes and crushing a wine

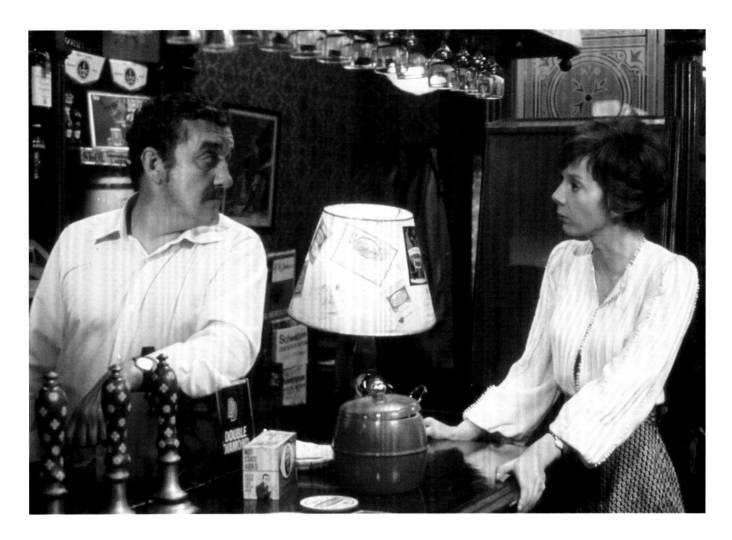

"He would always, before a take, tell you some dirty schoolboy joke. He did that to relax you because it relaxed him." ANNA MASSEY

glass in his hand. Inspector Oxford (Alec McCowan) prefers a good cooked breakfast, but his wife (Vivien Merchant), an amateur French gourmand, serves elaborate but unappetizing dishes to him as they discuss the case. It was a reference to Hitchcock and his own wife, but Reville's cooking was much more to Hitchcock's taste.

The scene Hitchcock relished the most involved a body hidden in a potato truck, for which all 118 takes needed for this particular scene had been dictated to his secretary far in advance. "It should be very amusing," he said of this scene. "I've only shown nudity when it was vital to the story," he added. "If you noticed, I tried to be as discreet as possible with that nude corpse in the potato truck."

While Hitchcock was at times displeased with Jon Finch, he was kind to Barbara Leigh-Hunt and Anna Massey, his two murder victims. He particularly enjoyed Leigh-Hunt's company, and she was the focus of the most disturbing scene that had ever appeared in a Hitchcock film, the nudity in which inspired a body double clause in her contract. Leigh-Hunt told a film crew on the set, "It's not a pleasant scene. It's very well written I think, and Mr. Hitchcock knows exactly what he wants.

BARBARA LEIGH-HUNT

Born in Bath, Somerset, in 1935, Barbara Leigh-Hunt trained in acting at the Bristol Old Vic Theatre School and appeared in many productions at the Royal Shakespeare Company and the Royal National Theatre. She crossed into film as Catherine Parr in *Henry VIII and His Six Wives* (1972) and *Bequest to the Nation* (1973) but *Frenzy* was her most famous film role.

In 1983 she starred opposite a stellar cast of British actors—Laurence Olivier, John Gielguid, and Richard Burton—in the mini-series *Wagner* and played Lady Catherine de Bourgh in the BBC's hugely popular *Pride and Prejudice* (1995). She also had a small role in *Billy Elliot* (2000). She was married to actor Richard Pasco from 1967 until his death in 2014.

Opposite Left: Julie Harris's costume sketch and fabric samples for the green dress worn by Barbara Leigh-Hunt during her murder scene. The shade of green referenced Hitchcock heroines of the past.

Opposite Right: The scene where Brenda is strangled by Rusk is one of the most disturbing that ever appeared in a Hitchcock movie.

But the actual process of being strangled I can't say is pleasant, no."

Massey also appears naked when her character, Babs, climbs out of bed nude and puts on her socks. Hitchcock never presumed that Massey would do this shot herself. "Hitchcock never asked me to strip—a double had been organized without my knowledge," she said.

Jonathan Jones in the *Guardian* commented in 2009, "Hitchcock in his old age has been portrayed as a man losing his self-control and slipping into embarrassing behavior towards his actresses. The main witness for the prosecution is Tippi Hedren. If her account was typical of Hitchcock, he would surely have upset Massey and Leigh-Hunt, who are sexually assaulted and strangled in *Frenzy* in the most horrible, sexually twisted way Hitchcock ever devised. They never detected any connection between what was on screen and Hitchcock's own benign, reassuring personality."

Brenda Blaney is successful, impeccably groomed, and, as *Film Quarterly* described, "her beauty is in the glossy tradition of the Hitchcock blonde, but rather softened here to fit the middle-class milieu and one's identification with the story." Her pristine look of pearls, brooches, and tailored dresses serves to contrast with her ex-husband's scruffy appearance, demonstrating how far he has fallen.

Hitchcock called Massey a "personality," and she brought tough, Cockney warmth to her role as barmaid Babs, the only Hitchcock heroine, who, as the *Guardian* pointed out, has the pluck to deliver a line such as "stuff your rotten job right up your jacksie." Babs is the hippest of all the characters in the film. We first see her in a blouse and long, printed bohemian skirt, and later a coral jacket and miniskirt emphasize her Twiggy-like figure. But, unlike heroines of the past, she is a warm character rather than glacial, making her demise, and Rusk's defiling of her body in the potato truck, even more tragic.

Film Quarterly described Babs as "a superb, original creation, almost Dickensian in effect. She is completely without pretensions, sensible and although tough, just a bit guileless. Miss Massey succeeds in being the season's most unlikely and lovable heroine, with a perky-bird earthiness all her own."

In an initial meeting with Hitchcock, Massey noted his "formidable" charm. For the first forty-five minutes, nothing of the plot was

Frenzy
Rape dress

No waist
seam.

Tears from
side bodice
seam.

Colour
only.

Julie Harris

mentioned. Instead they talked about the best way to make a "batter pudding," waiting until "the atmosphere was warm and friendly" before talking business.

"Hitchcock was involved in every department," she said. "He wanted to see all my costumes and insisted that my bust be padded. At this meeting he told me he had made a similar request to Grace Kelly and then told me a rather risqué joke which ended 'there's gold in them there hills.' I didn't understand this joke, but I think it referred to Miss Kelly's décolletage. The myth that Hitchcock treated actors like cattle is completely false. He always had time for you and you could ask him for guidance whenever you need to."

One of the most memorable scenes is when trusting Babs is lured to Rusk's apartment. The floating camera follows them up the stairs and pauses as they enter into the flat. The camera retreats backwards, down the stairs, out the door, and across the busy, noisy Covent Garden street, leaving Babs up there and alone with the killer. We know that she won't make it out alive. It was a complex, tricky shot, executed with absolute fluidity despite transitioning from the studio to the Covent Garden location.

Jean Marsh played Brenda's receptionist, Monica, originally to be the final victim of the killer. She was made to look like a dowdy spinster, with oversized glasses and brown-toned clothing. At a British Film Institute question-and-answer session in 2012, she recalled that Hitchcock hired her because she was short-sighted and could wear her own glasses in the film. She added of the violence, "I don't think there was any point making that film if you didn't get the truth."

By the 1970s, Hitchcock's work was subject to critical analysis, much of it linked to misogyny. The women's liberation movement criticized *Frenzy* in particular for its brutal depiction of rape and murder. The National Organization of Women gave the film the wryly named "Keep Her in Her Place" award as part of Women's Rights Day. Victoria Sullivan

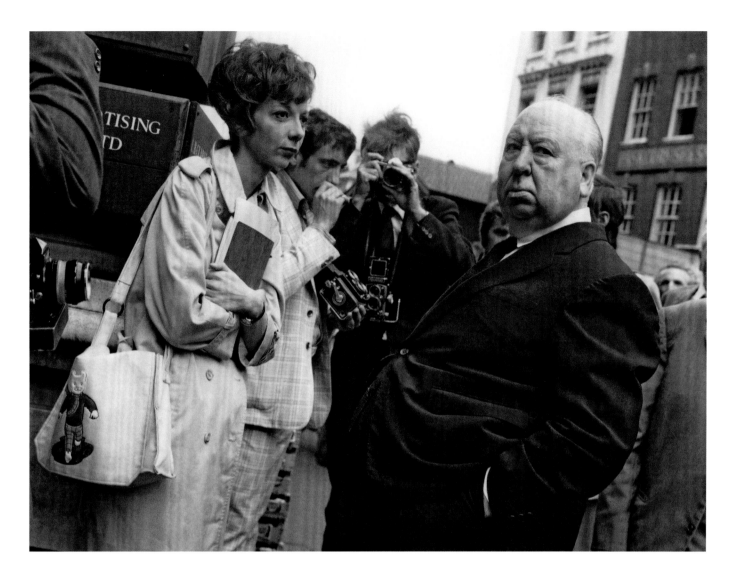

Opposite: Jean Marsh, who played Brenda's receptionist, Monica. She was dressed in brown tones and wore over-sized glasses to make her look dowdy.

Above: Anna Massey and Hitchcock before shooting a scene on location in Covent Garden, London.

in the *New York Times* was particularly critical. "I'm tired of going to movies and seeing women get raped. It makes me so damned angry," she wrote. "I suspect that films like *Frenzy* may be sicker and more pernicious than your cheapie hum-drum porno flick, because they are slicker, more artistically compelling versions of sado-masochistic fantasies."

After another trip to Scotland to dream of filming *Mary Rose*, Reville suffered a stroke. Hitchcock was completely distraught, but he pressed on with *Frenzy* as she slowly recovered. When Reville saw the completed *Frenzy*, she cried with pride at the realization he had created something sensational. The audience gave Hitchcock a standing ovation at the end of its screening at Cannes, and it was his most successful film since *Psycho*, with *Time* praising it as "the dazzling proof" he was still on form. "It is not at the level of his greatest work, but it is smooth and shrewd and dexterous, a reminder that anyone who makes a suspense film is still an apprentice to this old master."

INSIGHT EDITIONS

PO Box 3088
San Rafael, California
www.insighteditions.com

 Find us on Facebook:
www.facebook.com/InsightEditions

 Follow us on Twitter: @insighteditions

Design and layout © 2018 Palazzo Editions Ltd
Text © 2018 by Caroline Young

Created and produced by:
Palazzo Editions Ltd
15 Church Road
London SW13 9HE
United Kingdom
www.palazzoeditions.com

Design by Katherine Winterson, Spokes Design

All rights reserved. Published by Insight Editions, San Rafael,
California, in 2018. No part of this book may be reproduced
in any form without written permission from the publisher.

Library of Congress Cataloging-in-Publication Data available.

ISBN: 978-1-68383-081-8

Insight Editions, in association with Roots of Peace, will plant two
trees for each tree used in the manufacturing of this book. Roots
of Peace is an internationally renowned humanitarian organization
dedicated to eradicating land mines worldwide and converting
war-torn lands into productive farms and wildlife habitats. Roots
of Peace will plant two million fruit and nut trees in Afghanistan
and provide farmers there with the skills and support necessary
for sustainable land use.

Manufactured in China

10 9 8 7 6 5 4 3 2 1

As a lifelong Alfred Hitchcock fan, this book has been many years in planning
and researching. I'd like to offer special thanks to the knowledgeable staff at the
Margaret Herrick Library at the Academy of Motion Picture Arts and Sciences,
particularly Kristine Kreuger and Louise Hilton. Thanks also to Brett Service at
Warner Brothers Archives, USC School of Cinematic Arts, Cristina Meisner at the
Harry Ransom Center, The University of Texas at Austin, for providing access to
the David O. Selznick Collection, Ron Mandelbaum and Howard Mandelbaum
for assistance with picture research at Photofest NYC, and to Claire Smith and the
other staff at the British Film Institute, London.

T: top; B: bottom; R: right; L: left; C: center

ACADEMY OF MOTION PICTURE ARTS AND SCIENCES: 10, 16, 42, 64, 110,
112, 115, 150, 151, 153L, 153R, 178, 179, 181T, 181B, 182 (From the core collection
production photographs, Alfred Hitchcock papers, costume design drawings, and
RKO Radio Pictures photographs of the Margaret Herrick Library, Academy of Motion
Picture Arts and Sciences); ALAMY: Cover, back cover L, back cover R, 103, 104,
117, 124, 131, 147, 156 (ScreenProd/Photononstop); 14, 17, 19, 60, 66, 67, 70, 73, 84,
90,102, 126, 134, 177, 184 (Everett Collection Inc.); 18, 38, 51, 78, 128T (Collection
Christophel); 28, 113, 114 (Pictorial Press Ltd); 31, 54, 98, 121, 160 (Photo 12);
back cover C, 34, 53, 62, 99 (AF archive); 75 (Glasshouse Images); 118 (Moviestore
collection Ltd); 152 (cineclassico) AUTHOR'S COLLECTION: 13; BFI NATIONAL
ARCHIVE: 27, 30, 190; 189L (Julie Harris BFI National Archive); BRIDGEMAN
IMAGES: 122 (Private Collection / Photo © Christie's Images); GETTY: 2 (Mondadori
Portfolio); 4 (Hulton Deutsch); 6 (RDA); 8, 81 (Peter Stackpole/The LIFE Picture
Collection); 22 (Ullstein bild); 40 (Getty General Photographic Agency / Stringer); 55
(John Kobal Foundation); 77 (J. R. Eyerman); 80 (John Springer Collection); 94, 95,
100, 107T, 108, 170 (Sunset Boulevard); 107B (Silver Screen Collection); 132, 175
(Archive Photos / Stringer); 164 (Bettmann); 180 (Hulton Archive / Stringer); MPTV:
58, 59, 68T, 68B, 116, 119, 120, 140, 159, 169, 176, 191 (mptvimages.com); 135, 139
(© Sanford Roth/mptvimages.com); PHOTOFEST: 20B (Gainsborough Pictures/
Photofest © Gainsborough Pictures); 25, 26 (©Sono Art-World Wide Pictures); 32T,
36, 37, 47 (Gaumont/Photofest © Gaumont); 32B (Photofest); 76, 163, 166, 168, 171,
187, 189R (Universal Pictures/Photofest © Universal Pictures); 83 (20th Century
Fox Pictures/Photofest © 20th Century Fox); 87, 88, 91 (United Artists / Photofest
© United Artists); 89 (Selznick International Pictures / Photofest © Selznick Inter-
national Pictures); 93, 96 (RKO/Photofest © RKO); 111 (Warner Bros./ Photofest ©
Warner Bros.); 127, 128B, 130, 137, 142, 144, 146, 161(Paramount Pictures/Photofest
© Paramount Pictures); REX/SHUTTERSTOCK: 20T, 43, 46 (ITV); 39 (Gaumont-
British); 44-45 (Gainsborough); 48 (United Artists); 56 (RKO/Kobal); 123, 138, 143,
145, 162 (Paramount/Kobal); 148 (MGM/Kobal); 155 (Apger/MGM); 167 (Universal/
Kobal); 173 (McCallum); WCFTR: 129 (Wisconsin Center for Film and Theater
Research 27341).

Cover: Grace Kelly-one of Hitchcock's greatest leading ladies-as Lisa in *Rear Window*.

Title page: Grace Kelly stars as Francie in *To Catch a Thief*.

Page 4: Grace Kelly and Alfred Hitchcock, Cannes 1954

Back cover: Janet Leigh in *Psycho*; Ingrid Bergman in *Notorious*; and Marlene Dietrich
in *Stage Fright*.